MW00581710

THE
HOTEL

OCCUPIED SPACE

The Hotel: Occupied Space explores the hotel as both symbol and space through the concept of "occupancy." By examining the various ways in which the hotel is portrayed in art, photography, and film, this book offers a timely critique of a crucial modern space.

As a site of occupancy, the hotel has provided continued creative inspiration for artists from Claude Monet and Edward Hopper, to genre filmmakers like Alfred Hitchcock and Sofia Coppola. While the rich symbolic importance of the hotel means that the visual arts and cinema are especially fruitful, the hotel's varied structural purposes, as well as its historical and political uses, also provide ample ground for new and timely discussion. In addition to inspiring painters, photographers, and filmmakers, the hotel has played an important role during wartime, and more recently as a site of accommodation for displaced people, whether they be detainees or refugees seeking sanctuary.

Shedding light on the diverse functions that the hotel serves, Robert A. Davidson argues that the hotel is both a fundamental modern space and a constantly adaptable structure, dependent on the circumstances in which it appears and plays a part.

ROBERT A. DAVIDSON is an associate professor of Spanish and Catalan at the University of Toronto and the author of *Jazz Age Barcelona*.

Robert A. Davidson

THE HOTEL

OCCUPIED SPACE

UNIVERSITY OF TORONTO PRESS
Toronto Buffalo London

© University of Toronto Press 2018
Toronto Buffalo London
utorontopress.com
Printed in Canada

ISBN 978-1-4426-41853 (cloth) ISBN 978-1-4426-10941 (paper)

Printed on acid-free paper.

Library and Archives Canada Cataloguing in Publication

Davidson, Robert A., 1970–, author
The hotel : occupied space / Robert A. Davidson.

Includes bibliographical references and index.
ISBN 978-1-4426-4185-3 (hardcover) ISBN 978-1-4426-1094-1 (softcover)

1. Hotels – Social aspects. 2. Hotels – History. I. Title.

TX908 D38 2018 647'.94 C2018-903370-3

This book has been published with the help of a Research Publication Grant
from Victoria University in the University of Toronto.

University of Toronto Press acknowledges the financial assistance
to its publishing program of the Canada Council for the Arts and
the Ontario Arts Council, an agency of the Government of Ontario.

Canada Council Conseil des Arts
for the Arts du Canada

Funded by the Financé par le
Government gouvernement
of Canada du Canada

ONTARIO ARTS COUNCIL
CONSEIL DES ARTS DE L'ONTARIO

an Ontario government agency
un organisme du gouvernement de l'Ontario

Canadä

For Bill and Berna

CONTENTS

Illustrations ix

Acknowledgments xiii

Introduction: The Overlooked Space 3

PART ONE: THE REALM OF IMAGINATION

chapter one The Pictorial Hotel 13

chapter two The Cinematic Hotel 47

PART TWO: THE BUILT ENVIRONMENT

chapter three The Wartime Hotel 89

chapter four The Displacement Hotel 119

Conclusion: The Hotel Attraction 147

Notes 155

Works Cited 167

Index 175

ILLUSTRATIONS

1.1 Claude Monet, *Hôtel des roches noires, Trouville*. 1870. 15

1.2 Georges Braque, *The Terrace at the Hôtel Mistral*, 1907. 17

1.3 John Singer Sargent, *A Hotel Room*, ca 1906–7 18

1.4 George Grosz, *Metropolis*, 1916–17. 19

1.5 Edward Hopper, *Hotel Room*, 1931. 22

1.6 Edward Hopper, *Hotel by a Railroad*, 1952. 23

1.7 Edward Hopper, *Hotel Lobby*, 1943. 24

1.8 Edward Hopper, *Hotel Window*, 1955. 27

1.9 © Burt Glinn/Magnum Photos, 1959. Headquarters in the Hilton Hotel, Havana. 30

1.10 © Burt Glinn/Magnum Photos, 1959. "Fidelistas," Hilton Hotel, Havana. 31

1.11 © Burt Glinn/Magnum Photos, 1959. Soldiers, Hilton Hotel, Havana. 32

1.12 © Burt Glinn/Magnum Photos, 1959. New Years Day, Havana Libre. 34

1.13 Deena Stryker, *Lobby, Habana Libre Hotel*, 1964. 36

1.14 Deena Stryker, *Habana Libre Hotel, Interior, Night*, 1964. 36

1.15 Deena Stryker, *Habana Libre Hotel, Foyer*, 1964. 36

1.16 *Cityscape with Hotel Habana Libre*. Peter Schickert / Alamy Stock Photo 37

1.17 Ramón Serrano, *What You See Is What You See #1*, 2003. 39

1.18 Ramón Serrano, *What You See Is What You See #2*, 2003. 40

1.19 Ramón Serrano, *What You See Is What You See #3*, 2003. 41

1.20 Ramón Serrano, *What You See Is What You See #4*, 2003. 42

1.21 Ramón Serrano, *What You See Is What You See #5*, 2003. 42

1.22 Ramón Serrano, *What You See Is What You See #6*, 2003. 42

1.23 Ramón Serrano, *What You See Is What You See #7*, 2003. 43

1.24 Ramón Serrano, *What You See Is What You See #8*, 2003. 45

1.25 Ramón Serrano, *What You See Is What You See #9*, 2003. 45

1.26 Ramón Serrano, *What You See Is What You See Triptych*, 2003. 45

2.1 *Weapon of Choice*. Dir. Spike Jonze, 2000. 48

2.2 *Weapon of Choice*. Dir. Spike Jonze, 2000. 48

2.3 *El hotel eléctrico*. Dir. Segundo de Chomón, 1905. 51

2.4 *El hotel eléctrico*. Dir. Segundo de Chomón, 1905. 51

2.5 *El hotel eléctrico*. Dir. Segundo de Chomón, 1905. 53

2.6 *El hotel eléctrico*. Dir. Segundo de Chomón, 1905. 53

2.7 *The Last Laugh*. Dir. F.W. Murnau, 1924. 56

2.8 *The Last Laugh*. Dir. F.W. Murnau, 1924. 56

2.9 In-house telephone operators. *Grand Hotel*. Dir. Edmund Goulding,
 1932. 58

2.10 Overhead lobby shot. *Grand Hotel*. Dir. Edmund Goulding, 1932. 58

2.11 From kaleidoscope to beacon. *Ménilmontant*. Dir. Dimitri Kirsanoff,
 1926. 61

2.12 *Ménilmontant*. Dir. Dimitri Kirsanoff, 1926. 61

2.13 Submerged hotel sign. *Ménilmontant*. Dir. Dimitri Kirsanoff, 1926. 61

2.14 French movie poster for *Vivre sa vie*. 65

2.15 Sex hotel lobby. *Vivre sa vie*. Dir. Jean-Luc Godard, 1962. 67

2.16 Sex hotel room. *Vivre sa vie*. Dir. Jean-Luc Godard, 1962. 67

2.17 Open transaction. *Vivre sa vie*. Dir. Jean-Luc Godard, 1962. 67

2.18 Nana looks for a second prostitute. *Vivre sa vie*. Dir. Jean-Luc Godard,
 1962. 68

2.19 Lobby of the Red Star Hotel. *Alphaville*. Dir. Jean-Luc Godard, 1965. 70

2.20 Bright colours. *Made in USA*. Dir. Jean-Luc Godard, 1966. 71

2.21 Beginning of crane shot. *Young and Innocent*. Dir. Alfred Hitchcock,
 1937. 73

2.22 Lattice shadow. *The Man Who Knew Too Much*. Dir. Alfred Hitchcock,
 1956. 74

2.23 Point of view at the door. *The Man Who Knew Too Much*. Dir. Alfred
 Hitchcock, 1956. 74

2.24 United Nations lobby. *North by Northwest*. Dir. Alfred Hitchcock, 1959. 76

2.25 Judy in profile. *Vertigo*. Dir. Alfred Hitchcock, 1958. 77

2.26 Judy's duality. *Vertigo*. Dir. Alfred Hitchcock, 1958. 77

2.27 Scottie gazing at the camera. *Vertigo*. Dir. Alfred Hitchcock, 1958. 78

2.28 Normal background light. *Vertigo*. Dir. Alfred Hitchcock, 1958. 79

2.29 Backlit by the eerie green light. *Vertigo*. Dir. Alfred Hitchcock, 1958. 79

2.30 Park Hyatt, Tokyo. *Lost in Translation*. Dir. Sofia Coppola, 2003. 82

2.31 Bob Harris, Tokyo. *Lost in Translation*. Dir. Sofia Coppola, 2003. 82

2.32 Tokyo in focus. *Lost in Translation*. Dir. Sofia Coppola, 2003. 83

2.33 View outside. *Lost in Translation*. Dir. Sofia Coppola, 2003. 84

2.34 The Chateau Marmont Hotel. *Somewhere*. Dir. Sofia Coppola, 2010. 85

2.35 Marco's ennui. *Somewhere*. Dir. Sofia Coppola, 2010. 85

3.1 *Battle at the Hotel Colón*. Pérez de Rozas, 1936. 93

3.2 *Hotel Colón converted into recruiting centre*. Pérez de Rozas, 1936. 94

3.3 *Public Cafeteria at the Ritz Hotel in Barcelona*. Anonymous, 1936. 96

3.4 *Beirut Snipers*. © Raymond Depardon/Magnum Photos 103

3.5 *La bataille des hôtels*. Lamia Ziadé. 105

3.6 *Modified Hotel Posters*. Lamia Ziadé. 106

3.7 *Detail of Modified Hotel Poster*. Lamia Ziadé. 106

3.8 *Holiday Inn Beirut*. Photo: Jennifer Varela, 2011. 108

3.9 *Sarajevo's Holiday Inn during and after the Siege*. 2005. 109

3.10 Lionov and Karadzic above Sarajevo. 113

3.11 French movie poster for *Sniper*. 113

3.12 *Iraq–US War Wounded Journalist's Camera*. © Getty Images/Patrick Baz. 115

3.13 *American Tank Firing on the Hotel Palestine Baghdad*. AFP/France 3. 115

3.14 *White Flags at Hotel Meridien Palestine*. © Getty Images/Ullstein Bild. 116

4.1 *Heritage Inn, Toronto*, 2017. Photo: Paul David Esposti. 129

4.2 *Hotel Iveria in Tblisi, Georgia*, 2001. AP Photo/Shakh Aivazov. 132

4.3 *Radisson Blu Iveria*, 2013. Photo: Beniamin Netan. 133

4.4 *Gate at the Spree Hotel, Bautzen*, 2016. AP Photos/Jens Meyer. 135

4.5 *Burnt Former Husarenhof Hotel, Bautzen*, 2016. EPA/Oliver Killig 136

4.6 Title, *Café Waldluft*. Still © M. Kossmehl 137

4.7 *Dinner at the Waldluft*. Still © M. Kossmehl 137

4.8 *Last Syrian Family Leaving the Toronto Plaza Hotel*. Getty Images/Carlos Osorio 143

4.9 Screen capture, TripAdvisor 144

4.10 Screen capture, TripAdvisor 144

5.1 *Gran Hotel Internacional*, 1888–9. Antoni Esplugas. 149

5.2 Hotel Attraction section drawing. 151

5.3 *Hotel Attraction and the Shadow of ...* Marc Mascort i Boix, 2002. 151

ACKNOWLEDGMENTS

This book has benefited from the help, encouragement, and prodding of many people. A timely sabbatical (thank you, U of T!) enabled me to figure out how to tighten the focus and finally finish. Finally. To those who have heard me talk about this book for years, I thank you for your generous comments and apologize that I wasn't able to incorporate all of the great ideas and references that I received. Thank you to Alison Mathews David for her help with my art history sections and a special shout out to Jennifer Varela, a vociferous proponent of this project from early on and an enormous help with the research and analyses contained in the film chapter. Thank you, Paul David Esposti, for all of your work on my images and for generating the many stills; the book is much richer for them. I am indebted to Ramón Serrano for our great conversations about – and the high quality shots of – his *Lo que se ve…* series and to Jane Corkin for access to the original canvases and drawings at her gallery; Matthias Koßmehl for providing me with his wonderful film *Café Waldluft*; Lamia Ziadé for the images of her *La bataille des hôtels* and a spatial primer on Beirut; and *diacritics* and *Romance Quarterly* for permission to reproduce parts of previous articles. Thank you to Megan Ó Connell at the David M. Rubenstein Rare Book and Manuscript Library at Duke University for helping with the Stryker photos and Anne Young at the Indianapolis Museum of Art for facilitating my inclusion of Hopper's *Hotel Lobby*. *Gracias también* to Patricia for her help on that Hopper section and Stephanie, Fran, Alexandra, and Kevin for going over early versions of chapters and for their continued interest in the book and support over the years. I am thankful, as well to the anonymous readers who considered the manuscript and were very generous with their time and comments.

I am lucky to be at a school that gives me the freedom to do interdisciplinary projects such as this one, and I am very grateful to Josiah Blackmore and Stephen Rupp, who have been invaluable colleagues and friends as I've learned the ins and outs of the profession. Aphrodite, Bao, and Jill make my Bader home a lovely place to be while Vic and Northrop Frye Centre time would simply not be the same without

Jamie and now Amelia, as well. Rosinda and Sara, you have always been patient with my requests – thank you! I am indebted to everyone who makes it possible for me to write and teach – from the great staff in Physical Plant, Events and Housekeeping at Victoria College to the upper echelons of the administration. I never take this gig – or its great conditions – for granted.

I am grateful to UC Berkeley, Wheaton College, U Mass Amherst, Johns Hopkins, the School of Advanced Study at the University of London, Western University, the Freeman Spogli Institute at Stanford, the Institute of Fine Arts at NYU, Mills College, Green College at UBC, the Tourism History Working Group at the University of Guelph, the Arts and Letters Club of Toronto, and the Victoria Women's Association for having invited me to speak on various aspects of this project. Financial support from Victoria University has been crucial in the communication of my research as I have progressed and the Research Publication Grant is much appreciated as well.

Anyone who has published with the University of Toronto Press knows how great it is to work with their team and I would like to specifically thank Mark Thompson, Suzanne Rancourt, and Siobhan McMenemey for their support and encouragement over the past few years. To James Leahy and Frances Mundy, I say thank you for polishing and guiding my work to publication.

I was once told that we all need a team around us as we go through life and, man, do I have a good one. Thank you to my parents, Gail and Stu, and sister, Carrie, to Duma, Andrew, Amber, Victoria, Rosi, Néstor, Manuel, Morgan, Heino, Anna, Marc, Jordana, Katia, Joan Ramon, Dom, Enric, Gordon, and Sarena for all of your support over the years. Carlota Caulfield and Peter Harris, your unique perspectives are always appreciated. To Jess and all at The Comrade, Brett (formerly of Raval), Alessandro at Isabel, John at Alo, and, of course, Stephanie and Dollie at the Duke, thank you for the drinks and enthusiastic encouragement when I needed them. Deep gratitude, as well, to David "The Tailor" Petrash who puts Italy on my back and who is a constant reminder of what can only be described as "life's rich pageant" beyond the walls of academe.

My partner, Hélène Grégoire, has been lucky enough (heh heh) to hear about this project for well over a decade now and her presence in Sarajevo made that research trip very special. I cannot thank her enough for her continued support of all that I do and for encouraging me to get involved in other rewarding work as well.

The idea to turn my interest in hotel space into a monograph came from two of the coolest and smartest people I know on the very first day that we met. Bill Egginton and Bernadette Wegenstein effortlessly combine the best of American and European sensibilities, and their own work has pushed me to be a better scholar. That they have also shared their family with me means more than they know, and for their continued, inspiring presence in both my academic life and my personal one, I dedicate *The Hotel: Occupied Space* to them.

THE
HOTEL
OCCUPIED SPACE

INTRODUCTION:
THE OVERLOOKED SPACE

Of the many urban spaces that have been integral to the modern experience – among which figure the railway station, the café, the factory, and the shopping arcade – the hotel has been the most under-appreciated and least theorized.[1] This is especially remarkable given that the hotel is a cultural and built edifice that is a ready-made conduit for transculturation. At once embodying the grey zone between public and private, the transience of the tourist, and, in the case of a postmodern city such as Las Vegas, the victory of simulacrum over monumental authenticity, the hotel is intimately linked to processes of modernity and postmodernity and is emblematic of the urban experience in the way that it provides both space and time for the forging of different types of contact. When parts of chains, hotels are interurban spaces that encourage and, to a certain degree enforce, the replication of spatial practice from one city to another. They are connected intimately to transport systems, a relationship that was fundamental during the West's vibrant nineteenth and early twentieth centuries, when the rise of the grand hotel mirrored that of rail and motorways.[2] During that period, hotels anchored city centres, commanded views of beaches and mountains, and became destinations unto themselves, images of which adorned postcards and the ephemera of the world traveller. Integrated and implicated as it was in the flows of modernity – and is now in the discontinuities of post- or supermodernity – the hotel must thus figure in our understanding of the relationship between an increasingly complex notion of what may be called global "conduct" – the movement of goods and people, behaviour, styles and aesthetics – and the experience of the built environment of the modern metropolis. The hotel has been many things: meeting point, outpost, way station, home, stage, and prison. Its social, cultural, and business functions continue to expand and change – along with its physical form – such that now, in the twenty-first century, hotel designers and architects not only draw on past practices and motifs but also cater to the new relationships humans are developing with each other, with nature, and with themselves. A unique zone that has closely tracked the development of modern urban societies, the ubiquitous hotel is a rich source of insight.[3]

This is a book about the hotel in the realm of the imagination and of the physical, built environment. I read the hotel both as a symbol and as a space and propose the particular mode of being that it engenders – occupancy – as a broad, unifying concept that allows us to better understand the hotel both in its various artistic forms and in the diverse ways in which it functions as a structure. By considering the many variations of the hotel one gains new perspectives not only on a fundamental modern space but also on the multiple disciplines, domains, and circumstances in which it appears and plays a part. While the hotel's underappreciated symbolic importance means that the visual arts and cinema are especially fruitful in this regard, its architectural permutations and varied historical and political uses provide ample fodder for new analyses in terms of the physical experience of the space by different types of people. In addition to inspiring painters, photographers, and filmmakers, it has played important roles during wartime and more recently served in the accommodation of displaced people – whether they be detainees or refugees seeking sanctuary – making its study all the more imperative and timely.

Occupancy, which is at the core of my interpretation and analysis of the hotel, is a flexible concept. In addition to describing a basic physical position or the act of residing temporarily, it extends to the assertion of a more militant or resistant presence. As regards the hotel, specifically, I contend that it functions both metaphorically and literally, extending equally through the realms of the imagination and the physical world. I argue that occupancy relates to and is informed by the mechanisms and experiences of travel and tourism and that not only does it dovetail with the hotel's penchant to serve as a space of decompression among circuits of ever-faster modern travel, it also conditions the building's role in spatial requisitioning and in detention regimes. The versatility of occupancy as a guiding concept thus permits a multifaceted approach to the hotel's unique spatial and temporal effects in both the imaginative and tangible realms.

Occupancy and the basic formula or calculus of the hotel, "space over time," go together. I propose that hotel occupancy in its many forms is indicative of a new relationship with space, one that is specifically delineated and limited by the contractual time of one's stay. This temporal element pushes the traveller by choice's presence in a hotel into a new category. Temporariness measured by a clock or a calendar makes time the paramount factor. Dwelling, while possible under certain circumstances, is clearly not the default experience here.[4] What is more, whereas "home" is governed by family rules, traditions, and cultural convention, hotel occupancy is a different and simpler beast. It is the market revealed on a supremely intimate level; this controlled space where we engage in such private activities as sleeping, dressing, and having sex is commodified along the temporal axis and supplied according to means, taste, and availability.[5] Hotels may appear in all shapes and sizes, but the space-over-time equation remains an essential baseline from which alternate versions spring. How this fact adapts under different circumstances contributes to a deeper understanding of the space's versatility.[6]

It is important to note, though, that hotel occupancy is not restricted to the guest room; "run of house" grants access and services throughout the building and grounds, expanding and informing the mode of being and modified domesticity that one assumes and encounters in the hotel. It is particularly intriguing to see how this aspect manifests in art, the focus of chapter 1 of this book. Of course, the nature of occupancy itself is mutable and can result in different experiences within the same general system depending on one's gender, race, and/or class. What is more, prolonging stays and extending occupancy allows for increased contact with staff, some of whom become very aware of one's habits, thus creating the potential for formal and informal relationships. Repeated visits and loyalty programs mean one's inclinations may be logged and catered to automatically in an almost familial fashion. Occupancy is also closely connected to an overlooked element of cosmopolitanism that I identify as decompression, or the relaxing of tension inherent in the modern subject's experience of time-space condensing that occurs during travel. If planes and trains squeeze us into seats in metal tubes that zoom through the air or hum along rails, hotels at our destination serve as points of decompression. There, we check into rooms in which we can relax and compose ourselves. First, though, we must pass through a transition point that is half-private, half-public: the lobby. This particular aspect of hotel architecture is often synonymous with the entire space and was the subject of perhaps the most famous critical piece about the hotel, Siegfried Kracauer's essay "The Hotel Lobby" (1922–5). Before moving on, it is worth engaging briefly with the ideas that he proposes.

Even though in his commentary the German critic – who along with Walter Benjamin and Theodor Adorno was one of the early theorists of modern mass culture – takes up the aesthetic effect of the lobby (*Hotelhalle*) in the modern detective novel specifically, his critique extends much further. Kracauer's opinion of the lobby and of its denizens is not necessarily a positive one; he considers it a "negative church," a place for those "who neither seek nor find the one who is always sought" (175). In contrast to a congregation that comes together before the Almighty in a house of God, those who loiter in a lobby symbolize detachment and displacement in the hotel's space. What is more, he sees them as isolated, "anonymous atoms" who dwindle in an existential stream and lack the unifying "we" of a gathering that is secure in its sense of self (182–3). This absence of communion is evident, according to Kracauer, in the hotel guests' separation from society at large and the resulting alienation that this condition supposedly creates.

While his starting point may be the German detective novel, Kracauer clearly reads the hotel lobby in more expansive terms: "Removed from the hustle and bustle, one does gain some distance from the distinctions of 'actual' life, but without being subjected to a new determination that would circumscribe from above the sphere of validity for these determinations" (179). Thus, from the philosopher's perspective, lobby dwellers become "tensionless." And even though they may still represent

society, it is not because "transcendence here raises them up to its level; rather, this is because the hustle and bustle of immanence is still hidden" (184). Here, Kracauer is plainly critical of the social masks that he sees worn in the lobby.

Even though Kracauer contends that the anonymous social performances in the lobby are mere surface appeal and "pure exterior," he does not lay all the blame on the individual (183). No, the hotel manager, an "impersonal nothing (who) occupies the position of the unknown one in whose name the church congregation gathers" also comes in for scrutiny (176). According to the critic, this nobody is another symptom of the lack of concrete social relations that are seemingly impossible in the hotel lobby, which, as Marc Katz points out, Kracauer describes in more and perhaps better detail in his later writings on the space.[7] When the philosopher then suggests in this first piece on the subject that the hotel management "thoughtfully conceals from its guests the real events which could put an end to the false aesthetic situation shrouding that nothing" (184), Kracauer further implicates the hotel writ large in the process of modern alienation and disconnection to which he believes it contributes.

Kracauer's essay presents interesting theories on the spatial effects of the lobby, especially, as Anthony Vidler puts it, regarding "the conditions of modern life in their anonymity and fragmentation" (72) and the inherent performative element that the space engenders. Nevertheless, I find this particular early analysis of his, which he ostensibly limits to the detective novel but fails to keep centred there, to be flawed. I do not accept Kracauer's contention that the lobby – and by extension the hotel – is "a mere gap that does not serve a purpose dictated by *Ratio*" (176). By rejecting any rational component and then further insisting that it is a space that "does not refer beyond itself," the philosopher seems to deny the growing importance and ubiquity of the hotel in early twentieth-century Europe and ignores the fact that the space was quickly becoming a major part of the West's day-to-day life (177). Rather than representing a profane space in opposition to the holy congregation of a church, the hotel stands, in my view, as a secular sanctuary – one in which for better or for worse, cosmopolitanism was to find fertile ground in which to grow. As will become clear in the readings throughout this book, the hotel can serve as a site of connectedness par excellence. It works as a hub, bringing people together as it provides both the space and even more critically *the time* for connections to happen. Thus, while I consider Kracauer's essay an ideal foil against which to work initially, I propose a more expansive reading of the hotel's spatial effect in which the space both reflects and engenders occupancy, a new mode that is less a result of modernist alienation and more due to the specific architectural and social nature of the space itself as well as the changing desires and expectations of travellers.

Kracauer's rather negative view of the hotel and its aesthetic effect here is not surprising given his outlook on empty rationality and the spectacle-like nature of modern culture.[8] A space that both replaces "home" temporarily and creates new, random, seemingly ephemeral communities often in a monumental setting analogous to a

church, the hotel is indicative of deep social changes revolving around mobility and mores and the mixing of old and new codes in what was literally a threshold zone. Already a key marker of the urban experience during the 1800s and early 1900s, the potential for anonymity is heightened in the hotel, as is the capacity for surreptitious observation of others in a new context.[9] The capacity for and propensity of seeing and being seen are integral parts of the performative nature of hotel spaces both inside and out and thus naturally privilege the visual in the symbolic economy that exists as part of this new mode of being. Not surprisingly, this unique space finds its way into the work of painters and photographers. The fact that the hotel's inherent spatial mutability should be evident in their representations and the way in which they engage with its various elements is also to be expected. Nor is it a shock that the hotel would continue to figure in the West's imaginary throughout the twentieth century and into the twenty-first in a variety of diverse forms ranging from paintings to film to music videos. Hotels make for intriguing art.

While this book is informed by how the space of the hotel has evolved over time, this is not a blow-by-blow history. The diverse and intriguing ways in which the hotel has manifested and functioned within both the aesthetic sphere of the visual imagination and in the material world are what especially interest me. To this end, I have structured *The Hotel: Occupied Space* in two parts: the first looks at the pictorial and cinematic hotels, respectively, and in the second, I consider two important but often overlooked versions of the structure: the wartime hotel and what I call the "displacement hotel." One result of my desire to treat these "alternative" forms of hotel space is that there is a noticeable change in tone between the two halves. This reflects the radical difference between the experience of travel by choice and that forced by displacement. Finishing the book with an examination of Antoni Gaudí's apocryphal Hotel Attraction project allows me to bring the two parts together in an analysis of an intriguing fusion of artistic vision and urban design that solidifies the hotel's enduring symbolic power.

In terms of time frame, I focus on the period from the mid-nineteenth century to the first decades of the twenty-first. The first two chapters point to a very salient aspect of the hotel: that it is a space that inspires creators. In "The Pictorial Hotel," I cast a critical eye on the hotel in painting and photography; it is striking to see how the space serves as a focal point for certain artists. I pay especial attention to Edward Hopper's hotel paintings, which when considered together provide a visual key for what might be termed "traditional" hotel occupancy. Likewise, works by Cuban artist Ramón Serrano evidence an almost obsessive attention to one hotel in particular, the Habana Libre, thus revealing a deep understanding of the requisitioned Hilton as a symbol that came to visually occupy an entire city. On the photographic side, pictures made of that same hotel by Burt Glinn and Deena Stryker provide intriguing visions of what has proven to be a particularly compelling transnational space and nods, as well, to the later discussion of requisitioning that I undertake in chapter 3. While

chapter 2's look at modes of occupancy in cinematic hotels ranges from early films like *El hotel eléctrico* (1905), *The Bellboy* (1918), and *The Last Laugh* (1924), through the classic *Grand Hotel* (1932) and genre films, I also dedicate space to specific auteurs such as Jean-Luc Godard, Alfred Hitchcock, and Sofia Coppola, who have engaged with the space onscreen in extremely productive ways. Their stylized approaches to the manner in which modern subjects occupy hotel space allow for a more nuanced understanding of the evolving relationship we have with this increasingly diversified space and how its cinematic version both informs the inherent temporal element of the hotel equation and naturalizes the space and how we experience it.

Any discussion of the hotel of the imagination will naturally take into account salient real features like the revolving door, the lobby, and the general practices of hospitality that inspire and inform art. Rather than rehash these or give a simple accounting of how hotels have evolved, in the second part of this book, I discuss two particularly compelling variants: the hotel that exists during wartime and that which is used to accommodate displaced people either as part of a detention regime or in a refugee resettlement situation. While I continue to reference artworks and texts of different types, I argue that the wartime hotel is especially valuable for understanding both how the tourist gaze works within the hotel environment and the way in which combatants and journalists alike occupy and requisition the space for different purposes. Here we see a more strategic version of occupancy, which when combined with an analysis of the tourist gaze's overlapping with that of the sniper and the media, underlines the unique qualities of the wartime hotel as its own special spatial form with different symbolic values in play.

Significant too is the way in which the hotel has increasingly come to figure in cosmopolitanism's defining tension between a chosen exposure to other cultures and the phenomenon of displacement. The use of hotels as detention centres for immigrants in states like France and Canada clearly shows how political machinations have inflected this space and changed the nature of occupancy. In such situations, the hotel's liminal mien is distorted either to prevent migrants and refugees from entering national systems or to extricate them from national space. Either way, this is a dynamic that reframes the hotel's established connections to movement and transportation infrastructures, defeating any decompression effect. In this case, the experience is no longer that of a traveller by choice; it is inverted, and rooms meant to be occupied willingly become de facto cells. In this chapter, I examine how states use these physical properties of the hotel to their advantage and transform occupancy in an obscene way such that the space/time formula takes on a new, darker meaning. While I argue that in the form of the hotel, the non-place's latent political potential is realized through calculated state intervention in the movement of individuals and groups, I conclude this chapter on a more hopeful note by considering how the space has been used to accommodate asylum seekers in Germany and Canada in the wake of the

Syrian refugee crisis. The hotel as refuge is still alive even if it exists alongside a more nefarious incarnation and has had to withstand a growing backlash.

Finally, I end the book by delving into the controversial Hotel Attraction, which was supposedly planned for New York City by the famous Catalan *modernista* architect Antoni Gaudí. While the provenance of the design is in serious doubt and should be attributed not to the master but rather to a former apprentice, the project still resonates to a surprising degree and continues to garner supporters on either side of the Atlantic who want to see the hotel built. Rather than dwell on the controversy, though, I approach the Hotel Attraction as a unique synthesis of the imaginative and the real and consider what it would have meant to transpose a Catalan *modernista* building to the New World grid of the Big Apple. I believe that the utopian impulse inherent in this wish speaks especially to the diverse forms of hotel space and occupancy that I engage in this book and to the way in which the realms of the imagination and the built environment can intersect.

PART ONE

THE REALM OF IMAGINATION

THE PICTORIAL HOTEL

The hotel is a remarkable space for the sheer range of its uses and activities. Ideally suited to bringing people together, its lobbies and bars, especially, have a long history as stages for singers, comics, jazz bands, fashion designers, and business people of all stripes who make their pitches and ply their wares. The hotel lends itself to imagination and to fantasy, and through its vast capacity for variety and mixing, it has attained a symbolic charge that translates into aesthetics. Art, like the hotel, can be a frontier to something new and different. And while cosmopolitanism extended people's horizons, as Peter Sloterdijk points out, it did not necessarily allow them to share in the "good of happiness of the big world" (512). Thus, for him, it fell to the hotel "to become a mythical place" because it

> symbolized a dream of social heights on which the modern ephemerality of existence could at least be compensated for with worldly, comfortable glamour. In the hotel, the world chaos seemed to organize itself once more into a scintillating cosmos. Like a last organic form, it resisted the confounding and arbitrariness of events. This elevated the hotel to a central aesthetic idea of modernity; as if of itself, it suits the revue-like, polythematic, simultaneous forms of experience in the big city and nevertheless, as a factor of unity, possesses its own myth, the *genius loci* and its inner order. (512–13)

The hotel is a place of make-believe that can serve as a backdrop to interpretations of space, desire, and the simple act of being in the world – and it has done so in painting and to a lesser extent photography for the past century and a half. While Edward Hopper's hotel works may stand out as iconic examples of the way in which occupancy, the hotel's special mode of being, appears on canvas, the unique qualities of the space are evident in art produced before and after the American master.

During the second half of the nineteenth and early part of the twentieth centuries, the hotel was only an occasional subject for Western painters. Cafés and theatres along with general streetscapes were the most common public spaces to

be represented – most famously by the likes of Henri de Toulouse-Lautrec, Édouard Manet, and Pablo Picasso.[1] That said, as the hotel became more and more a space of the everyday, artists began to add it to their work. An important early example is Claude Monet's *Hôtel des roches noires, Trouville* (figure 1.1). This 1870 piece is interesting for the way in which it positions its occupants on the outside, presenting the hotel structure obliquely while extending the guests' run of house beyond the walls and privileging the social environment that its monumental and shadowed facade creates in space. The imposing hotel on the right is offset by the light of the opposite side of the canvas, where vacationers mingle and linger and take the sun in close proximity to the beach. The strong wind that propels the flags towards the building gives a kinetic feel to the work that underscores the massiveness of the building, which withstands the elements and guides our view down the promenade. While the foregrounded flag and the hotel draw the eye, the social element of *Hôtel des roches noires, Trouville* is particularly noteworthy. Monet does more than capture the strolling and lounging inherent to the boardwalk; he also depicts a precise moment of introduction in the lower left of the painting. In this way, the artist represents both the natural energy of the strong wind and the social energy that the hotel engenders – and that is exemplified here by the man's doffing of his hat as he elegantly makes the acquaintance of two (unknown?) women. *Hôtel des roches noires, Trouville* may, on the surface, appear to be a simple depiction of coastal idyll but in his choice of perspective and content, Monet successfully underlines the hotel's importance as a social institution where interaction and more importantly the time to interact that hotel space offers come together.

Both Georges Braque's *The Terrace at the Hôtel Mistral* (figure 1.2) and John Singer Sargent's *A Hotel Room* (figure 1.3) saw the light of day in 1907 and offer two different takes on hotel occupancy. The year 1907 was an important one in the history of Western art on account of Guillaume Apollinaire's introduction of Braque to Pablo Picasso. This act, which took place in November of that year, would put into motion a friendship that would be central to the growth of the seminal movement soon to be known as cubism. Braque's *The Terrace*, which he painted while still under the waning aesthetic influence of fauvism, appeared during the same period as his better-known *The Viaduct at L'Estaque*. Like *The Viaduct*, the piece reflects the fauvists' lack of nuance in their use of colour (Goldwater 51) and is interesting for the tension that the painter depicts between nature and the built environment carved out of it. Rather than being the subject of the gaze, though, the hotel is the vantage point; the terrace, its limit delineated by the balustrade in the foreground, allows the painter and, by extension, the viewer to remain within the protective aegis of the hotel yet experience and observe the wilds of nature all the same. In the resulting painting, the clean space of the patio acts as a rational counterweight that keeps the dense foliage at bay while contrasting with the rural structure in the upper part of the work. The border effect at the bottom of the piece creates a virtual painting-within-the painting,

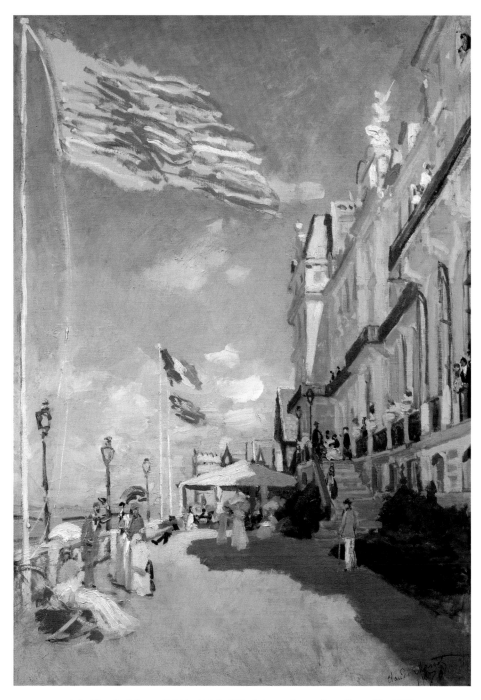

1.1 Claude Monet (1840–1926). *Hôtel des roches noires, Trouville*. 1870.
Scala/Art Resource, NY.

further emphasizing the act of looking that the hotel space facilitates. Interestingly, *The Terrace* visually anticipates the eco-hotel trend of the late twentieth century that would see guests eager rather than apprehensive to surround themselves with nature in such a way and to spend the night – literally – in the forest treetops.[2]

If Braque's work offers an external, projecting view of/from the hotel influenced by the tenets of fauvism, Singer Sargent's *A Hotel Room* on the other hand, is a realist take on an early twentieth-century *chambre* – complete with lace curtains around the bed, a table with a water jug and perfume bottles. In Sargent's piece, the open suitcases and their clutter of dark clothes in the lower half of the painting anchor the relative lightness of the upper. Consequently, any metaphorical happiness of arrival or relief at having escaped domestic concerns embodied in the airiness above is offset below by this matter-of-fact reminder of the weight and discomfort of travel. The open suitcase lays bare the mechanics of the trip and codes the room as temporary, thus making patent the hotel's intrinsic calculus in which one occupies a certain piece of space for a determined period of time. With *A Hotel Room*, Singer Sargent, who was a renowned portraitist, succeeds in capturing not the likeness of the traveller but rather the image of the spatial practice of occupancy in this specific locale. The messiness of the luggage speaks to all travellers by choice who have rummaged through their bag as they temporarily "live out of their suitcase."[3]

Any rustic gentility associated with the space is utterly lacking in another important hotel painting that appeared a decade later: George Grosz's frenetic, oppressive, and angry *Metropolis* (1916–17) (figure 1.4). The work depicts a red-hued cityscape populated by streams of grotesque figures that collide in the foreground and contribute to a visual cacophony with allusions to the violence and degeneration that Grosz considered inherent to modern Western society. A monumental grand hotel, the Atlantic, sits in the centre of the upper portion of the painting, its stylized dome taking pride of place at the top, yet also repeated in the background to the left of the central image and hinted at to the right as well. The hotel in this instance serves as an axis around which the frenzied citizens mill and also as a billboard for superimposed names of products. The centrality of the building and the fact that it is replicated privilege the space to the extent that any one image may be favoured in a painting as chaotic as this. *Metropolis* suggests at once sheer urbanity and the hotel's increasing role in the modernist metropolis as a space and a text that can be read both explicitly and implicitly. That the hotel and its facades are central to the formal composition of the work yet secondary in terms of subject matter does not detract from this painting's impact. Clearly, Grosz equates the hotel with a vibrant and potentially dark urbanity, and its position in the picture gives it a cornerstone-like quality. The fact that it is embroiled in the violent energy that he depicts reminds the viewer that the hotel's cosmopolitan role as a place of meeting and contact can be both positive and negative – a dimension that I explore in greater detail in the last chapter of this book.

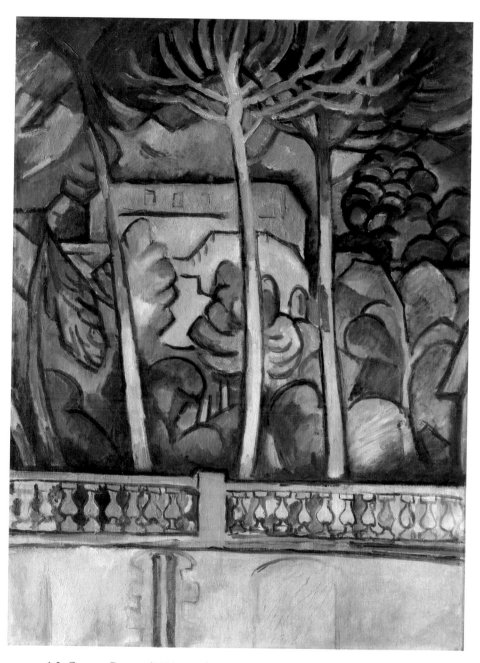

1.2 Georges Braque (1882–1963) ©ARS, NY. *The Terrace at the Hôtel Mistral,*
L'Estaque and Paris, autumn 1907. Oil on canvas. The Leonard A. Lauder Cubist Collection.

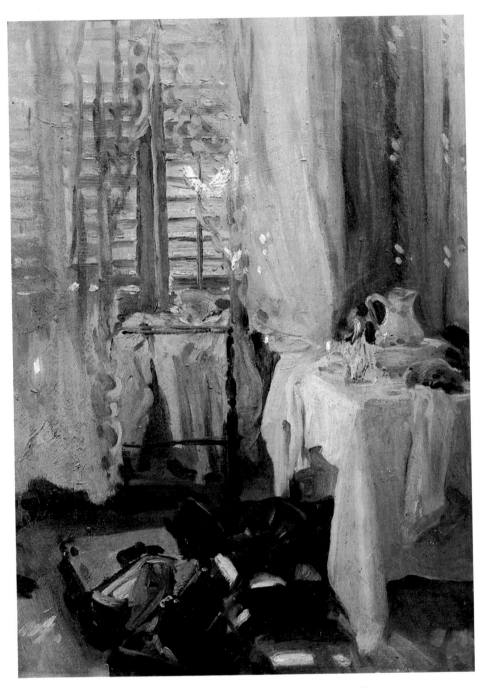

1.3 John Singer Sargent, *A Hotel Room*, ca 1906–7.

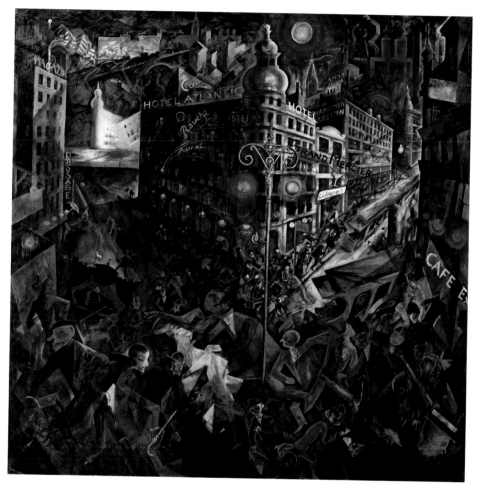

1.4 George Grosz (1893–1959), *Metropolis*, 1916–17.
Madrid, Museo Thyssen-Bornemisza. Oil on canvas © 2017.
Museo Thyssen-Bornemisza/Scala, Florence.

Although Monet, Braque, Sargent, and Grosz did dedicate isolated pieces of their oeuvres to different and suggestive elements of hotel space, theirs was not a concerted engagement with the experience of it.[4] That distinction goes to American artist Edward Hopper, the twentieth-century painter who would most explicitly commit the space of the hotel to canvas and in so doing best reflect the special character of the space and its relation to time and occupancy.

Hopper's paintings of American landscapes and cities have assumed iconic status and attracted a rich and varied reception from both critics and the general public alike. The artist's attention to form and his exquisite manipulation of light betray the deep debt to impressionism that he acquired after an extremely formative sojourn in

France when he was a young man. That he used this European movement as an initial motor for his visual engagement with America is still perceptible in his later work and helped set him apart from his contemporaries throughout his career (Hopper and Liesbrock 14).[5] That said, when one considers his treatment of human subjects and their relationship to architecture – in this case, the hotel – Hopper's reticence to being labelled as part of any specific school seems justified.

Hopper's paintings broach the ineffable, and their ambiguous qualities not only perplex but also disturb through their affective impact. The atmospheric nature of his work has led observers to point to their capacity to evoke feelings ranging from sentimental nostalgia (Levin, Liesbrock) to the uncanny (Iversen). It is for his treatment of human subjects, though, that Hopper's artistic production has acquired a reputation for representing the ennui and alienation of the modern condition. For many his figures exist almost in stasis, often in what appears to be a state of either literal or figurative isolation. I contest the prevailing interpretation of these subjects by proposing that the artist's treatment of them as hotel occupants, at least, is not so much a reaction to metropolitan overstimulation à la Simmel or postwar languor, but rather an indication of the modern subject's capacity to engage in détente with his/her built environment. I argue that this quality is tied directly to the nature of the hotel space and its differentiation from traditional conceptions of home and the domestic interior.

In his prologue to a collection of Hopper's best-known pieces, Liesbrock suggests that rather than represent the restlessness of American life, Hopper's urban world – the automobile and streets of the United States – have become part of the interior still life (23). This is an intriguing idea not only on account of the manner in which it reinforces the concept of stasis that is palpable in the artist's work but also because the threshold aspect of many of Hopper's scenes reinforces this perspective. I would build on Liesbrock's interpretation by stressing the way in which the artist specifically treats the architecture of the hotel in this aesthetic reworking and interiorization of the American urban environment. Hopper's privileging of the subject here creates a new way of looking at the hotel that dovetails with my notion of the space's special relationship to time and, by extension, occupancy. In his portrayal of this still interior, Hopper condenses the elements that make the hotel different but does so not by painting the interior of a domestic abode, so to speak, but rather an affective interior, one that is unique and apropos to the experience of the hotel, which is a space that estranges us from our homes but still provides many of its comforts while offering new possibilities of being. In this way, the famous link that Walter Benjamin establishes between an increasingly cluttered bourgeois interior and "the trace" of our material life is broken. For the very nature of the hotel room and its condition of being "reset" with each new occupant defeats the possibility of concrete traces of individual dwelling. Hopper displays this quality in his hotel paintings not simply by avoiding adornment, a key marker of the bourgeois interior and consequently the affective qualities

of Western notions of "home," but by palpably depicting the feelings of two key spaces – the individual hotel room and the lobby – and by bringing into question the notion of occupancy that makes physically being in the hotel such a unique experience for travellers by choice.

One painting in particular, his iconic *Hotel Room* from 1931 (figure 1.5), especially captures the subtleties and particularities that the building elicits. The first striking feature of the work, which hangs in the Thyssen-Bornemisza Museum in Madrid, is its size. Measuring 152.4 cm by 165.1 cm, the piece immediately conveys a sense of space and depth in which the principal subject sits half-naked on the bed, her face in shadow as she reads a letter or schedule.[6] The principal tension in *Hotel Room* hinges on the deceptively simple yet unresolved question that confronts the viewer: is she coming or going? Hopper trades on the ambiguity of this undefined trajectory and in so doing engages the core dynamic of the hotel room space and the act of occupancy that lies at its heart. The tension between "here" and "away" is blatant throughout the painting: from the uncertainty inspired by her semi-nakedness on the still (or is it recently?) made bed, to the neat placement of luggage that is either the bellhop's touch upon arrival or mere preparedness for an imminent departure.

At the calm centre of this ambiguity, the woman is still. I propose that she is less a victim of the alienation supposedly inherent to modern metropolitan existence and more someone who is simply serene; she is in a state of détente with her surroundings. Hopper's use of colour and lighting supports this interpretation in that he creates a balance between the grey band on the left, the dresser on the right, and the ephemeral lightness of the wall and curtain against which she sits and is backlit. Thus, the space resists being confining; the painter's shading strategy combined with the work's size and the verticality Hopper attains through his use of lines, mitigate any potential claustrophobia. In this sense, rather than oppress or convey a feeling of ennui, I argue that *Hotel Room* captures instead – for the first time on canvas involving a subject – occupancy, the modern mode of being that is specifically generated by the hotel and the one that powers this book.

Hopper conveys this same sense of occupancy – as opposed to dwelling – in a later painting of a hotel room as well. *Hotel by a Railroad* (figure 1.6) depicts an older couple in a room that gives directly onto the railway. Once again, the viewer is confronted by a liminal space – in this case both the room itself and the open window that separates the static inside from the constant movement outside. Both figures in the painting are in a relaxed state; the man, who calmly enjoys a cigarette, contemplates the railyard while his companion, dressed only in a simple nightgown, rests a book on her lap as she reads. The room is adorned simply and the positioning of the chair beside the dresser is extremely suggestive. As it stands, the chest cannot be used because the drawers will not open. Either the chair has been moved to take advantage of the light coming in through the window or it has been put there for the simple reason that hotel guests never stay long enough to make use of the drawers.[7] In either case,

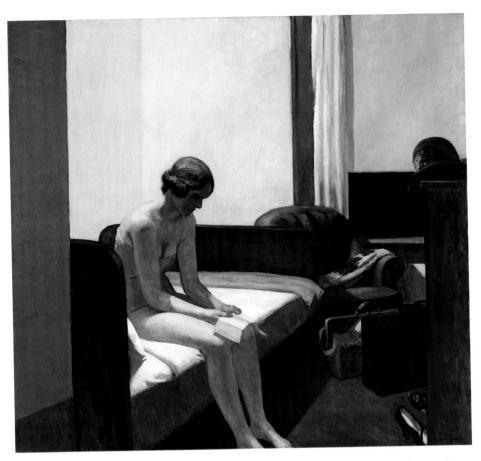

1.5 Edward Hopper (1882–1967), *Hotel Room*, 1931. Madrid, Museo Thyssen-Bornemisza.
Oil on canvas. © 2017. Museo Thyssen-Bornemisza/Scala, Florence.

the insistence in this hotel room's aesthetic and affective architecture is squarely on the present – on the needs of occupying the space at that precise moment as opposed to any day-to-day dwelling.

With these readings in mind, I propose that Hopper is looking at the spaces of the hotel through a new lens – one that does not apply old codes and expectations of dwelling but rather is sympathetic to the fact that being in a hotel represents a different way of interacting with the built environment. He is keenly sensitive to the transitive element of the hotel space and yet, importantly, he does not convey a sense of hurriedness or pressure in his work. I argue that this dynamic is due to the artist's understanding – explicit or not – that to be in a hotel presupposes a different relationship to time and space. This sensitivity, which is on display in both his iconic *Hotel Room* work and the lesser *Hotel by a Railroad*, is also evident in Hopper's take on a key hotel space that influences how the building and occupancy are understood and experienced: the lobby.

1.6 Edward Hopper, *Hotel by a Railroad*, 1952. Oil on canvas.
Gift of the Joseph H. Hirshhorn Foundation, 1966. Photography by Lee Stalsworth.
Hirshhorn Museum and Sculpture Garden, Smithsonian Institution.

A central fixture in the permanent collection at the Indianapolis Museum of Art, *Hotel Lobby* (1943) (figure 1.7) is an excellent example of Hopper's keen understanding of the subtleties of the hotel. True to its name, the painting depicts a lobby scene in which an older couple apparently wait to go out while a younger blonde woman reads a magazine and a virtually hidden fourth figure stands behind the reception desk in the back corner of the room. Given that a bright green band on the carpet divides the painting diagonally, there is a temptation to consider *Hotel Lobby* almost as two different works. However, one quickly recognizes that this apparent dividing line is also what ties the scene together, serving as it does as a vector that directs the eye toward the dining room and the reception desk, the literal and metaphoric motor of the lobby and the feature that makes the space unique. The desk's "official" presence relieves people in the lobby of any need to engage with others in this semi-public sphere – there it is OK to mind one's own business because someone else can respond to inquiries or problems, be it the concierge, receptionist, or bellhop. By providing this social buffer, the reception desk thus enables a separation between people (to

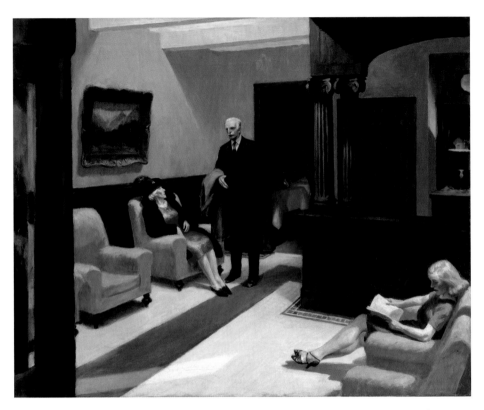

1.7 Edward Hopper, *Hotel Lobby*, 1943. Oil on canvas. Indianapolis Museum of Art
at Newfields, William Ray Adams Memorial Collection, 47.4 © Edward Hopper.

the extent that they want it) within a common area that is simultaneously public and
private. In this unique way, the lobby allows for discrete zones and different "rules of
engagement" while maintaining a fundamental cohesiveness as a site where multiple
discourses, services, and expectations converge in a transitional space.

Often, the hotel lobby is a place to wait, but this is not always the case. For not only
is the space ideal for people-watching, given its role in occupancy, it serves also as
the "living room" for guests and has an inherent element of performance or show. As
regards Hopper's painting and the act of waiting that the artist depicts, while Wieland
Schmied may consider it "enervating" and see the older man's gaze as full of a "mixture
of boredom and irritation" (70), I propose, on the contrary, that the guests in *Hotel
Lobby* are at ease. For not only is the man's visage sufficiently inscrutable so as to invite
doubt as to his demeanour, but the charge of "enervation" falls flat given the whole
of the work. Yes, the older couple are obviously waiting – perhaps for a friend or a
taxicab – and, as usual in Hopper, the figures' gazes do not meet, but the fact that they
are still well within the lobby and thus subject to its particular spatial effect cannot be

ignored. In the first place, the older woman in *Hotel Lobby* is seated comfortably. Her coat is on and her hat is in place, which indicates that she is not anticipating a long wait. Underlining this fact is the way her husband stands ready and gazing towards the door on the left side of the painting. That the couple are still in the lobby proper and not, for instance, hovering directly by the entrance, is important in that it suggests a basic way in which guests occupy hotel space. The two take advantage of the comfort that the lobby offers; they know that, as guests, they are welcome to use the space as long as may be necessary. This is far from a state of enervation.

The revolving door towards which the older man is oriented occupies the same space as the greyish-blue wall in Hopper's earlier *Hotel Room*. Here, the mixture of dark wood and glass serves a similar framing purpose and finds its counterweight in the wooden arch on the opposite side of the canvas. This heavy, dark block adds depth as it both offsets the white floor and represents a symbolic and, on this occasion, faux-monumental, destination for those entering the lobby from the street. The arch also marks an inner-threshold behind which a glimpse of the mechanics or inner workings of the hotel are visible. *Hotel Lobby* is especially compelling for the way in which, like the classic film *Grand Hotel*, it merges the so-called "front" and "back of the house." The reception desk, elevator, and dining room line the far wall of the space, and Hopper's use of light and shading keeps these "service areas" in both the literal and figurative backgrounds while the green band on the floor at once propels the eye and links the street to the reception. By hiding the desk clerk behind a lamp and portraying him with his head down as if working, the painter literally objectifies the hotel staff member, thus fusing the human labour that goes into the running of the hotel and the architecture that bulwarks the space. What is more, by ironically illuminating his face in a soft glow, Hopper creates a contrast between this distorted and obfuscated figure and the brightly lit blond woman found directly below him in the foreground of the painting.

Like the female subject of *Hotel Room*, the blond woman in *Hotel Lobby* is engaged in the act of reading. She sits comfortably, seemingly engrossed in her magazine, at ease in her area of the lobby. Whether she is waiting or simply passing time is unimportant;[8] as an occupant of the hotel, she can do as she wishes. As someone with the run of the house, her manner of occupancy is fluid and extends from the rooms to the shared areas of the hotel. Kracauer would not approve. As in Monet's *Hôtel des roches noires, Trouville* the concept of occupancy here reaches beyond the room; that it extends to the lobby, the literal threshold of the hotel space, is natural. In this painting Hopper balances the restful sense of détente and the surface tension of the barely seen door that has its own buffer zone punctuated by a beam of sunlight that shines into the room. At the same time, his specific placing of the guests alludes to another aspect of hotel occupancy, one that is especially germane to the lobby: the sharing of common space by strangers who, regardless of whatever anonymity they may seek to preserve, nevertheless gain a temporary pertinence to the group of those staying at an establishment.

By including in his painting the elevator as well as the cubbyholes behind the reception desk where keys and messages are left, Hopper comments directly on the lobby's interconnectedness both with the rest of the building and with the outside world. This eminent "porosity" of the lobby is mirrored on the other side of the painting by the partial depiction of the lobby door and by the very perspective of the viewer him/herself. The potential for movement in this space – and Hopper's recognition of it – make *Hotel Lobby* an even more suggestive work in that it becomes clear that the attitude of the figures and occupants is not one of external alienation but rather a chosen mien of détente that the space of the hotel affords those who wish to avail themselves of it.

As he did with the hotel room, Hopper revisited the lobby space once more in the 1950s. His *Hotel Window* (1955) depicts a well-dressed older woman sitting expectantly on a divan in a rather stark lobby space that is dominated by the window from the painting's title (figure 1.8). The gaze of the subject is directed outward, and while she is dwarfed by the vastness of the lobby in which she waits, the red-clad woman is, at the same time, a figure who commands the space.[9] The neoclassical column behind her in the centre of the painting shines from external lights, creating a fine counterpart to her bright skin, white hair, and coat. Once more, the fact that she has the coat on her shoulders suggests that her wait is not expected to be a long one. This temporal element is important because if one keeps it in mind, then it becomes clear that the woman is not languishing indefinitely, caught in the stasis of a lonely, disconnected space, but rather occupying the lobby area expectantly and using it like the portal to further connections and encounters that it is.[10]

Edward Hopper's hotel works offer the viewer a unique perspective on two key spaces of the modern hotel. Through his pictorial explorations of the room and the lobby respectively, Hopper captures the subtleties of hotel going, of being in a new space in a new way. As opposed to Kracauer's cut-off church with no possible transcendence, Hopper's hotels, which do portray a quiescence that was and is often misunderstood as alienation, for the first time depict fully the modern state of being that is occupancy as it relates especially to that engendered by hotels during the early to mid-twentieth century.

If Hopper is the artist of what might be considered "traditional" hotel occupancy by travellers, Cuban painter Ramón Serrano has been the one to capture the equally important way in which the revolutionary nature of hotel architecture can fold back on itself and create a wider form of occupation in which the entire hotel serves as a symbol. Using the former Havana Hilton (now called the Habana Libre) as his monumental subject, Serrano's *Lo que se ve es lo que se ve* (*What You See Is What You See*) series portrays the Western hemisphere's most iconic revolutionary hotel as a palimpsest of the social and cultural dynamics that have competed in Cuba from the second half of the twentieth century to the present day. When his paintings are read in the light of Cuba's political history and considered alongside both Burt Glinn's

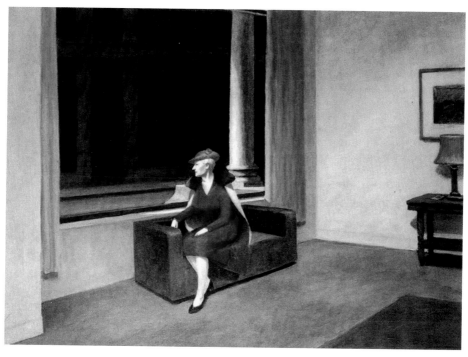

1.8 Edward Hopper, *Hotel Window*, 1955. Private collection.

illuminating photographs of the Hilton's requisitioning in 1959 and Deena Stryker's images of the subsequent normalization of the space, one can appreciate even more the breadth and importance of Serrano's work on the hotel.

A former link in the Hilton chain, the Libre or the Hotel Habana Libre Tryp – as it has been known officially since its remodelling in 1997 – was designed by Welton Beckett and Associates along with the Cuban firm of Arroyo y Menéndez. The Hilton saw no direct combat during the initial military phase of the Cuban Revolution but stands as a unique example of how architecture, art, and politics combine. On one level, the edifice condenses the evolving tensions inherent to a post–Second World War international marketplace in which tourism, the power of capital, and an American vision of the hospitality industry coalesce in spatial and architectural practice. At the same time, though, the Habana Hilton/Libre is a symbol of socialist ideology in a capitalist hemisphere and, specifically, of the ongoing Cuban Revolution.

It is important to keep in mind that in its moment of requisitioning by Castro's forces the Hilton did not shed the hegemonic valence that it had already acquired. For three months following the initial takeover, the Continental Suite, room 2324, served as the "Puesto de Mando de la Revolución" (Headquarters for the Revolution), thus converting the hotel into a media site and the space from which the revolution would

be proclaimed across the globe. A monument at once to Castro's initial military triumph, the Hilton would come to represent a widening ideological struggle that inevitably would see Cuba forced to adapt to economic realities and to confront the lure of a growing market of international tourism. At the moment of its requisitioning and occupation, however, the Hilton represented revolutionary feedback in a growing circuit of luxury hospitality spaces designed to expand the American capitalist model.[11] As a control centre for a nascent utopic inversion of the social order, the Habana Hilton/Libre became a building that was metaphorically at war with itself.

The symbolic importance that I ascribe to the Habana Libre and with which I argue Serrano's work engages so fruitfully, is borne out both by the specifics of its structural importance and its role in Castro's initial consolidation of power. When the thirty-storey, six-hundred-room Hilton opened on 19 March 1958, it was no less than the largest and tallest building in Latin America (Lefever and Huck 15). The $24 million hotel was operated by the recently formed Hilton International group but was financed by the local catering workers' union, the Caja de Retiro y Asistencia Social de los Trabajadores. Thus, from the outset there was an essential tension between what we might call the ideology of the Hilton empire and the control of the capital that resided, ultimately, in the work of the union members. Construction had gone ahead during the late 1950s even though Castro's guerrilla war had begun in 1956 and the Batista government was already facing generalized popular discontent on the local front in addition to the bands of armed insurgents in the provinces. While in retrospect the decision to build such an iconic structure could be viewed as a Cold War–inspired determination to forge ahead with an imperial agenda on the part of the conservative-minded Hilton organization, Lefever and Huck infer that the head of the Caja fund simply saw his group's investment as leading towards a larger tourist stake for Cuba (15). Both, though, point to the same processes of internationalization and massification that were to mark the second half of the twentieth century in the form of the democratization of American tourism and the possibility of the middle classes to begin to emulate in earnest travel patterns previously restricted to the elite.

Once constructed on La Rampa in the Vedado district, the hotel offered patrons unprecedented views of the sea, the city, and Morro Castle. For those on the outside looking in, it had become a looming presence on Havana's skyline, visible from all over the capital. This overwhelming massiveness coupled with its central location made the Hilton like no other hotel in Cuba. A new centre of modern luxury, it was to eclipse the more traditional Hotel Nacional as the place where dignitaries and entertainment stars stayed while visiting the country.[12] The owners and staff were Cuban but the Hilton marquee still projected the empire-oriented ambitions of the luxury hotel chain nonetheless.[13] The visual and visible dominance of the Havana Hilton was in keeping with the chain's modus operandi. As Wharton points out, between 1949 and 1966, Hilton International built seventeen luxury hotels in foreign countries (2). Once these edifices went up, they were often both the first important

modern structures in the host cities and the highest buildings in their respective urban centres (3).[14] The Hilton was monumental from the moment it was built, occupying the skyline, impossible to ignore.

On 31 December 1958, during a New Year's Eve party that was in full swing in the Hilton's ballroom, word came through that President Batista had fled Cuba to escape Fidel Castro's advancing army. The rebels entered the city on 1 January 1959 followed by *el comandante* himself a week later. In defiance of the call for a general strike, the Hilton's staff continued to tend to the guests who remained. On New Year's Day, though, new visitors arrived in the form of six hundred rebel soldiers followed quickly by another six hundred men, among them members of the Revolutionary Council (Lefever 16). Thus, in the span of twenty-four hours, the Hilton went from a playground for the Cuban and American elite to the first rebel headquarters – effectively centring the socialist Cuban Revolution in the heart of the city's newest monument to capitalism.

Before analysing Ramón Serrano's pictorial approach to the Hilton's lasting urban presence as a requisitioned space, it is instructive to consider both the moment of change and how the space then became normalized within its new context. Here, the lenses of renowned American photographer Burt Glinn and journalist Deena Stryker provide intriguing looks at the hotel's interior during both the military occupation and its return to use as a functioning cosmopolitan space.

The career of Burt Glinn, an American photographer who worked for the influential Magnum Photos, took him from the Far East to the Caribbean, and it was in Cuba that he made a name for himself by documenting the early days of the revolution. His images of soldiers in and around the Havana Hilton not only portray clearly the military mode of occupancy but are especially striking when one considers that only days before, the majority of these men had been living in the jungle waging a guerrilla war. Figures 1.9–11 show the initial deployment of this advance force, and in the first photo (figure 1.9), the lobby dynamics of the Hilton are laid bare. In keeping with the established Hilton notion that the local and global should be visible to one another, the lobby offers sightlines outside the edifice via the large plate glass windows. American luxury is displayed within while the international traveller can use the lobby as a transition zone into the local city. In Glinn's photo, this transparency serves to illustrate the totality of the rebel occupation; the windows and doors establish a visual depth that underlines how the military presence outside the hotel is mirrored inside, while the letter "H" on the door handles proclaims the Hilton brand amid the ideological change that is taking place. The lone soldier on guard may seem incongruous when compared to his lounging comrades, yet his position in the centre of the photograph conveys the still-present spectre of violence and a readiness to react.

In figures 1.10 and 1.11 respectively, one can see how the space of the hotel still maintains its base function as a place of repose. Figure 1.10 is an exceptionally suggestive bird's-eye shot of two soldiers sleeping in the lobby. Note the aesthetic tension

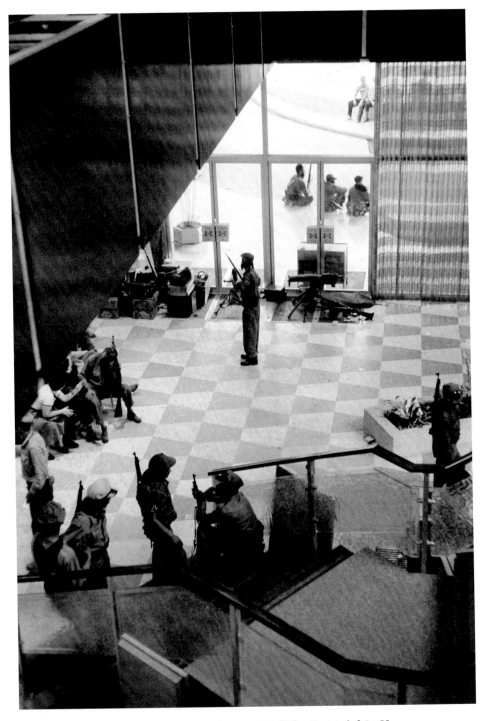

1.9 © Burt Glinn/Magnum Photos, 1959. "After Batista left La Havana,
Castro's forces began arriving. Here they are establishing an informal headquarters
in the lobby of the Hilton Hotel."





































































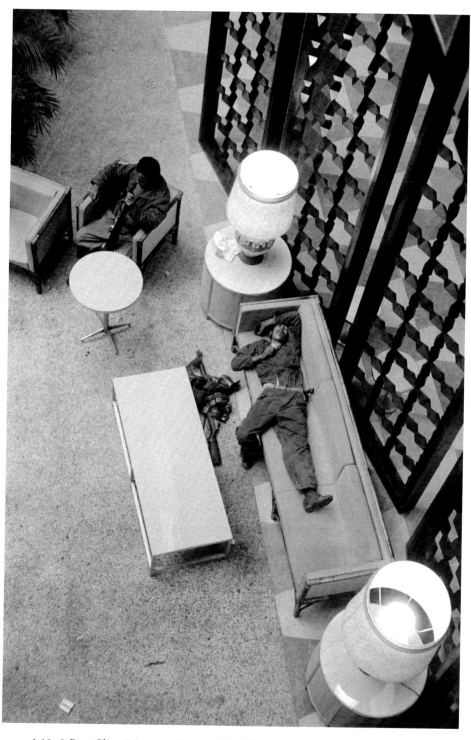

1.10 © Burt Glinn/Magnum Photos, 1959. "'Fidelistas' take over the Hilton Hotel and get their first rest after living in the field for months."

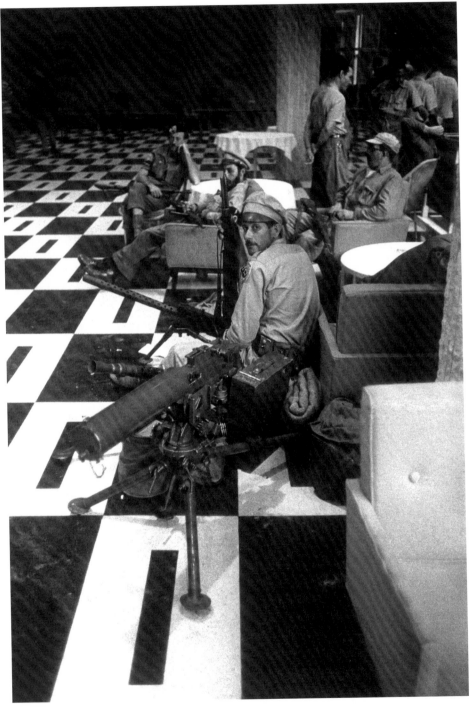

1.11 © Burt Glinn/Magnum Photos, 1959. "The Havana Hilton Hotel
in the hands of the mountain soldiers who stacked their arms on the marble floor
and lounged around in club chairs."

that Glinn creates through his juxtaposition of the modern furniture design and the ramshackle appearance of the exhausted soldiers in their fittingly named "fatigues." Figure 1.11 is equally eye-catching for the tensions that it displays in its depiction of a collection of seated rebels surrounded by weaponry. Here especially Glinn's composition makes for an absorbing snapshot of the extraordinary events taking place in the hotel. In the foreground, the ominous machine gun points diagonally towards the viewer, giving the impression that it is guarding the door. The different style of marble tiles evident in the picture, though, indicates that this is a photo of the lobby's mezzanine, thereby reducing the possibility of instant action and making the men's relaxed posture more understandable. Nevertheless, in both figure 1.10, where the sleeping men still keep one foot on the floor and one hand on the gun, and figure 1.11, the potential for action is there. As in Hopper's *Hotel Lobby*, there is a mix of postures in the lobby as different actors experience the space in different ways.

The final photo of Glinn's that I will deal with here is a masterpiece of composition (figure 1.12). The picture, which he took outside the Hilton's front doors, is a study of three different forms of the avant-garde. In the foreground, a group of Castro's rebels talk among themselves; the bearded men in uniform contrast with a blond woman on the right whose hair is tied back with a handkerchief. This is the military avant-garde of Castro's revolution, the first force to enter the capital and to secure it while *el comandante* slowly made his way to Havana from Santa Clara. Behind this group, and slightly truncated by the roof of an adjoining structure, one can see the intricate mural that festooned the front of the Hilton. Created for its opening by Amelia Peláez, a renowned Cuban artist, this work represents the artistic avant-garde that participated in and made use of the performative nature of the hotel space. That the Habana Libre would later become a showcase for officially sanctioned Cuban art only underlines this close relationship between artistic production and international exposure that takes place as part of the hotel's spatial practice. Finally, the third form of avant-garde evident in Glinn's photo is that of the capitalist expansionist ideals embodied in the grid of the hotel rooms that tower above the other two planes in the image. The rational lines of the Hilton's main structure contrast with both the abstract manner of the mural and the bodies of the men and woman in the foreground. Capital, represented in the earning power of each room, thus looms over both the artistic and revolutionary fields of vision, its rise seemingly uncontainable as it extends beyond the upper frame of the photo. Through the process of requisitioning, though, capitalism's profit potential will be harnessed for other means, but, as will eventually become clear to the leaders of the Cuban Revolution, it will not be shackled forever.

When American hotels were nationalized in 1960 and Castro renamed the site of his former headquarters he did so to reflect what he saw as the liberation of the city and country. By physically and metaphorically reinscribing the Hilton space he sought to imbue it with the spirit of the ongoing revolution. The "free" in Habana Libre stands in active opposition to more than just the Batista regime; it contests the very capitalist

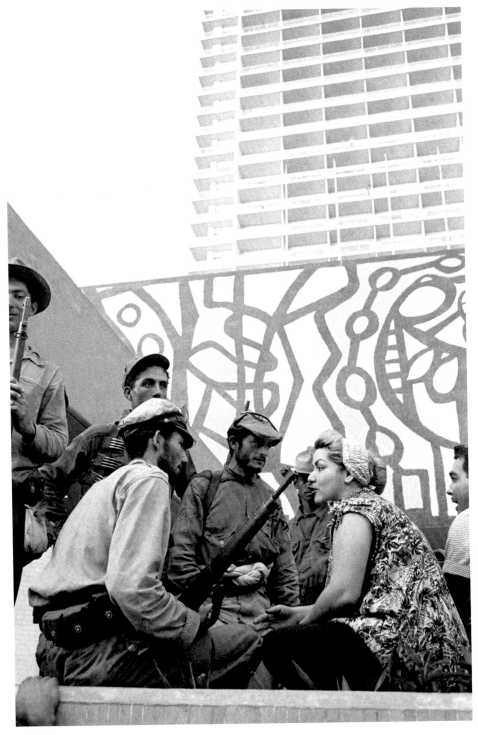

1.12 © Burt Glinn/Magnum Photos, 1959.
"New Year's Day in front of Havana Hilton, now Havana Libre"

mode of economics and tourism that the Hilton chain embodies. Glinn's photos offer a unique insight into the moment of requisitioning/occupation, and his sense of composition makes plain the competing discourses at work in the merging of social revolution and capitalism's literal and figurative architecture.

Once the initial military actions of the revolution were over, though, and nationalization had severed all official links with the Hilton chain, the renamed Habana Libre made up for the reduction in international tourism by hosting national guests (workers, national women's groups, students, and artisans) (Hunt) as well as international events such as the Tricontinental Conference and the World Chess Championship. Deena Stryker's photographs from 1963 and 1964 provide intriguing documents of life in the Cuban capital during the period of normalization and consolidation of Castro's power. That the former Hilton should figure prominently in her collection is a testament to its enduring importance among expatriates and, once more, the Cuban elite. Figures 1.13–15 are informative as to how the requisitioned hotel returned to "normal," welcoming guests and serving as a ludic site regardless of the ideological shift that had occurred around and within it. Consider, especially, the lobby's central staircase in figure 1.13 and mezzanine (figure 1.14); arms are no longer needed to secure these spaces as they were in Glinn's earlier photos. And as is evident in figure 1.15, the once-militarily occupied hotel has now been totally naturalized and made almost dreamlike by Stryker's use of soft focus; the Hilton's architecture may remain but the symbolic system that profits from its function has changed radically.

A monument to an increasingly fraught state of tension between capitalism and socialism, the Habana Libre is also the subject of Ramón Serrano's equally monumental collection of paintings from 2003, *What You See Is What You See* (*Lo que se ve es lo que se ve*). A Cuban artist and former dean of the Instituto Superior de Arte at the Universidad de las Artes de Cuba who moved to Toronto when he began to be persecuted for his art, Serrano has produced a series that is the most in-depth engagement with hotel space since Edward Hopper's. In some thirty works ranging from large-scale canvases to sketches and watercolours, the artist captures in an ironic fashion the enduring monumentality of the Habana Libre as a symbol of the Cuban Revolution. Through his intense meditation on the building's facade and the repetition of this central image, Serrano brings a new perspective not only to the way that artists have portrayed the hotel on canvas but also to the building's fundamentally unique relationship to time that contributes to its unique qualities. He attends to both elements by blurring and doubling the omnipresent image of the hotel that confronts Havana residents as it visually occupies the city (figure 1.16), thus inflecting one of the most overt aspects of the public archive of the revolution. In doing so, Serrano's work becomes a subtle yet powerful commentary on the built environment's relationship to history and memory. It also offers a palpable criticism of the persistence of an institution into which the "ordinary" Cubans for whom the revolution was fought, were excluded from entering when international tourism returned to the island and

1.13 Deena Stryker, *Lobby, Habana Libre Hotel*, 1964. Deena Stryker photographs, David M. Rubenstein Rare Book & Manuscript Library, Duke University.

1.14 Deena Stryker, *Habana Libre Hotel, Interior, Night*, 1964. Deena Stryker photographs, David M. Rubenstein Rare Book & Manuscript Library, Duke University.

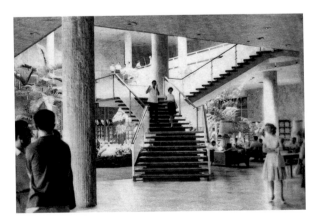

1.15 Deena Stryker, *Habana Libre Hotel, Foyer*, 1964. Deena Stryker photographs, David M. Rubenstein Rare Book & Manuscript Library, Duke University.

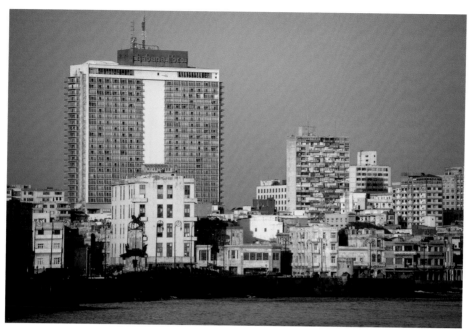

1.16 *Cityscape with Hotel Habana Libre.* Peter Schickert / Alamy Stock Photo

boomed during the 1990s. Even though this prohibition has since been lifted, economic realities make a stay at the Habana Libre impossible for Cuban citizens, and hotel security still restricts entry at the door in an attempt to deter prostitution. I propose that Serrano's work builds on the understanding of occupancy that one finds in earlier artists – especially Hopper and Glinn – and shows how the confluence of hotel space and visual art can broaden our understanding of the space's unique spatial and temporal qualities.

While critic Gary Michael Dault may see the intangibility of the building in Serrano's oeuvre as replacing the historic with the mythic (Dault 9), I read it as more of an overt political representation of revolutionary aims gone awry than a canonization of the same elements that seem to have inspired Serrano's meditation in the first place. The painter's work plays off the building's visual hegemony in a more direct way than mere allusions to myth. The title, *What You See Is What You See*, evokes Frank Stella's provocative minimalist asseveration that all that is in a painting is what one perceives. Serrano's use of this intertext is playful but cutting. It stresses the sheer visibility of the hotel but also brings into play the mutability of meaning and at the same time subtly underlines the fact that seeing it from the outside is the only way that the majority of Cubans will experience the edifice.

This sense of "lack" – of not having taken the requisitioning to its ideological conclusion but rather of creating one of what would be many "forbidden" buildings

for citizens – is evident throughout the series and perceived most suggestively in the graphic interpretation of the modernist building's elevator bank as a void on the fa-cade.[15] This space is cleaner than the hectic lines of the balconies and windows that surround it, an effect that ironically suggests transparency – as if the more plebeian cement could yield to a penetrating gaze while the windows of the elite remained opaque and distant.[16] Serrano mines this space fruitfully throughout his series as he alternately plays off this possibility and desire for transparency.

In his artist's statement, Serrano asserts that the groups or series of images that make up *What You See Is What You See* are intended to be exhibited as an installa-tion ("*Lo que se ve …*"). Intrigued by the possibilities of visual metaphor, he abstracts the images by painting double (and multiple) exposures in order to achieve what he describes as a "distorted appearance … that erodes the appearance of a documentary record, elevating the image to a poetic level, permitting one to retain a sense of objec-tivity" ("*Lo que se ve …*"). This objectivity in viewing and in remembering gives the series a political charge that is powered as well by the basic exclusionary fact of the Habana Libre. By working from photographs of the building and then employing the photographic technique of double exposure on his canvases, Serrano subtly engages and tweaks an "archive" that has stood in public view for over fifty years. His deep treatment of this one iconic building offers a compelling commentary on how the hotel exists and persists in a unique way both in time and space as different modes of revolution work on it, from capitalist to socialist and back again.

The series as a whole may be broken down into four stages: numbers 1–6, which offer variations on a similar study; the transitional #7; numbers 8 and 9, which break the previously predominant view; and then the concluding triptych. Close readings of these phases offer insights not only into the particular occupying valence of this compelling building but also into how the hotel functions and manifests on canvas.

In the initial six paintings, Serrano eschews any monolithic interpretation of the Habana Libre. Consider, for example, *What You See #1* (figure 1.17), which suggests slippage rather than solidity – as if the foundations of meaning of such a colossal building were not as firm as first thought. By blurring the bottom of the painting, the space representing that closest to the Havana public, the image appears to slide down the central axis of the elevator bank space. The pull to render the building more ac-cessible is also evident in the way light emanates from behind. This effect makes the brighter centreline even more redolent of possible transparency. Serrano will con-tinue to play with these concepts of solidity and porosity throughout the series as he modifies his interpretation of the hotel and the visual effects to which he submits the central image. The question arises: is the freedom that is supposedly embodied in the edifice real or merely a tropical mirage?[17]

While *What You See #2* maintains the same relative perspective as the first paint-ing, it immediately gives the viewer a different impression by portraying a darker,

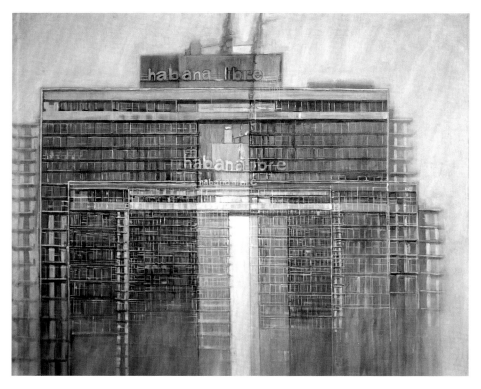

1.17 Ramón Serrano, *What You See Is What You See #1*, 2003.
Used with permission of the artist.

more solid structure (figure 1.18). Here, the hotel seems to build up on itself, thus suggesting that any accretion of meaning has happened vertically – that is, through official channels with no competing "horizontal" interpretations. With no gap or overlapping on the sides, Serrano's second interpretation of the hotel gives the impression that the structure's monumentality continues to grow. Yet even so, the artist injects a call for a competing gaze as he makes other buildings plainly visible in the lower half of the elevator area. Even in monumental growth, the subversive or inquiring view of the painter and spectator seeks to penetrate, thus conferring an illusory nature to the official party line.

By hinting at a succession of after-images in *What You See #3*, the artist gives the impression that rather than the building being unstable it is the viewer's gaze that wavers, thus complicating the documentary nature of the central image (figure 1.19).[18] What is more, when the overlapping effect of this multiplicity is coupled with the visual attraction of the elevator bank space and the blurring at the top of the painting, the viewer feels that he/she is falling into the image. The dynamism of *#3* thus infers

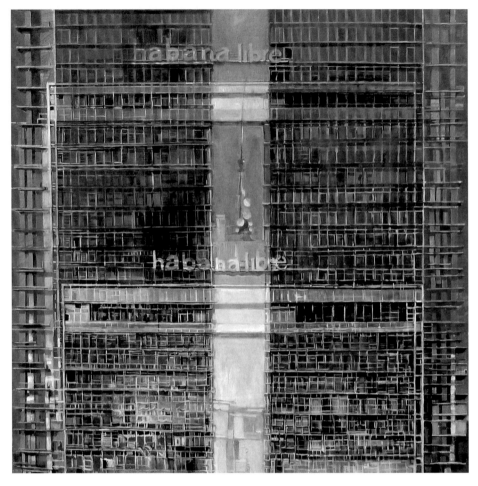

1.18 Ramón Serrano, *What You See Is What You See #2*, 2003.
Used with permission of the artist.

a collapsing of meaning that implicates the viewer in the rush toward a more solid centre, a centre that the artist has already established as a problematic site in which transparency and hegemony compete.

By highlighting the horizontal beams at the top of their respective hotel images, both *What You See #4* and *#5* create a feeling of consolidation rather than of slippage or collapse, while *#6* plays with size and time. In the first painting, the lighter and more muted tones coupled with some mild off-centring of the hotel's main double exposure draws the more skewed vertical image down towards it (figure 1.20). Conversely, *#5*'s sharper contrast and single added exposure ensure that the edge on the right side of the canvas remains clear and well defined while the balconies on the left suggest the rings of a notebook, a visual effect that underlines the hotel's status as

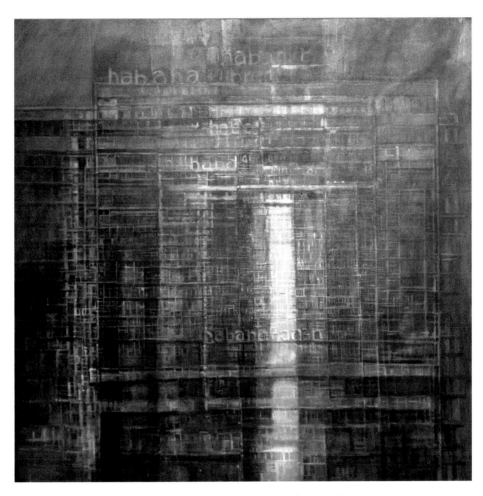

1.19 Ramón Serrano, *What You See Is What You See #3*, 2003.
Used with permission of the artist.

literal and figurative document and points once more to the challenge of interpreting
the Habana Libre's legibility over time (figure 1.21). *What You See #6*'s dilation effect
plays on distance and visibility while simultaneously referencing the passage of time
in that the smaller hotel image can be read as a template from which the larger is con-
structed or grows, an expanding and encompassing signifier that Serrano puts under
pressure in different ways throughout his collection (figure 1.22) and that also makes
one wonder about how the Habana Libre occupies its urban space over time.

What You See Is What You See #7 is another highly suggestive piece and a tran-
sitional one in that it marks a literal turn away from the vantage point of the previ-
ous studies as a forty-five-degree shift sees the upper frame of the picture truncate
the iconic sign and antennas (figure 1.23). The building's bulk compensates for this

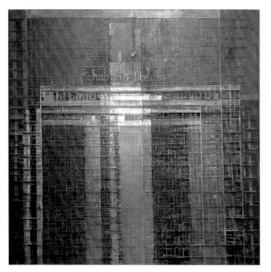 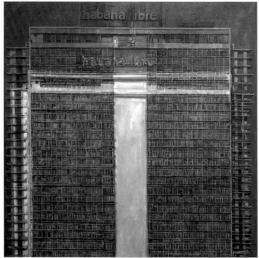

1.20 Ramón Serrano, *What You See Is What You See #4*, 2003.
Used with permission of the artist.
1.21 Ramón Serrano, *What You See Is What You See #5*, 2003.
Used with permission of the artist.

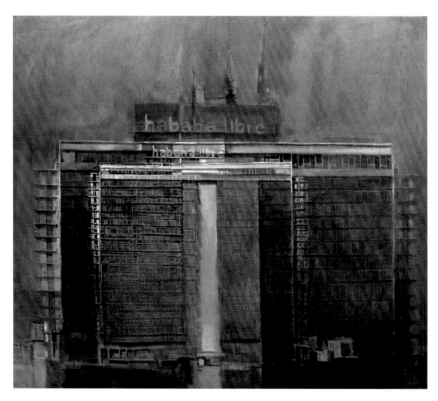

1.22 Ramón Serrano, *What You See Is What You See #6*, 2003.
Used with permission of the artist.

1.23 Ramón Serrano, *What You See Is What You See #7*, 2003.
Used with permission of the artist.

lack, and in this way Serrano comments on Havana's familiarity with the occupying structure; it does not need its name proclaimed as everyone in the capital knows this space already. The new angle signifies movement in the vicinity, further anchoring the building's centrality as a marker and establishing it even more as a waypoint around which navigation occurs. The smaller buildings in front of the hotel are better defined than in other pieces in the series, and this added detail serves to extend the area of influence that the Libre has and to connect its presence more directly to a larger urban whole. The overall effect of this painting is to reinforce the deep foundations that this building represents vis-à-vis the revolution and its ideals – an effect that primes it for further critique.

What You See Is What You See #8 is interesting in that, like #7, it does not sport the "Habana Libre" sign (figure 1.24). Furthermore, the shell of the hotel seems to be slipping away, with only the clean white of the elevator shaft area resisting the slide. This constancy establishes the primacy of this central space once more and makes the radical shift that one finds in #9 even more dramatic (figure 1.25). For rather than offer the frontal view of the Habana Libre, the incongruous, mug shot–like #9 strikingly portrays the building in profile, thus stripping the hotel of its horizontality, underlining its height, and, at the same time, filling in the central void that figures so prominently in the other works. In so doing, Serrano makes the Libre's massiveness immanent by repealing any possibility of transparency.

The last of the large canvases in the series, numbers 11, 12, and 13, form an imposing triptych that reinforces the Habana Libre's status as a landmark in both space and time (figure 1.26). By referencing the Arc de Triomph through his chosen angle, Serrano draws out the Libre's status as both a symbolic, commemorative edifice and a trophy in and of itself. The lighting scheme of the three together – dark, light, dark – suggests a natural rhythm that connects the building even more to the landscape and the social reality of revolutionary Havana in which the building is a well-known constant.

While Serrano's *What You See Is What You See* collection also includes a plethora of watercolour studies and other smaller pieces, his central series of large canvases remains the main attraction and the most important component of his engagement with hotel space. By casting such an intense gaze on a building largely forbidden to Cubans even though it had played such an important role in the birth of the revolution, Serrano brings to light the ways in which the hotel's meaning has subsequently folded back on itself. From a site of liberation and enunciation of the revolutionary aims of Castro's movement to an exclusionary space that stood as a reminder of difference in a supposedly levelled society, the Habana Libre has accrued many different meanings. That Serrano's artwork is so evocative and able not only to treat the physical monumentality of the hotel but also to engage with its temporal qualities as a document points to the Habana Libre's unique nature as both commemorative object and ongoing revolutionary space that quite literally occupies this part of the Cuban capital and is reflective of the very serious tensions that affect the socialist project as a whole.

Given its increasing ubiquity and growing importance in the day-to-day culture of the West, it was only natural that during the nineteenth and early twentieth centuries the hotel should begin to appear on the canvases of such distinguished painters as Monet, Braque, Sargent, and Grosz. As time went on and travel became more widespread and "democratized," the new way of being that the hotel's special relationship to space and time engendered – occupancy – also evolved. Edward Hopper's iconic treatments of the hotel lobby and rooms are a unique testament to this shift in the experience of the built environment and how it can be captured in art. This revolutionary nature and potential of the hotel became literal in addition to metaphorical with

1.24 Ramón Serrano, *What You See Is What You See #8*, 2003.
Used with permission of the artist.
1.25 Ramón Serrano, *What You See Is What You See #9*, 2003.
Used with permission of the artist.

1.26 Ramón Serrano, *What You See Is What You See Triptych*, 2003.
Used with permission of the artist.

the Cuban Revolution. In the requisitioning of the Havana Hilton, which was the tallest building in Latin America at the time and a tribute to American capitalism's expansion, Castro gained a highly visible urban monument to both his initial military victory and the ongoing socialist project. Renamed the Habana Libre, it would also be a site and inspiration for important documentary work by photographers Burt Glinn and Deena Stryker as well as the intensive aesthetic examination carried out by Ramón Serrano in his series of canvases. As is clear from these varied and insightful interventions through painting and photography and especially the compelling and suggestive way in which the building itself assumes an occupying quality, the hotel has been both a revolutionary forum and an intriguing subject that tells us more about travel and spatial practice as filtered through the artistic visual imagination. In the next chapter, I will now focus on *moving* pictures and explore how an understanding of hotel space and occupancy is further expanded through analyses of works of cinema.

chapter two

THE CINEMATIC HOTEL

A tired businessman sits slumped on a chair in an empty hotel lobby. Like the woman in Hopper's *Hotel Room*, it is hard to tell whether he is coming or going. The empty seat beside him and the absence of others immediately creates a sense of isolation mixed with weariness. The sound of vacuuming belies this solitariness but its nonde-script industrial white noise does nothing to warm or fill the space.[1] That it blends in so completely to the scene speaks to the viewer's own expectations regarding business travel and the anonymous spaces of chain hotels like the Los Angeles Marriot in which Spike Jonze directed this music video for Fatboy Slim's *Weapon of Choice*.

A fantastical take on a seemingly mundane space, this video, which was filmed 105 years after the first motion picture was screened in 1895, begins with an establish-ing longshot (figure 2.1) that clearly ties the lobby to film's immediate predecessor, the theatre. The scene even comes with curtains framing it and a shiny floor serving as proscenium. Christopher Walken's downtrodden businessman is on stage, but thanks to the power of cinema, this will be no ordinary performance. Two cuts five seconds apart bring the melancholy man into a medium shot in which his lethargy is even more evident. With Fatboy Slim's music emanating from off-screen, he turns his head to look. Jonze cuts to a point-of-view shot that shows a radio on top of a housekeeping cart next to the open door of a meeting room. Walken then stares directly at the cam-era and holds our gaze for a few seconds. With this somewhat reluctant recognition that he is not alone, he turns away and begins to move slowly to the beat before stand-ing and breaking into an elaborate dance that will make use of various spaces in the lobby and mezzanine and even see him soar through the air at the climax of the song before reassuming his initial pose (figure 2.2). The four-minute video is enthralling. Jonze not only makes a well-known, everyday space exciting by showing its potential for fantasy but also points to the ease with which the hotel lends itself to cinematic interpretations, the subject of this chapter.

If the hotel's connection to cinema seems an easy and natural one, it is partly be-cause the two share a long history. Hotels were the sites of early movie clubs and have

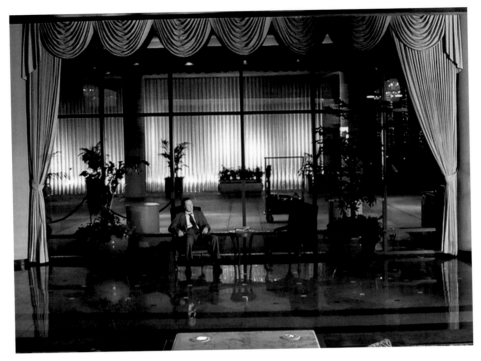

2.1 *Weapon of Choice*. Dir. Spike Jonze, 2000.

2.2 *Weapon of Choice*. Dir. Spike Jonze, 2000.

appeared in film since the first years of the art.[2] In this chapter I study these initial examples along with lesser-known genre films, with a focus on the work of "hotel auteurs" like Alfred Hitchcock and Sofia Coppola. I argue that through a close viewing of how hotels function onscreen, one can better understand the symbolic nature of this unique modern space while at the same time gaining a broader grasp of how occupancy functions within the realm of the visual imagination.

As a setting, the hotel has had and continues to have a long and vital career by means of its cinematic form. In his seminal work, *Delirious New York*, Rem Koolhaas points directly to the innate attraction of the hotel for Hollywood writers who made use of it during the 1930s: "In a sense, it relieves the scriptwriter of the obligation of inventing a plot. A Hotel is a plot – a cybernetic universe with its own laws generating random but fortuitous collisions between human beings who would never have met elsewhere" (148). Koolhaas's observation is astute not only for the many roles taken by the cinematic hotel but also because he alludes to the real-life parts that it plays and the social dynamics that subsequently inform these fictional versions. What the philosopher-architect calls the hotel's "routine operations" are the template upon which the diverse modes of occupancy are set and where its heterotopic characteristics also appear, which is not surprising since the edifice offers "a fertile cross section through the population, a richly textured interface between social castes" (148). This latter point is key to a fuller analysis of the cinematic hotel; for no matter the grandeur or squalor of the lobby, bar, or guest room, its "back-of-house" areas always exist as a cotemporaneous, behind-the-scenes world that both contrasts with and supplements the space's public zones. That film has so often made recourse to this fundamental duality speaks at once to both the sheer narrative force of the hotel's focus on service and the rich visual and symbolic potential that juxtaposition offers.[3] What I would further add to Koolhaas's description, though, is that often the hotel is anything but what he calls "a neutral background" of routine. Given its evolution, relationship to space and time, the accumulated weight of expectations regarding service, and the rise of specificity as a selling point, I argue that any chance that the hotel may act as a neutral zone is quickly becoming a thing of the past. The hotel is a very determined space with different and sometimes competing modes of occupancy depending on the needs of the subjects as they adapt to its inherent possibilities. This fact has emerged onscreen.

Early Hotel Films

Before 1930s Hollywood discovered the hotel's inherent charms and attractions and produced Edmund Goulding's classic and much-commented-upon *Grand Hotel* (1932), early filmmakers had already made use of the space's narrative potential as a way of both incorporating technical advances into their storytelling and coming to

terms with emerging social dynamics relating to hospitality and being-in-space that is not one's home. One ground-breaking example of this is Segundo de Chomón's *El hotel eléctrico* (*The Electric Hotel*), a five-minute short that was the first to make use of stop-motion single-frame exposures to create the illusion of continuous movement (Bentley 7).[4] A pioneer of early cinema, Chomón was known as the "Spanish Méliès" (Jordan and Allinson 4). He had worked in the Frenchman's colouring laboratory at the turn of the twentieth century and then returned to Barcelona to open his own facility and production company (4). While he was a master of special effects and the creator of many popular, fantasy-based shorts, Chomón's Catalan venture did not have the success that he had envisioned, and as a result he was forced to return to Paris, where the industry was more developed. Once back in the French capital, the filmmaker worked for Pathé's main studio and set about developing and perfecting new special-effects techniques.

El hotel eléctrico, which was financed in France and filmed upon his return, briefly recounts the experiences of Laure and Bertrand, a well-dressed couple who arrive at an unnamed hotel where services are not performed by human beings but rather occur "magically" through the power of electricity. The production of this silent film coincided with the general increase in electrification of public and private space in Europe at the time. As a result, Chomón's humorous tale stands as both an interesting commentary on and a form of working out how technology could potentially affect the burgeoning modern hospitality industry and the relatively new experience of modern hotel going.

El hotel eléctrico is notable, too, for being the first to employ the stop-motion technique created by turning the crank on the camera ever so slightly, exposing the frame, and then changing the mise-en-scène and advancing the film again for another exposure. In this way, Chomón was able to manipulate both the objects and humans in his picture in a startling new manner. That said, *El hotel eléctrico* begins normally enough and at regular speed – not stop-motion. Laure and Bertrand arrive in the lobby of the hotel in long shot and look around approvingly. An employee in a double-breasted jacket who is both bellhop and concierge greets them and signals that a room upstairs is ready. The couple sits, waiting perhaps for the bellhop to collect their things, but instead, their host turns his attention to a table with levers and buttons. This is the control device for the electrical currents that will animate the various objects inside the hotel. With the press of a button – and in an effect that, while primitive by today's standards, is still impressive – their bags glide on their own towards an automated elevator at the back of the lobby.

Once upstairs, the luggage travels to the guests' room of its own accord. After performing a little dance and moving themselves into position, the cases open so as to allow the packed items to stow themselves in dresser drawers. When the already-amazed couple arrives they are further delighted to see that they have been spared the chore of unpacking. In a move that underlines the sheer novelty of the

2.3 *El hotel eléctrico*. Dir. Segundo de Chomón, 1905.

2.4 *El hotel eléctrico*. Dir. Segundo de Chomón, 1905.

hotel's new technology, Bertrand's traditional clap for a bellhop produces instead an electric control panel similar to that found downstairs. He realizes that the labour has been displaced to the machine and mimes the services that the various buttons control. In short order, the hotel's electrical current manipulates different objects in order to shine Bertrand's shoes and then shave him (figures 2.3, 2.4). Chomón shoots these scenes in close-up with a static camera, which is understandable given the stop-motion technique needed to animate the brushes and razor. That the "worker" but not the work has been rendered invisible through the director's special effects marks a tentative step towards what will eventually become the type of seamless and invisible services that hotels offer clients today. An alternative reading would be that this time-saving technology is part of luxury occupancy and is a marker of even greater worker alienation through the literal disappearance of service labour. The fact that, when it is

Laure's turn to have her hair brushed, she activates the console herself demonstrates this new technology's additional emancipatory element as regarding gender.

The technologically advanced occupancy of the room does not last. When a drunken employee hits the wrong switches on the hotel's main control board, the guest room goes haywire (figure 2.5). Furniture and objects scurry about chaotically, flinging the unfortunate travellers around and whisking them down to the lobby in a jumble of furniture and strewn objects (figure 2.6). The film ends abruptly amid this commotion, which leads Bentley to correctly read *El hotel eléctrico* as a cautionary tale of the dangers of modern technology (9). Through its cinematic portrayal of the space of the modern hotel and invocation of electricity as the agent that facilitates luxury and timesaving, Chomón's movie touches on a turn-of-the-century zeitgeist that saw electricity's transformation of domestic and industrial spheres both thrilling and potentially terrifying.[5] In addition, I argue that it also serves as a fanciful imagining of what future occupancy and hospitality services might be like. As a space of the new, the hotel here acts as a frontier, a border with novel experiences that are both spatial – a temporary "home" – and temporal – a zone in which timesaving services are part of the rate. In this way, Chomón's rendering of the hotel as a novelty is in keeping with its valence as a site of contact; in this case, it is where travellers and technology coincide.

Another early cinematic example of the interest in – and comic potential of – hospitality service and the inner workings of hotel occupancy is one that takes place on the literal frontier: Roscoe "Fatty" Arbuckle's western-influenced *The Bellboy*, which appeared in 1918 during the First World War. While the thirty-three-minute picture set in the fictional Elk's Head Hotel is pure slapstick and matches the director with Buster Keaton, another genius of physical comedy, its frontier tale involving a love interest for the protagonist and a bank robbery does maintain a slight connection to the Old World through two allusions to the conflict in Europe. The first is a simple sight gag in which one sees a show of culinary solidarity far from the front in the shape of a sign for French food that has had the phrase "and German" scratched out. The second is an ingenious shaving sequence during which Fatty's deft use of a razor and props transforms an evil-looking, hirsute man known as "Rasputin the Mystic" first into Ulysses S. Grant, then Abraham Lincoln and finally Kaiser Wilhelm II – who is promptly bombarded with shaving cream. That *The Bellboy* trades on a frontier feel yet still evinces contact with Europe speaks to both the growing gentrification of hospitality in America[6] and the way in which hotels act as nodes in a larger network of information and expectations. The play on shaving is indicative, too, of the host of amenities that they offer; they were sites of multiple services for travellers and locals alike.

While the laughs in the picture rely on silly gags and physical comedy, they are underpinned by the viewers' expectations regarding levels of service and hygiene when occupying hotel space. In the case of The Elk's Head, an initial intertitle states that the saloon-like establishment offers "third-rate service at first-class prices." In this

2.5 *El hotel eléctrico*. Dir. Segundo de Chomón, 1905.

2.6 *El hotel eléctrico*. Dir. Segundo de Chomón, 1905.

way, the comedic stage is set on the basis of value, with the routine operations of the hotel's space/time equation placed at the heart of the narrative's humour. Whereas in Chomón's film the focus was on labour that was literally invisible, here the workers are front and centre; they are the protagonists who form the locus at which service expectations and the reality of hospitality coalesce, the behind-the-scenes lynchpins that bulwark guest occupancy. This dynamic is clear from the beginning of *The Bellboy*. The film opens with a long shot of the lobby, which has the appearance of a saloon or western hotel. Guests are reading and writing while the bored concierge waits and a bellboy, played by Buster Keaton, sits perusing a book. With a cut to a medium shot of the elevator, the film's hero emerges only to lean lackadaisically. It is Arbuckle, also dressed as a bellboy and the architect of the picture's first sight gag in which he produces a lit cigarette from *inside* his mouth and promptly extinguishes it in a water

dispenser upon hearing his boss's call to work. The irreverence of both his lazy de-
meanour and obliviousness to an amenity for guests establishes the tone of a picture
in which the comedy is fuelled by the audience's immediate and implicit understand-
ing of how Arbuckle's character undermines the expected level of hotel service. His
presence is not unlike that of a saboteur.

With codes of service and expectation in play, the director expands on the "behind-
the-scenes" dynamic that hotels so readily provide to inspire the film's initial scenes
while giving the viewer plenty of comedic insights into the hotel's workings. First,
the bellboys fall on their backsides as they load the bags of a departing couple onto a
horse-drawn trolley. Their attempt at efficient performance in unison fails to comedic
effect.[7] When a subsequent intertitle announces "Spring cleaning" as the next section
of the film, the viewer first sees Keaton apparently hard at work wiping the window of
the lobby phone booth from the inside only to discover that there is no glass and that
he has simply been miming the actions. The camera then cuts to Fatty lazily sitting on
the floor of the lobby scrubbing and mopping one section of the floor between his legs
at a time. The two comically perform the acts of service but always under the aegis
of inefficiency and a failure to meet what one would consider the minimum expecta-
tions of a site of hospitality. While the laughs revolve mainly around their ineptitude,
aspects of technology grease the wheels in the form of an elevated delivery basket for
hot towels from the kitchen to the barbershop and the humorous horse-drawn eleva-
tor. The latter is especially comical when it is employed for a group of visitors who
arrive at the Elk's Head and the animal refuses to advance far enough, thus providing
Arbuckle and Keaton one of their better set pieces in the film.

While the first two-thirds of *The Bellboy* are a series of episodes designed to
showcase Arbuckle's and Keaton's talents as physical comedians and to play off the
particular comedic possibilities of the hotel as a setting, later in the film the arrival
of a new group of guests and a love interest, Miss Cuticle, introduces a "win her af-
fections" element to the story. At this point, *The Bellboy* becomes less a hotel picture
and more a cops-and-robbers caper as Fatty attempts to woo his beloved by propos-
ing that his colleagues pose as thieves so that he may capture them and impress her.
Lo and behold, though, real bank robbers arrive in town and pull their own heist
only to be brought to justice in the end by Fatty and his friends. The film concludes
with an enamoured Arbuckle riding off with Miss Cuticle and an iris transition on
the couple cuddling, his job as an attendant to the needs of modern travellers seem-
ingly forgotten.

If *The Bellboy* mines the hotel's hospitality dynamic for comedy and adventure,
F.W. Murnau's silent feature *The Last Laugh* explores the melodramatic potential of
its internal hierarchy. A picture told with the visual power indicative of the German
director's later expressionist films, it is the simple story of a doorman who struggles
to maintain his dignity after being unfairly demoted to the position of washroom
attendant. The film's use of hotel space as both a physical site and class-coded social

locale is inspired, and the deep emotional portrait of the older doorman quickly communicates the strong connection between one's job and self-esteem. Murnau immediately immerses the viewer in the life and energy of Berlin's Atlantic Hotel. The film begins with a point-of-view shot in the lobby elevator followed by the camera gliding towards the revolving door before pausing at the threshold and taking in the bustle outside.[8] The continually spinning door serves as a visual allegory for the repetitive tasks that take an increasing toll on the body of the film's hero, who, in constant movement helping others come and go, is anchored to a fixed social station. Murnau's skills at mise-en-scène and use of montage are especially evident in the opening act in which he creates abundant layering through depth of field as a way of underscoring the sheer activity around a hotel like the Atlantic. *The Last Laugh*'s technical innovations also include one of the earliest uses of a moving camera along with multiple superimpositions and, as per expressionist techniques, extremely dynamic angles used to accentuate the mood and condition of the protagonist. As it will a few years later in *Grand Hotel*, the revolving door has immense symbolic value throughout the picture, here seemingly rooted to the hero's sense of self. In one celebrated dream sequence following his demotion, the drunken protagonist imagines working in front of an immense door (figures 2.7, 2.8) before heroically lifting a trunk that five other men can hardly budge.

Murnau made *The Last Laugh* in 1924, and the film is justly celebrated not only for its virtuoso visual storytelling during the silent era but also for the way in which the director liberated the camera mobile by removing it from the tripod. As Silberman observes from a theoretical perspective, Murnau's innovation "unchains" the camera and as a result replaces "the actor as producer of meaning'" (qtd in Hayward 177). I would add that the choice of the hotel as the setting for such a powerful story and innovative vision is not incidental, coded as it already was during the Roaring Twenties as a busy, transnational space in which not only people of different countries might collide but also those of different classes. In showing the humanity of one who works to serve the occupancy of the rich, Murnau creates a document of surprising power about the type of urban "fixture" – the doorman – that many would have already begun to take for granted. That the film has a gauche, tacked-on "happy ending" in which the protagonist is the recipient of a deux-ex-machina inheritance does not dilute the rest of the picture's incisive commentary on the space of the hotel and those who work to animate it.

The Classic: *Grand Hotel*

In 1932 MGM released Edmund Goulding's *Grand Hotel*, a much-celebrated picture that now stands as a seminal hotel film for the way in which it deftly treats aspects of both back and front of house while incorporating class divisions among guests as well.

2.7 *The Last Laugh*. Dir. F.W. Murnau, 1924.

2.8 *The Last Laugh*. Dir. F.W. Murnau, 1924.

Adapted from Vicki Baum's novel, the film puts into cinematic practice the symbolic and narrative possibilities offered by the type of heterotopic zone that Koolhaas describes. What is more, *Grand Hotel* codifies visually the fantasies associated with hotel space as it both draws on and inspires the characters' ways of imagining hotel occupancy; acting out the fantasy of staying at and frequenting the Grand Hotel is central to the film's plot.

The sheer diversity of characters played by recognized movie stars of the day is also fundamental to the film's appeal, which, despite not being nominated in any other category, won an Oscar for Best Picture. These actors portray guests drawn from a broad cross section of society all assembled under one roof. The ensemble ranges from humble members of the servant class and a diva with her entourage to an industrialist trying to finalize a merger, a thieving aristocrat brought low, and a socially

ambitious young woman whose precarious employment situation has her verging on prostitution. Crucial to the mix is the terminally ill Kringenlein, who serves as a lynchpin between classes and morphs the standard rags-to-riches tale. In his case, not only will one great dose of the good life at the Grand Hotel expend the sum total of his savings, it will also presumably take what little time he has left. In this way, the routine operations of the establishment, while encompassing a wide swathe of people, also bring into especial relief the temporal nature of hotel occupancy by neatly juxtaposing the basic necessity of paying to stay in such a luxurious space and the unique situation of a man who, relieved of pecuniary worries, may run out of life first.[9]

Over the course of the film, the building's revolving door emerges as *Grand Hotel*'s iconic image, a symbol of access and egress spinning endlessly like the wheel of life. Intriguingly, though, the picture begins with another shot that will also recur: a dynamic overhead pan of operators connecting people in the hotel's telephone exchange (figure 2.9). The switchboard acts as both a visual reminder of the technology that links and permeates the modern hotel – here the rooms are reduced spatially to circuits for connections to be made through the telephone – as well as a clever device to introduce and underline the myriad plotlines unfolding in the space. This latter aspect is mirrored by a subsequent and equally dramatic overhead shot of the busy lobby that further accentuates the ways in which the trajectories of guests and staff intersect while visually referencing the emblematic revolving door at the same time (figure 2.10). The democratic distribution of attention to characters of different classes in the film's opening phase is particularly relevant to developing a more nuanced understanding of how occupancy and the hotel are portrayed on screen. From the anxious porter, the diva's assistant, and the dying Kringenlein to the Baron and the desperate industrialist Preysing, essential plot points are laid out thanks to the communication technology provided by the hotel. The camera treats all of them equally, even as their specific narrative circumstances and relationships to the space differ. In a telling remark that points to the range of experiences, for example, the front desk porter exclaims that being tied to his job at the Grand Hotel is akin to "being in jail."

The opening plot exposition concludes with a series of short cuts between the characters and then a final transition to the one hotel occupant who seemingly abides outside contemporary time: the war-scarred Dr Otternschlag. This disconnection is evident when the Doctor, a veteran turned long-term resident of the Grand Hotel, continually inquires in vain if anyone has asked for him or left a message. It is he who, while calmly smoking in the lobby among the hubbub, proclaims: "Grand Hotel: people come, people go, nothing ever happens." The repeated adage matches the spinning of the revolving door and bookends the film, thus casting the various narratives as mere snapshots of a series of different, interlocked experiences at the hotel.

The Doctor's role as a chorus figure is important for the insights he provides regarding hotel life. Aside from his famous opening and closing line, one conversation featuring Kringenlein is particularly apropos. The scene takes place in the hotel's

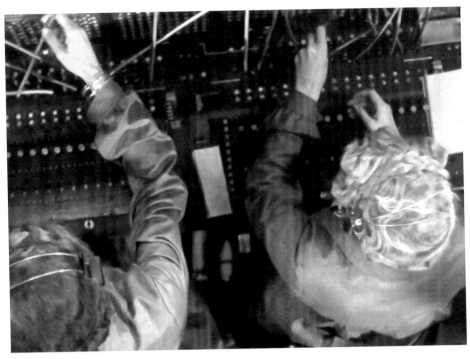

2.9 In-house telephone operators. *Grand Hotel*. Dir. Edmund Goulding, 1932.

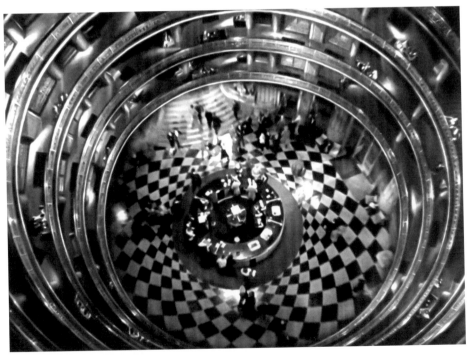

2.10 Overhead lobby shot. *Grand Hotel*. Dir. Edmund Goulding, 1932.

busy American bar as a dolly shot from the servers' point of view comes to rest in a medium shot framing the two men. While Kringenlein, the guest who had marvelled earlier at having his own private bathroom, continues to be wide-eyed about the space and its practices around him, the Doctor, a tad drunk and pouring himself even more, muses on the deep existential architecture of the grand hotel experience in general. He observes wryly: "And what do you do in the Grand Hotel? Eat. Sleep. Loaf around. Flirt a little, dance a little. A hundred doors leading to one hall. No one knows anything about the person next to them. And when you leave, someone occupies your room, lies in your bed ... that's the end." This insightful commentary made by the resident observer sums up the generic experience of the hotel guest, who has the luxury of being able to travel by choice. His words touch on fundamental elements such as: the evasion of domestic duty, the inherent sexual possibilities and other ludic amusements in a hotel, as well as the anonymity afforded by a stay there. At the same time, the Doctor, a holdover from another age, underlines the temporary notion of occupancy and the impossibility of actually owning the space; his own temporal distance gives him clarity and perspective about the hotel and its effects. Part of the importance and appeal of *Grand Hotel* as a hotel film, though, is that it does not hew to a single interpretation but rather explores occupancy at different levels through its characters. While the Doctor's observations may be true for a segment of society, the presence of Kringenlein as the interlocutor here generates tension. Both his general unfamiliarity with the codes of elite travel and specific behaviour in exclusive spaces convert him into a surrogate for the middle-class viewer who imagines him/herself in his place. Otternschlag's comments also obscure the experiences of the staff, who are extremely present in the film – from the cleaners and floor clerks to the porters. This diversity of perspectives and imagery, both narrative and visual, is what makes *Grand Hotel* such a symbolic and seminal hotel film and an important example of forms of occupancy onscreen.

Genre Films: From Noir to New Wave

While early films like *El hotel eléctrico*, *The Bellboy*, and *The Last Laugh* established the hotel as a viable and rich locale for cinematic action revolving around labour, and a blockbuster such as *Grand Hotel* not only solidified this aspect but also furthered its breadth through a deepening of the potential meanings of occupancy, the use of hotel space in so-called genre pictures – especially the thriller and noir – quickly took hold. As Susan Hayward points out, "genre is more than mere generic cataloguing" (166); the concept also entails "the role of specific institutional discourses that feed into and form generic structures" (166). Although these discourses primarily comprise aspects of cinematic production, distribution, and marketing, I argue that the architectural and symbolic characteristics of the hotel itself also lend themselves to

the incorporation of the space into genre pictures. This is especially true for films in the thriller, suspense, and noir genres – of which there are many – in which the hotel figures as a setting for immorality and corruption, anonymity, and as a general space for fringe and transient elements of society to operate.[10] For the purposes of this chapter, I have chosen to focus on examples that contribute to a broad understanding of this symbolic role of the hotel along with the developing notion of occupancy.[11] Pictures such as *Ménilmontant* (1926) and *Hôtel du nord* (1938) speak to early noir aesthetics through the avant-garde and a burgeoning sense of poetic realism, respectively, while *When Strangers Marry* (1944) and *Key Largo* (1948) are excellent examples of how hotels and the visual narrative of cinema intertwine productively in "traditional" film noir. Meanwhile, Jean-Luc Godard's French New Wave classics, *Vivre sa vie* (1962), *Alphaville* (1965), and *Made in USA* (1966), stand as compelling instances of the manners in which previously established genre conventions regarding the hotel can appear and work in new ways and thus inflect both the space's symbolic importance and our understanding of how characters occupy the space onscreen.

Directed by Russian émigré Dimitri Kirsanoff, *Ménilmontant* (1924) is a stylistically avant-garde silent morality tale that traces the melodramatic lives of two sisters who are forced to move from rural France to the capital following the brutal killing of their parents. When the younger sister falls for the charms of a ne'er-do-well only to subsequently discover that her sister has done the same, the bond between them is severed. Nine months later, the younger sister has given birth to an illegitimate child while the eldest has become a prostitute. The film ends with the sisters reconciled and the man hunted down and murdered by another woman. While melodramatic in the extreme, *Ménilmontant* makes effective use of dissolves, skewed angles, overlaps, and kinetic movement to communicate the mental states of the sisters and transmit an overall feel for the city in which they have been corrupted. The hotel holds symbolic importance here; it is a locus of depravity, a space woven into the fabric of the tumultuous modern city that acts as a threshold or access point to another life.

The initial appearance of the illuminated "Hotel" sign comes after a kaleidoscope-like flurry of urban images symbolizing the decentred, unstable atmosphere – both physical and moral – of the metropolis (figures 2.11, 2.12). The beacon-like sign is a presence in the sudden darkness that holds the promise of refuge. The mise-en-scène of the next scene belies any possibility of sanctuary as the viewer immediately discovers that the hotel is instead implicated in exploitation and depravity. First, a man and woman are shown in long shot but framed in such a way that they are rendered anonymous. Then, after the couple enters the hotel, the camera pans up the door, revealing a wire security screen and another "Hôtel" moniker before coming to rest on a dark window that is subsequently illuminated from within. The effect of the camera's movement and focus on the window is such that the word "Hotel" comes to a temporary rest at the bottom of the frame, submerged in the darkness, a visual analogy to the activities within (figure 2.13).

2.11 From kaleidoscope to beacon. *Ménilmontant.*
Dir. Dimitri Kirsanoff, 1926.

2.12 *Ménilmontant.* Dir. Dimitri Kirsanoff, 1926.

2.13 Submerged hotel sign. *Ménilmontant.* Dir. Dimitri Kirsanoff, 1926.

When the camera pans back down to the street, another man is present. The close-up on his hands as he counts out coins connotes a dual commodification of time and sex within the precinct of the hotel. A moralizing perspective on prostitution and its connection to the hotel is further reinforced by lingering close-ups of the older sister's muddy feet as she paces the street in front of the building. With its unexpected instances of violence and avant-garde cinematography, *Ménilmontant* directly implicates the hotel in a pessimistic view of the modern city, portraying it at both the visual and narrative levels as a symbolic space tied to exploitation and immorality, one far removed from rural domesticity.

Another example of a cinematic hotel intimately connected to underworld depravity is that featured in Marcel Carné's *Hôtel du Nord* (1938), a film in an early noir,

poetic realist manner that recounts the story of a failed suicide pact and the lives of the residents as they deal with the consequences of the protagonists' actions. As Travers astutely points out, the film begins with what could be the climax of a film noir melodrama: two social outcasts who are running from their past cannot go on and are ready to end it all together (Travers). Having shot Renée, Pierre loses his nerve and finds he cannot turn the gun on himself; instead, he flees, not realizing that the bullet has merely wounded his companion. Upon her recovery, the hotel owners offer her a job as a waitress. She then falls in with Edmond, a pimp who lives at the hotel with his mistress, the prostitute Raymonde. Eventually, Edmond's own past comes calling and an old accomplice murders him. The film ends on a cautiously optimistic note with Renée leaving the Hôtel du Nord with Pierre, who has recently been released from prison. In this picture, the hotel is a hybrid: a space for both long-term and temporary residents. The presence of both types of occupancy under one roof, though, makes for an uneasy tension as the proximity of seedier elements casts the more family-oriented, domestic aspects of the story, such as the celebration dinner for a girl's communion at the beginning of the film, in a different light.

Hôtel du Nord's visuals are striking, and the elaborate set that was built for the film became a popular attraction.[12] Likewise, while the picture's most famous line, "Atmosphère, atmosphère …," which Raymonde spits at Edmond during a quarrel may serve as a brief moment of comic relief, it draws attention back to the utter seedi-ness of the film's story and mise-en-scène. In this way, one can consider the Hôtel du Nord as a multi-functional space and, like the Grand Hotel six years before it, a plot device that enables crossings and connections between people with different modes of occupancy within the culturally specific context that poetic realist aesthetics provides.

John Huston's classic film noir *Key Largo* (1948) is another example of the ho-tel's potential to offer different experiences, and importantly, it is a work that points to the space's potential and proclivity to be requisitioned, an aspect of hotel occu-pancy that I touched on regarding the Habana Libre and examine in greater detail in the next chapter. Here though, the setting is the Hotel Largo, which is run by Lionel Barrymore's character, James Temple. It is an establishment that caters to a variety of clientele: from people in transit on the Florida Keys, to those interested in the area's rich fishing waters. The hotel is also a metaphoric and literal meeting point between the white owners and the local Seminole tribe, with whom Temple shares a special re-lationship that will be shattered over the course of the film. When Humphrey Bogart's Frank McCloud arrives to meet the father (Temple) and fiancée of a friend with whom he had served in the war, he finds the hotel open and occupied yet paradoxically still closed to the public. Eventually, he discovers that the notorious exiled gangster "Rocco" has slipped back into the United States with a shipment of counterfeit money and temporarily taken over the hotel. The onset of a hurricane traps McCloud, the owner, his daughter, and a local police officer in the building with Rocco and his crew. The tension increases in concert with the storm outside, coming to a violent climax on a boat that McCloud is forced to pilot for the gangster's escape.

The shots of McCloud's arrival at the Hotel Largo are important for the way in which they immediately begin to ratchet up the suspense. The protagonist enters in a long shot that establishes the generous space of the tropical hotel's lobby. As he walks in and approaches the desk, a seated figure observes him closely. Passive surveillance is, of course, a characteristic of the visual nature of lobby space, but here the viewer instantly recognizes that there is an added edge to the stranger's gaze. McCloud finds the front desk unattended and rings the bell; the lobby loiterer informs him that the establishment is closed. At the same time, noise can be heard from the adjacent bar. There, the inquisitive McCloud finds a small group engrossed by a horse race on the radio. When he is denied a drink, the only woman in attendance insists on his behalf and the barman reluctantly serves him. The opening pace to the film is deliberate, but through a very simple tweaking of the normal run of things in a hotel setting, Huston manages to instantly create a sense of foreboding. The surveillance, lack of staff, and the presence of guests in a hotel that is "closed" are just odd enough to put the viewer on edge. As the plot develops, the isolated and enclosed nature of the setting feeds this suspense. The hotel becomes a clandestine area, one that resists its role as a community refuge when Rocco refuses to allow the local Seminoles to shelter there during the storm. Under the control of the gangsters, it is a liminal space between law and disorder, a transitory zone carved out for the alternative morality of the criminals who invert the "natural" order of the space. In a telling moment that underlines this transformation and highlights the effective requisitioning that has occurred, Rocco replies to the question, "Am I to understand that we're your prisoners?" by succinctly countering, "Well, put it this way, Pop, you're gonna be *my* guests for a little while." As a genre-fuelled hotel picture, *Key Largo* is extremely interesting for the ways in which it signals how occupancy and requisitioning can overlap. The initial lobby shot also stands the test of time and underlines just how engrained the spatial expectations of a hotel can be while pointing to the narrative advantages of altering them, as Huston so adeptly does.

Bogart's character in *Key Largo* is a Second World War vet turned drifter whose stay in the hotel is marred by violence. William Castle's 1944 film, *When Strangers Marry*, which was re-released in 1947 as *Betrayed*, makes atmospheric use of hotel space in a way that dovetails with a similar uncertainty and rootlessness evident in the protagonists during a period when war in Europe was also changing America. The film begins with a murder at the Hotel Philadelphia before cutting to the female lead, Millie, as she travels by train to the Sherwin Hotel in New York to await her new husband – a man who is little more than a stranger on account of their marrying soon after meeting. Upon arriving, Millie coincidentally runs into a former flame played by a young Robert Mitchum, and when her husband fails to meet her on time, she begins to suspect that he may be involved in the Philadelphia murder. Ultimately, it is revealed that Fred, the ex-boyfriend, is the real killer, and after the police capture him, the new couple is free to get on with their nascent life together.

The narrative identifies both the Philadelphia and the Sherwin as hotels frequented by travelling salesmen, workers whose job requires a high degree of mobility as

well as a national hospitality infrastructure.[13] In keeping with the novel union that drives the plot, *When Strangers Marry* is full of spaces that resist traditional domesticity: from the salesmen's hotels, Paul's rented apartment in which Millie wishes to cook a meal but is unable, to the boarding house where the couple tries to hide only to be turned in by a suspicious landlady and her daughter. The film's basic premise of "marrying strangers" responds to the phenomenon of "quickie marriages" during and after the war when young people would get hitched without having spent much time getting to know each other (Mark). Millie's lack of familiarity with and knowledge about her husband combined with the multiple transitory spaces in the film such as the train, hotel, and temporary flat, contribute to this classic B-movie's suspense. That the murderer uses the hotel space for his crime and is almost successful in getting away with it only underlines the facility with which criminals employ and leverage its spatial dimensions to operate outside the law. The same qualities and characteristics that make it accessible and convenient to travellers like tourists and salesmen permit others to exploit the anonymity and transitory conditions that it affords.

During the 1960s, Jean-Luc Godard, one of the founders of the French New Wave, drew on multiple established film noir tropes for his own stylized takes on themes such as prostitution (*Vivre sa vie*) and the hard-boiled private eye (*Alphaville* and *Made in USA*). His films offer original interpretations of the characters and spaces germane to genre pictures, and in these three urban-focused works, which appeared between 1962 and 1966, the auteur's treatment of the hotel is particularly notable. Through his interpretation of the space, the viewer sees not only how Godard inflects the concept of occupancy (especially in *Vivre sa vie*) but also leverages the hotel's characteristic qualities to enhance different approaches to the noir detective film. Like Hitchcock, whose hotel films I consider separately below, these pictures by Godard actively engage with the hotel's spatial effects and characteristics.

Vivre sa vie (1962) follows the gradual fall into prostitution of Anna Karina's character Nana. From a virtuoso opening that instantly captures a couple's alienation to Nana's tragic end, Godard's psychological take on Sarcotte's exploration of the call girl life[14] is a pastiche of scenes set in a dirty, realistic Paris that is suffused with modern-day consumerism and moral decay. Nana enters the profession slowly; after being evicted from her flat she flirts with various men for favours before finally deciding to exchange sex for money *tout court*. *Vivre sa vie* recounts the consequences of that decision. It is very much a film of the Parisian streets and, not surprisingly given the hotel's prominence in sex work, the space emerges as a prominent one. That it also features significantly in the marketing of the film (figure 2.14) underlines its importance as both locale and symbol.

Nana's first time turning a trick is illuminating for the way in which Godard communicates visually the utilitarian elements of the hotel and base transactional nature of prostitution itself in advance of the extensive dialogue on the subject that will follow some minutes later. Through close-up shots and a combination of inventive and

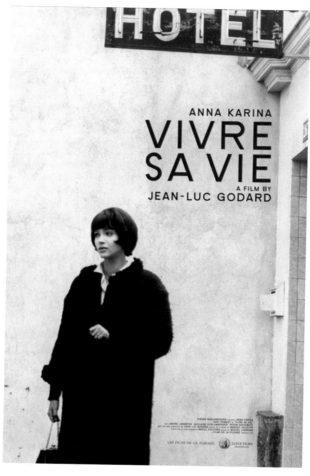

2.14 French movie poster for *Vivre sa vie*.

straightforward mise-en-scène, the director portrays Nana's initiation in an extremely accessible way to the viewer; we learn along with her. The scene begins with an almost-surprised Nana effortlessly acquiring a john on the street. The man, who has clearly done this before, knows which hotel to use. Godard then cuts to a shot of the two of them inside the cramped "lobby," which is far from the glamorous space of more illustrious establishments. In the foreground, Nana looks to an unseen figure in the office who, without prompting, asks if she would like room 27 or 28. No training is needed here; the mechanics of the sex hotel function automatically, regardless of the experience – or lack thereof – of the girl presenting herself at the door. Simultaneously, the position of the camera and location of the mirror invert Nana and her john (figure 2.15); the reflection of the man in the same space occupied by the male manager creates a doubling effect, with the angle eliminating her own reflection

and thus diminishing her presence as a subject and further reinforcing the economic, physical, and symbolic power that men hold over her. For Nana, this hotel is a threshold from which there will be no return.

Once the two of them have moved to the sparse ground-floor room, Godard's camera lingers on the slightly turned-down bed and the modern lines of the suspended nightstand and small reading lamp (figure 2.16). In the light of day, the furnishings appear sanitized – a sense that the camera underlines even more when it approximates Nana's gaze in a POV shot that comes to rest on a small towel and bar of soap conveniently left for her to clean herself between tricks. When talk turns to money, the neophyte Nana is uncertain as to the rate. Upon hesitantly naming her price, the man pauses before sliding his right hand into his trouser pocket for the bills. Godard is unambiguous in his framing of this shot as he positions the man's groin front and centre, thus creating an obvious connection between his sex organ and the money he is about to spend. What is more, beside and behind him, an ashtray sits on the stand, a gleaming recipient for the phallic cigarette that he is smoking.

Once Nana comes under the power of the charismatic pimp, Raoul, she and the viewer learn more of the intricacies surrounding the prostitution industry and the centrality of the hotel comes to the fore. In contrast to the first hotel room scene, the second time now sees Nana turning down the bed herself and money being freely exchanged – even if Godard's framing of the transaction dehumanizes the two participants by reducing them to sets of hands exchanging cash (figure 2.17).

Following this scene, Godard strings together a series of shots of Nana with different men as she and Raoul converse in voice-over regarding how prostitution works in France. He describes the routine in detail and includes the rather repulsive observation that "usually only the towels are changed between tricks, not the sheets." Raoul's answers and tone are rational and matter-of-fact. As Cannon points out: "The film treats prostitution as if it were a job like any other, not only in the 'hours and conditions' dialogue between Raoul and Nana, but also in brief exchanges between prostitutes, complaining about the facilities in the hotel rooms or in Nana's letter to a provincial brothel-keeper which outlines her qualifications as any job application would" (288). The sense that prostitution is simply a service job is reinforced in chapter 10 of the film when one of Nana's customers decides that he wants to include another woman in their session. The camera follows her into the hallway, trailing behind as she peeks into successive rooms looking for a free girl. The visual effect of her making the rounds casts the viewer even more deeply into the role of voyeur as we are made privy to various scenarios being played out behind closed doors (figure 2.18). The ancillary effect of this sequence, though, is to portray the women as mere workers in their "cubicles" or offices.

Godard's matter-of-fact, behind-the-scenes approach to prostitution casts the hotel in a new light. By taking the viewer inside these cheap hotels, the camera and the director's eye strip away any stereotypical glamour that may cling to the sex industry.

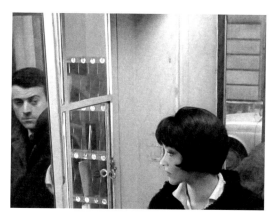

2.15 Sex hotel lobby. *Vivre sa vie*. Dir. Jean-Luc Godard, 1962.

2.16 Sex hotel room. *Vivre sa vie*. Dir. Jean-Luc Godard, 1962.

2.17 Open transaction. *Vivre sa vie*. Dir. Jean-Luc Godard, 1962.

2.18 Nana looks for a second prostitute. *Vivre sa vie*. Dir. Jean-Luc Godard, 1962.

And while *Vivre sa vie* does contain its highly stylized and exuberant moments – such as Nana's famous dance in the bar or the sudden shootout in the street – the cold, impassive look at the space of the hotel and the women who occupy it is what lingers. *Ménilmontant* may have hinted at this sordidness but *Vivre sa vie* takes the viewer inside the building, thus inflecting our conception of occupancy once again.

Whereas *Vivre sa vie* shows the dingy side of Parisian hotels, Godard's science fiction classic *Alphaville* provides access to the luxurious Hotel Sofitel Paris Le Scribe, which here doubles as the Grand Hotel, base of operations for hard-boiled private eye/secret agent Lemmy Caution. Described in the Criterion DVD blurb as "a cockeyed fusion of science fiction, pulp characters, and surrealist poetry," this low-budget film was shot mainly at night so as to avoid the need for special effects. The futuristic tale, which revolves around Caution's efforts to destroy a totalitarian supercomputer in a far-flung city, is a case study in atmosphere. Hotel space once again figures prominently, and in addition to the modern Sofitel, which features in many scenes, the protagonist also visits the darker, more sordid Red Star Hotel, which is pointedly described by one character as being on the "other side of the bridge." It is there where Caution finds Dickson, who furnishes him with a copy of Paul Éluard's *The Capital of Pain*, the collection of surrealist poetry that will be the supercomputer Alpha 60's eventual undoing.

Lemmy Caution's arrival in the lobby of the Grand Hotel is dynamic; the camera tracks alongside as he drops off his famous white Ford Galaxie and then accompanies him through the revolving door. From there, the brusque manner of the protagonist runs up against the odd situation in the hotel. Caution is assigned a "Seductress" who escorts him on the long walk through interminable halls to his room. Once there, she turns down the bed, removes her jacket and offers to take a bath with him while he unpacks. The gruff Caution rebukes her and then suddenly becomes embroiled in

a fight with what the script identifies as a "Detective" (Godard 19). At first, the two men battle in the bathroom to an incongruous classical soundtrack before Caution flees into the bedroom pursued by the assailant, who smashes the internal suite doors trying to get at him. Eventually, Caution grabs his gun and fires. The man flees and the viewer is uncertain as to his fate. The peculiar setup of the suite, which contains multiple rooms – and even has a jukebox in a small atrium – combined with the odd Seductress and sudden appearance of the Detective casts the space of the hotel room as far removed from the stereotypical urban sanctuary for the weary traveller. In Godard's futuristic city, the hotel is a site of pervasive surveillance and potential violence even in its most intimate spaces.

The oddness continues when Caution, who has rebuffed the woman's advances, has her sit in a chair while he takes photographs.[15] He then instructs her to hold a nude pinup of a woman above her head. With a quick cut to a car driving in the street, the scene returns to the room with a close-up of Caution lying on the bed reading *The Big Sleep*. Suddenly, he raises his weapon and fires two shots through the breasts of the pinup girl. With that done, he admires his handiwork before pushing the Seductress out of the room, at which point the artificial voice of Alpha 60 comes over the bedside intercom and informs him that Natasha von Braun, played by Godard's muse Anna Karina, has arrived to see him.

While the first hotel featured in *Alphaville* sports an odd mix of violence, displaced sexual energy, and an odd physical layout, the second, the Red Star, is equally quirky. Rather than having expansive, brightly lit spaces, this marginal establishment is cramped and dark. As figure 2.19 shows, though, it too is replete with strangeness. Caution's first glimpse of the lobby is of another seductress calmly having her thigh caressed by a man who casually eats dry cereal. By this point, the viewer may be becoming accustomed to the peculiar nature of Alphaville, but still, the odd takes on familiar settings serve to destabilize the conventions of genre. Godard succeeds in creating a world that, while anchored in an identifiable, nocturnal Paris, is sufficiently different to suggest the fantastic yet at the same time familiar enough to allow him to leverage our expectations in order to produce something new. *Alphaville* portrays a futuristic world in which a director who has mastered intertextual influences has tweaked genre codes, resulting in an entertaining portrayal of an alternative world. As the space where the viewer's surrogate traveller arrives, the hotel serves as a foothold that we intuitively understand. By using an ultramodern building such as the Sofitel and further casting it as a space in which surveillance and violence can occur at any time, Godard initializes the destabilization that he will project throughout the picture. Once more, the hotel is a key space not only in the narrative of a film but also in its stylistics and form; by making it strange, the director offers an implicit commentary on our relationship to it and the way it can condition our entry into new situations.

Also worthy of mention is Godard's *Made in USA* from 1966 in which he would return once more to the space of the hotel for another stylistic take on a genre film in the

2.19 Lobby of the Red Star Hotel. *Alphaville*. Dir. Jean-Luc Godard, 1965.

French New Wave style. An idiosyncratic homage to classic film-noir crime capers, the picture is exuberant and extremely colourful. Jointly inspired by Howard Hawks's *The Big Sleep* and Richard Stark's Parker series novel, *The Jugger, Made in USA* opens with the protagonist, Paula Nelson, in an "Atlantic City" hotel room. The character, who is based on the Bogart style of detective, is there to meet her lover but instead encounters the mysterious Mr Typhus. When she learns that her paramour may be dead, the intrepid protagonist begins to investigate. Later, Typhus and his niece are found shot in their room, thus turning the hotel itself into a crime scene. In keeping with its common usage in noir, the hotel interior in *Made in USA* is employed as a traditional site of encounter and as a zone where disparate people can meet. However, through Godard's liberal use of colour, which makes the location and wardrobe so noticeable, the space becomes the focus over the plot. In this way, the director once again implicitly questions the stylistic codes that we associate with a film ostensibly of this type. What does it do to *noir* when the sets are so bright? How are the viewer's expectations vis-à-vis the private eye challenged when she is presented as perhaps the most brilliantly dressed dick in the history of film? *Made in USA* employs multiple strategies – such as a lack of narrative coherence and challenging imagery – to confound the spectator and present Godard's view of the world as seen through his version of the hard-boiled lens. I would argue, though, that his deployment of such a modified hotel space right from the beginning is a key part of the film's disruptive tone. As such, the hotel in *Made in USA* makes for a playful counterweight to those employed by Godard in the much more serious *Vivre sa vie* and the futuristic, dystopic *Alphaville* (figure 2.20). A common space transformed by the vision of the director, the attention that it draws in the hands of the French auteur reminds us not only of the artifice of film but also of the plasticity of one of modernity's most ubiquitous spaces within the cinematic tradition itself.

2.20 Bright colours. *Made in USA*. Dir. Jean-Luc Godard, 1966.

Identity Issues: Hitchcock's Hotels

Alfred Hitchcock's prodigious output and innovative style, which he maintained over some fifty years, place him in a cinematic category all his own. Known as the "master of suspense," the British director pioneered many of the techniques that have become standard tools in the creation of psychological thrillers. Famously celebrated by François Truffaut and the French film magazine *Cahiers du cinéma*,[16] Hitchcock would not receive the same level of respect in the UK and US until later in his career. Nevertheless, his status as an auteur cannot be denied, and his filmography is replete with works that have become recognized as classics.[17]

Given the extensive nature of his oeuvre, it is not surprising that several of his films would make use of hotels as locations. That the ones that do revolve around questions of identity, either mistaken or hidden, is intriguing and is further testament to the hotel's spatial characteristics and the non-permanence intrinsic to occupancy. Whether they are glamorous (*North by Northwest*) or seedy (*Vertigo*), Hitchcock's hotels offer insights into the ways in which the cinematic version of the space contributes to narrative questions of identity and the notions of presence and absence that fuel suspense while also playing a role in Hitchcock's recurring treatment of the cinematic gaze.

The film that establishes the archetype of the Hitchcockian hotel, *Young and Innocent* (1937), has been somewhat overlooked, coming as it does between the popular *The 39 Steps* (1935) and *The Lady Vanishes* (1939) (Hutchinson and Paley) and surely also because of its use of blackface. The tale of a man falsely accused of murder, the film mixes virtuoso set pieces and an amiable cast in a plot structured around a double chase. This picture may not have garnered a lot of critical attention, but it is remembered for the tour-de-force crane shot that begins the climactic sequence of the film and is important to consider here for the insights regarding hotel space that it provides.

This extended shot begins with a high angle that takes in the busy lobby area where concierges attend to guests and a bellhop to some bags. The crane-mounted camera then moves over the wall to the frenetic ballroom (figure 2.21).[18] In this way, Hitchcock instantly gives the viewer a privileged perspective of the variety possible at any given moment in a busy hotel. From this point, the camera leads the viewer slowly yet surely directly into the eyes of the real killer, who is hiding in plain sight as the black-faced drummer in the house jazz band.[19] The resulting shot is one that drifts from an impersonal establishing view of the architecture to the ultra-specific psycho-logical narrative involving the killer's give-away twitching eye. The hotel is implicated in the suspense through its accommodation of the bustling, anonymous crowds – the same characteristic that permits the felon to hide. What is more, the initial visual cod-ing of this area as one of privilege and segregation is further underlined by the pres-ence of the character Old Will, who stands out for his shabby dress, Cockney accent, and complete ignorance of the codes of upper-class behaviour. This is an important point in the plot given that through Will's presence, Hitchcock sets up a sly situation in which police activity regarding this lower-class intrusion is misread by the nervous villain. The anxiety stimulated in him not only by the amateur sleuths who are getting closer but also the increasing movements of the police becomes too much and he suf-fers a breakdown. Social expectations relating to hotel space – and not only *who* may occupy it but *how* – thus contribute directly to the plot's climax.

Between 1956 and 1959, Hitchcock directed three films in which the space of the hotel and the ways in which he employed it are important either narratively or stylis-tically in the elaboration of characters' identities. While the treatment of the tourist hotel in his remake of *The Man Who Knew Too Much* (1956) is more incidental and plot-driven, its use in *North by Northwest* (1959) builds on Hitchcock's earlier han-dling of the space and ties in directly to the play of identity at the core of the film's intrigue. The third film from this period, 1958's *Vertigo*, exploits other aspects of hotel space and occupancy in the director's exploration of the identity issues of one of the protagonists.[20] Brief close readings of specific points in these films show the extent to which Hitchcock was able to incorporate the hotel and the experience of the space into his films and deploy them both visually and thematically as he played off its fa-miliarity and at times uncanny domesticity.

In *The Man Who Knew Too Much*, a luxury tourist hotel in Morocco is a meta-phorical oasis for an American family confronted with intimidating Others. At the same time, it is the site of a scene that, while showing the uneasy yet growing relation-ship they have with the mysterious Bertrand – who turns out to be a French agent – adds a shade of menace to what is an idyllic retreat from the perceived chaos of Marrakesh. The sequence begins with the camera entering the room as Jimmy Stewart adjusts his tie and Bertrand waits in the background near the terrace holding a mar-tini. The camera pans to the right to show Doris Day also getting ready for the evening and then follows her into an adjoining room where she sings "Que sera, sera" with

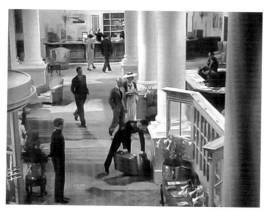

2.21 Beginning of crane shot. *Young and Innocent*. Dir. Alfred Hitchcock, 1937.

her son, Hank, as he gets into his pyjamas and robe. The presence of Bertrand during the rather private act of the family's preparations gives the situation a slightly off tone but also reminds the viewer of the versatility of a space like the hotel room, or in this case a suite, which, while incorporating elements of domesticity, is flexible enough for other spatial practice as well, such as entertaining. The modification of domestic routine is further underlined by the arrival of a room service meal for the boy and word that the manager – rather than the parents – has arranged for a babysitter. The camera then follows Day onto the terrace where she joins Bertrand for a drink. Suspicious of him and prying for information, she is nonetheless stymied by his elusive replies. During this part of the scene, Hitchcock frames the Frenchman with the shadow of the Moroccan lattice of the terrace (figure 2.22), thus underscoring his mysterious identity with "exotic" architectural flourishes of the hotel that communicate its dual resonance both as part of the local vernacular and as protective retreat and staging space for foreign visitors' forays into the city.

Bertrand's interrogation ends when a knock on the door sounds and Day opens it to reveal a man obscured by the darkness. The camera zooms in to focus on the new arrival's seeking gaze and then cuts quickly to his point of view from the entrance (figure 2.23). When he spies the mysterious Frenchman situated between the two Americans in a mise-en-scène reminiscent of the first shot of this hotel room scene, the unknown caller hastily explains that he is looking for a "Mr Montgomery" and abruptly takes his leave. The incident spurs Bernard to cancel dinner plans, further ratcheting up the mystery surrounding him. The next time the family will see this man, he will die at their feet in the Jamaa el Fna square after having passed on the warning of a coming assassination attempt to Stewart's character – the information that will result in the kidnapping of Hank and propel the rest of the film. Thus, while brief, the use of the hotel as a location in *The Man Who Knew Too Much* is telling for

2.22 Lattice shadow. *The Man Who Knew Too Much*. Dir. Alfred Hitchcock, 1956.

2.23 Point of view at the door. *The Man Who Knew Too Much*. Dir. Alfred Hitchcock, 1956.

how it contributes to the building of suspense. As always, Hitchcock's blocking of the actors and choice of angles is at the heart of his mastery of the thriller. Here, though, he also displays his remarkable sensitivity to both the space of the hotel and the effect of disrupting its perceived intimacy and safety.

In *North by Northwest*, well-known tourist hotels like the Plaza in New York and the Ambassador East Chicago are integral parts of the film's action and the case of mistaken identity that drives the plot. The trouble begins for Cary Grant's Roger Thornhill when he decides to send a telegram from the Plaza's famous Oak Bar. He raises his hand and calls over a server, but unfortunately, this act coincides with the exact moment of an announcement paging a certain "Mr Kaplan," who it turns out is the target of foreign spies. Thornhill is summarily whisked away by lurking agents, putting in motion a story that will see the hero wanted for murder and on the run while also

trying to track down the elusive man for whom he has been mistaken. Hotel spaces and others that resemble it like the UN building and a passenger train, are fundamental settings in *North by Northwest*, but what really makes this film stand out from Hitchcock's other hotel films is that the "MacGuffin" here is the Kaplan figure himself. Upon Thornhill's capture, the ringleader of the foreign agents, who believes the protagonist to be the man they want, tells him that they have tracked him (Kaplan) from city to city across the United States and now have finally caught up to him in New York. The chase has been a litany of hotels: The Sherwyn in Pittsburgh, Philly's Benjamin Franklin, the Statler in Boston, Whittier in Detroit, the Plaza, the Ambassador East, and finally the Sheraton Johnson in Rapid City. Thornhill's protestations that he is not who they think he is are rejected, and after having survived a murder attempt at the hands of these foreign operatives, he goes looking for the elusive Kaplan himself. At the Plaza he easily gains access to the man's room and is even greeted by name by the staff. In one funny yet suspenseful moment, Thornhill answers the ringing phone in Kaplan's room: "I'm not Mr Kaplan," he objects again, only to be rebuked once more: "Of course not. You answer his telephone. You live in his hotel room …"

It is only after Thornhill is on the run and mistakenly wanted for the murder of a UN official that the viewer learns the truth about Mr Kaplan. Through a rather clunky expository scene, we are told that he is indeed a phantom, a fictional construct of a US government intelligence outfit desperate to create a red herring to protect their undercover source who has managed to infiltrate the gang of spies. As the agency chief observes, they have gone to great lengths to invent "elaborate behavior patterns" and have even moved props belonging to the fictional guest in and out of hotel rooms across the country. Mr Kaplan, around whom the case of mistaken identity revolves, does not actually exist. He is an invisible hotel guest who nevertheless occupies space, a perfect visitor who, aside from laying out a few belongings and asking for occasional dry cleaning to enhance the illusion, never requires the linens to be changed.

North by Northwest also makes use of two other hotel-like spaces as important settings: the UN building in New York, with its grand entrance, front desk, and lobby space (figure 2.24), and the 20th Century Limited train on which Thornhill meets Eve Kendall, the government agent embedded in the foreign cell, who becomes his love interest. One is architecturally similar to the hotel, while the other, although literally transitory, offers the same variety of spaces (public restaurant cars and private rooms) that permit character development and also increase the suspense. These spaces notwithstanding, the film's main contribution is the imaginary guest, Kaplan – an inspired construct whose immateriality is, ironically, immaterial given his existence in the hotel registers and through the seeming traces of life that are staged in the rooms "he" does not actually fully occupy. As in real life, a hotel room paid for is one effectively occupied whether one physically appears there or not.

Vertigo, which Hitchcock released in 1958, has been lauded as the best film ever made.[21] In addition to the fear of heights alluded to in the title, the story revolves

2.24 United Nations lobby. *North by Northwest*. Dir. Alfred Hitchcock, 1959.

around the protagonist's obsessive desire to recreate the ideal image of a dead woman with whom he had fallen in love. That two hotels are part of the pursuit and transformation of Judy back into her Madeleine persona adds yet more texture to the overall treatment by Hitchcock of hotel space and its occupancy.

The first hotel in the film is the McKittrick, where the protagonist Scottie trails Madeleine and discovers that she signs in under the name "Valdes" only to go and sit quietly in her room. The moniker belongs to that of the woman of whom she supposedly believes herself to be the reincarnation. Here we have three levels of representation: Judy playing Madeleine, who in turn is playing Carlota Valdes. In the overall scheme of the plot, her name in the hotel register is just part of the architecture of the fantasy needed to cover up the murder of the real Madeleine, Gavin's wife whom he wants out of the way. Thus, the McKittrick Hotel serves as an identity prop in a hoax being staged for Scottie's benefit. Judy's occupancy is an element of performance, itself a link to and key feature of the second hotel in the film: the Empire. Since renamed the "Hotel Vertigo" in real life on account of the film's success, the cinematic Empire stands out for what might be called the film's famous "transformation sequence" in which various scenes depict Judy once again becoming Madeleine so as to satisfy Scottie's obsessive desire. Both the initial scene when she agrees to spend more time with him and the culminating one of her curated metamorphosis are bathed in the eerie green light of the Empire's neon hotel sign. Here the hotel's presence and literal aura permeate the mise-en-scène, diluting the domestic feel of her long-term stay room and impregnating both phases with a sense that identity here is unstable and fluid.

Consider the moment in which she verbalizes that Scottie only wants to be with her because she looks like the woman with whom he was in love.

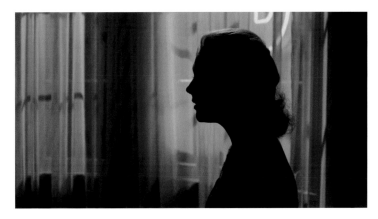

2.25 Judy in profile. *Vertigo*. Dir. Alfred Hitchcock, 1958.

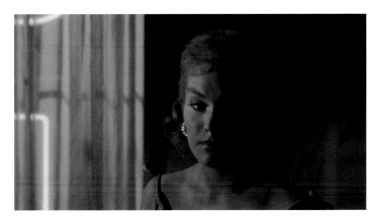

2.26 Judy's duality. *Vertigo*. Dir. Alfred Hitchcock, 1958.

The medium shot of her in profile from Scottie's point of view metaphorically ren-
ders her a blank slate for the transformation that he craves (figure 2.25). By cutting
to a different angle during her moment of hesitation, Hitchcock visually captures her
own duality and doubts about what she did once and now may do again. The light
from the hotel sign illuminates half of her face, further revealing her remorse (fig-
ure 2.26). The colour green is a leitmotif throughout the film[22] and likewise figures
prominently again during the climactic scene of the transformation sequence. With
Judy now dressed as Madeleine and with her hair dyed, Scottie insists that she put it
up as well. She enters the bathroom as the camera follows him in medium shot until
he is in a similar position to her earlier one, framed by the green-lit window and vis-
ible hotel sign. His gaze scans and comes to rest for a second directly on the camera

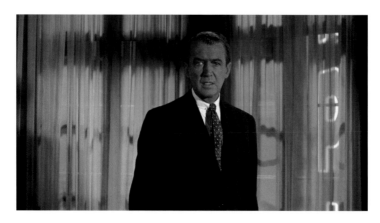

2.27 Scottie gazing directly at the camera. *Vertigo*. Dir. Alfred Hitchcock, 1958.

(figure 2.27), linking his desire to the visualizing power inherent in the lens. Then, he slumps half-seated, seemingly cognizant of the perversity of what he has done. Before he can reconsider anymore, though, the music swells, the camera zooms to a close-up on his face and then cuts to a long shot of a ghost-like Madeleine across the room.

In the famous embrace that follows, Scottie's kiss releases his memories and the couple is transported to the past while the camera appears to whirl around them before returning them to the hotel room (McGilligan 557). I would point out, though, how the initial staid and more domestic background (figure 2.28) also transforms, as she has done, reverting back to the eerie green of the hotel sign light (figure 2.29) and thus simultaneously reinforcing the otherworldly aspects of the plot and the mutability of identity in a space such as this, which was foreshadowed earlier by Hitchcock's choice of angles.

Hitchcock's masterful use of hotel space in the films examined here stands out for the way in which he integrates it so precisely into the narratives that he constructs. The British auteur's mise-en-scène speaks not only to his understanding of the hotel's multifaceted nature but also to how variations on the space can create different effects. Whether he employs it to slightly unnerve the viewer as in *The Man Who Knew Too Much*, makes it a space that is integral to the plot like in *North by Northwest*, or activates the hotel's inherent capacity for transformation as in *Vertigo*, Hitchcock shows a keen appreciation of the hotel in his visual treatment of it on film.

Sofia Coppola: A Contemporary Hotel Auteur

The hotel continues to be an attractive setting for filmmakers in the twenty-first century, and one in particular has made it a recurring locale in her work. Sofia Coppola's

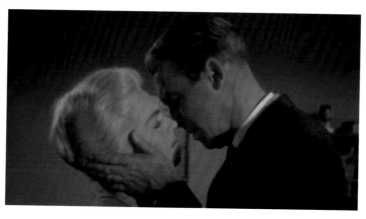

2.28 Embrace with normal background light. *Vertigo*. Dir. Alfred Hitchcock, 1958.

2.29 The couple backlit by the eerie green light. *Vertigo*. Dir. Alfred Hitchcock, 1958.

artistic engagement with the space began early. She was still a teenager when she co-authored the short, *Life without Zoe*, with her father Francis Ford Coppola, who then directed the piece as part of the anthology *New York Stories*, which also featured works by Woody Allen and Martin Scorsese. As Geoff King observes, parallels exist between the story and Coppola's own childhood upbringing given that the hotel in the film was one in which the Coppolas had resided when Sofia was little (55). This first foray into the narrative possibilities of the hotel is entertaining, and as her growing filmography attests, it has not been her last. Coppola made her reputation with three features – *The Virgin Suicides* (2000), *Lost in Translation* (2003), and *Marie Antoinette* (2006) – that all deal with what Lim has described as "young women on the awkward verge of self-definition" (Lim). For King, the women are either physically or mentally isolated to varying degrees (52). I contend that Coppola's treatment of these characteristics

reveals an appreciation of spatial matters in both her screenwriting and directing. Given this sensitivity, the fact that the hotel has become another important trope and central space in terms of setting and metaphor in her oeuvre is understandable. Coppola's use of the hotel and different forms of occupancy are varied, yet she clearly understands both its aesthetic and narrative potential. As such, readings of her "hotel films," *Lost in Translation*, *Somewhere* (2010), and *A Very Murray Christmas* (2015), provide insights into not only how the auteur makes use of this multifarious space over a variety of pictures but also how the use of the space itself continues to evolve onscreen.

To varying degrees, all three films deal with aspects of fame and personal connections. *Lost in Translation*'s treatment of an intergenerational relationship facilitated by the insulated yet still permeable space of a luxury hotel is Coppola's most popular movie and became an indie touchstone. For its part, the more languid yet still atmospheric *Somewhere* explores the ennui of celebrity in a recognizable locale that is known as both a home and a haunt for the rich and famous. As this picture makes abundantly clear, occupancy in a hotel such as this may underline one's wealth but it is a guarantee of neither happiness nor fulfilment. For its part, the Netflix holiday film *A Very Murray Christmas* uses the Carlyle Hotel in New York as a setting for an old-style episodic musical special in which Bill Murray and a cast of actors and singers are stranded during a storm. Part forced, part inspired, *A Very Murray Christmas*'s relationship to the space it occupies is not overt; still, access to both back and front of house reveals the texture of an institution that is a plot in and of itself.

As its name suggests, *Lost in Translation* is a film that highlights moments of incomplete meaning – some of them cultural, others generational. Once again, the modern hotel facilitates meetings between disparate people, in this case, the famous yet past-his-prime actor Bob Harris (Bill Murray) and the young philosophy graduate Charlotte (Scarlet Johansson). The Park Hyatt hotel in Tokyo serves as the base from which they share adventures in a city that both find bewildering. And while it acts as their refuge, the diversity of what is to be found within means that it is also a source of dislocation, a place in the city that is familiar yet just odd enough to help foster their growing sense of shared experience. Likewise, the viewer too is faced with moments that resist understanding. From the opening medium shot of Charlotte's derrière through sheer pink underwear on a hotel bed – sexual promise that will be left unfulfilled? – to scenes that invoke Japanese stereotypes – are they played for laughs or derision? – Coppola casts the Park Hyatt as a space in which the Western spectator's gaze is questioned along with those of her protagonists.

Bob Harris's status as a famous figure is established early on in the film when, during his arrival from the airport, he catches a glimpse of himself on a billboard. The film plays with this prestige as another element to be translated. While he is granted a degree of freedom from his American life, he still cannot escape mundane domestic questions about family and redecorating. Nevertheless, Japan is a place that allows him to be more relaxed, especially around Charlotte. For her part, the recent graduate

and newlywed finds herself metaphorically shipwrecked in the Park Hyatt, left on her own when her photographer husband leaves on an extended shoot. Her errancy through the space of the hotel and the city brings her together with Harris in a chaste May–November relationship. They occupy hotel rooms together, watching bizarre Japanese television and talking, but do not take their relationship any further even though they are afforded plenty of opportunity. This temperateness checks the sexual potential that hotels possess, ratcheting up the tension such that their eventual kiss, which comes out in the street during the film's climax, is cathartic.

Coppola's affection for and knowledge of hotels is clearly apparent in *Lost in Translation*. From her framing of shots to the way she uses handheld cameras and manipulates the focus, the director links her narrative to the space in ways that are both aesthetically pleasing and insightful. In her hands, the Park Hyatt not only provides for connection and introspection but also serves as a beautiful backdrop in and of itself, a world within a world connected to the outside but sustaining its own cycles.

The Park Hyatt hotel's location on the upper floors of the Shinjuku Park Tower complex means that, unlike other cinematic hotel arrivals such as in *Grand Hotel* or *Alphaville*, the viewer's introduction to the space is staggered. Coppola first shoots Bob's car dwarfed in long shot under an impersonal and sober modern awning (figure 2.30) before cutting to an entryway where Harris briefly meets his hosts and receives a multitude of cards and gifts in the first of the film's many humorous moments. Another sight gag follows immediately as the director shoots the tall American surrounded by shorter Japanese businessmen in a crowded elevator. Once delivered to the Hyatt's check-in lobby on the forty-first floor, Harris is finally able to reach his room, where he is pictured in what has become an iconic image from the film: him sitting on the bed in a robe and slippers, bewildered (figure 2.31). Meanwhile, off-screen the television shows images of flowers swaying in the wind to a classical music soundtrack.

From the beginning of the picture with its bright neon signs, reflected lights, and buildings passing by, it is clear that the cityscape will be a key leitmotif, what King identifies as "an important part of the visual fabric of the film" (102). Shot alternately in and out of focus, it helps bind scenes together and, as relates to the hotel specifically, underlines the distance that the characters feel from themselves and others – especially Charlotte. The city is both a recognizable Tokyo and a more metaphoric expanse, a veritable sea of buildings and people down below surrounding the occupants of the Park Hyatt, who are literally above it all. As we see in figure 2.31, though, the hotel's insulation is not complete. Coppola's mise-en-scène here has the window positioned at the same level as Harris's head such that it visually connects the exterior to his continuing state of confusion. When the scene shifts to the hotel's luxurious New York Bar, the skyline background grows in the screen again, framing the crooning singer as she entertains distracted patrons. Two scenes later, after the viewer has watched Bob struggle to sleep and have his American domestic environment intrude

2.30 Entrance to the Park Hyatt, Tokyo. *Lost in Translation*. Dir. Sofia Coppola, 2003.

2.31 Bob Harris and the Tokyo cityscape. *Lost in Translation*. Dir. Sofia Coppola, 2003.

2.32 Tokyo in focus. *Lost in Translation*. Dir. Sofia Coppola, 2003.

via fax, Charlotte appears for the first time since the enigmatic opening, sitting in her hotel room window, a pose that she will repeat on multiple occasions in the film. Insomnia and the cityscape are the connecting tissue between protagonists, and for a split second, the city is briefly in focus (figure 2.32) before the camera shifts to her, reducing Tokyo to a blurred, symptomatic vision of her ennui.

Interestingly, once she has fallen in love with Bob, she will sit with her back to the view, looking inward rather than out towards the vast city, a small yet intriguing shift that points to a growing connection between them that is further strengthened by an evening's talking on the bed.

Gradually, Coppola's treatment of recurring spaces changes as they become more familiar to both the protagonists and the viewer. One example of this is the turning circle where town cars drop off guests. The long shot from earlier is not repeated. Instead, the director shows the area from much closer, a touch that accents the valets and staff, or in a POV shot from within the hotel (figure 2.33), thus allowing the viewer to spy the hitherto-unseen green space across the way. For even such a banal space as this, Coppola's composition is thoughtful and connected to the ongoing narrative as she links the hotel space affectively both to her characters and to the viewer, who is getting to know the space along with them.

Lost in Translation helped launch Scarlett Johansson's career and gave Bill Murray a role for which many thought he deserved an Oscar. The film also made a character of the Park Hyatt hotel, spawning fan pilgrimages to its New York Bar. In addition, according to one critic, Coppola's picture also contributed to the revival of shoe-gaze music thanks to its atmospheric, dream-like soundtrack.[23] Through her thoughtful

2.33 View outside. *Lost in Translation*. Dir. Sofia Coppola, 2003.

composition, which keeps in mind the spatial effects of architecture and hotels in par-
ticular, combined with a script that allows hotel space to emerge in different ways,
Coppola shows that, like Hitchcock, she has a genuine empathy for this space. For
these many reasons, *Lost in Translation* stands alongside *Grand Hotel* as an iconic hotel
film, connecting the director's auteurism to one of modernity's quintessential locales.

In both 2010 and 2015, Coppola would return to the hotel as a central setting with
her feature film *Somewhere* and the Netflix release *A Very Murray Christmas*, which
hews to the style of a classic twentieth-century "holiday special." Radically different
in tone, the films nonetheless contribute to Coppola's growing status as a hotel au-
teur and offer new insights into the symbolic potential of the space as both residence
and refuge. The hotel at the geographic and narrative centre of *Somewhere* is another
famous location: the Chateau Marmont, an exclusive and well-known hangout for
Hollywood's rich and famous (figure 2.34).[24] The films tells the story of Johnny Marco,
a B-list star who lives in a limbo-like state in the Marmont until he is suddenly forced
to care for his eleven-year-old daughter. It is a deliberate and slow-paced examination
of fame and parenthood that relies on many static camera shots in its quest to repro-
duce cinematically the ennui of Johnny's life (figure 2.35). The film does not present
clear-cut answers; even the title is both specific and vague – is the "somewhere" a
geographic location or a place in the protagonist's life? However, like the ambiguity
evident in the ending of *Lost in Translation*, the meaning of *Somewhere* is indetermi-
nate yet hopeful.

Key to my interpretation is Marco's ability to finally break free of a lifestyle root-
ed in a form of occupancy that has become torpid. The Chateau Marmont, a space
that can approximate an adult playground, fits well with Johnny's initial lethargy. The

2.34 The Chateau Marmont Hotel, West Hollywood. *Somewhere*. Dir. Sofia Coppola, 2010.

2.35 Marco's ennui. *Somewhere*. Dir. Sofia Coppola, 2010.

introduction of an actual child, though, creates just enough contrast to instigate a divergence within him. The realizations regarding fatherhood that arrive in the wake of his renewed relationship with Cleo spill into his inner life. When he tearfully confesses to his ex-wife that he is "fucking nothing … I'm not a person" he is acknowledging the artificiality of a fame-based subjectivity. The hotel that he occupies is both symbolic of that persona and implicated in its maintenance. In the same way that he cedes control of his time to an agent, he lacks command of the space in which he lives. Parties seemingly throw themselves in his suite, and at one point a woman appears unexpectedly in his bed naked save for a sailor's hat. Like the physical boundaries of his hotel room, the borders of his identity are weak – if not porous – and his decision in the film's final act to move out of the Marmont is one step in his refortification of the self.

Coppola followed up her take on the hotel as long-term residence with a humorous and entertaining seasonal piece in which it acts as a temporary and improvised refuge. Set in the Carlyle Hotel in New York,[25] *A Very Murray Christmas* (2015) tells the tale of Bill Murray's attempt to host a live Christmas musical special during a massive snowstorm and subsequent power outage. With the majority of his guests missing, Murray is forced to begin on live television but breaks down from the stress. Eventually, he is saved from doing the entire show himself when it is cancelled due to the blackout. What follows is a series of songs performed in the hotel's swank Bemelmans Bar in which the protagonist joins musical forces with various members of the staff and even manages to save the rocky relationship of a soon-to-be-married couple along the way. At the end of the second act, a drunk Murray passes out and dreams that he is on the elaborate set of the Christmas special along with George Clooney and Miley Cyrus, with whom he drinks martinis and performs. When he comes to, he is still in the hotel, but as the viewer has witnessed, the show did go on.

A Very Murray Christmas is far from being a polished work like *Lost in Translation* or *Somewhere* but it is still compelling on account of the performance by Murray and the way in which Coppola goes behind the scenes in a hotel for the first time. While she does marginally include workers from the Marmont in *Somewhere*, in this musical she casts actors and singers as members of the Carlyle's backroom staff who are stranded along with the erstwhile host. The tale of the aborted TV special becomes the actual Netflix special, a tongue-in-cheek journey inside the bar and kitchens of a famous hotel, and peppered with numbers such as "Baby, It's Cold Outside," "The Twelve Days of Christmas," "Christmas (Baby Please Come Home)," and a stirring rendition of "Fairytale of New York," among others. Coppola's latest treatment of hotel space may be a light entertainment but it underlines the hotel's symbolic nature as a site of performance. On both architectural and narrative levels it is well suited for episodic works such as this and contributes to the director's hotel oeuvre.

In this chapter we have seen multiple examples of the productive and compelling history that film and the hotel have shared. From the early days of the art through a century's worth of storytelling, filmmakers have mined the narrative possibilities that the hotel space offers and in turn have shed light on the ways in which the realm of imagination can inform our understanding of what it means to occupy space. And while we may have become somewhat inured to the hotel's effects and circumstances out of sheer familiarity, when we pause to consider how it materializes on screen we are afforded a chance to re-examine the structural and social grammar of an institution that has played a key role in transculturation and travel during the past 150 years. That directors over that time have consistently made use of the full thickness of the hotel, including multiple facets of both its symbolic importance and architectural qualities, is a reminder of what a complex space the hotel is.

PART TWO

THE BUILT ENVIRONMENT

THE WARTIME HOTEL

As we have seen in the first two chapters, the hotel is a space that holds significant symbolic value. While this importance has manifested in different forms of visual art for over a century and a half, the inspiration for the paintings, photographs, and films that have featured the hotel and its varied effects, lies in the real world of the built environment. It is to that realm that we now turn. What interests me particularly here, though, are forms of hotel space that deviate from the more traditional or "classic" one associated with the traveller by choice, which by and large has conditioned and powered our understanding of the space in the popular imaginary. To that end, in the second half of this book I read the hotel as it functions under much different circumstances: first during wartime and then how it is experienced by travellers who are either detained or have been displaced against their will. Unsurprisingly, the style and tropes of these grimmer forms differ from those seen in the previous chapters, and it is perhaps inevitable, then, that the cleavage between the two requires that I employ a different tone. This is a product not so much of form but of content: the flipside of traditional hotel usage is very often bleak. Nevertheless, the overarching concept of occupancy continues to bind the different forms and inform our take on the hotel both in visual culture and in the built environment, of which it is an increasingly ubiquitous part.

Of all the ways in which the modern hotel has existed physically over the past hundred and fifty years, its incarnations and uses during wartime stand as particularly striking examples of the unique qualities of its space and of the particular symbolic resonances that it can generate. Often one of the first buildings to be requisitioned during urban conflicts, hotels have served at various times as military headquarters, embassies, improvised hospitals, and political recruiting stations[1] – not to mention as safe havens for journalists and those affected by local conflicts.[2] It would be in this latter capacity that the structure would act as a form of home base, a neutral place where agents of differing stripes could broker information. Thus, as with its close relationship to film, the hotel and journalism – especially war reporting – can be said to

have grown up together. By considering what the disruptive dynamic of appropriation does to the space of the hotel, we see the building's unique relationship to information gathering and dissemination come to the fore. In this way, I draw a line between the hotel and the various acts of looking that revolve around, emanate from, and penetrate it.

The modern city has been gazed upon by two sets of lingering eyes: those of the tourist and those of the sniper. The first takes in, sees afresh and captures; the second controls, terrorizes, and eliminates. These gazes, which spring from the modern practices of tourism and war, have played important roles in the experience of the wartime hotel and conditioned the conventions of journalism. With this in mind and beginning with Civil War Barcelona and George Orwell's multifaceted involvement there as a foundation for disparate ways of seeing, I trace the hotel's part in the development of different gazes through the horrors of Lebanon's civil war, the siege of Sarajevo, and up to the Battle of Baghdad, during which this confluence of the journalistic and sniper's gazes led, I argue, to the end of the hotel's real-world symbolic status as a secular sanctuary.

The arrival of modern urban warfare during the twentieth century accentuated the need to adjust combat strategies as wars that had been confined previously to extra-urban battlefields began to have a direct and immediate impact on the city. Urban warfare, or FIBUA (Fighting in Built Up Areas), changed the scale of conflicts. Battlefields and strategies changed. As a result, the built environment is now as intimately linked to command and control during periods of urban conflict as natural geography in conventional battlefield clashes.[3] While all localized war affects normal day-to-day activities and routines, FIBUA disrupts supplies, services, and communications while endangering non-combatants to a much greater degree. Under the catastrophic circumstances that immediate war imposes there inevitably occur important changes in how citizens and visitors alike experience the urban environment. Urban warfare's alteration of daily life creates a state of flux that makes possible the literal occupation of space for new – and potentially ideologically charged – practice. This requisitioning and occupation of space responds to very tangible considerations of use, need, and convenience. As was evident with the Havana Hilton, which inspired Burt Glinn, Deena Stryker, and Ramón Serrano,[4] the hotel's unique architecture not only makes it a meeting place for local and global but also enables its potential as a staging ground. Given the unique temporality that the hotel holds as a site where time and space come together in a unique way, its transformation during wartime is particularly compelling. This is especially so when one considers that the inherently interactive nature of the hotel's semi-public spaces facilitates the assimilation and dissemination of information. Before the advent of the smart phone, hotels were essential locations in or near conflict theatres on account of the availability of local contacts or "fixers," international press, and communication technologies such as phone banks, telexes and faxes. Hotels have long been haunts for journalists as well as tourists, and even

more so during periods when urban warfare has changed the normal rules of life in a city. It is then when services that were appreciated by the tourist during peacetime become strategic lifelines for the wartime reporter. Directions, access to translators, and recommendations of where to go all take on a new meaning. When one considers that hotels tend to have an even greater military value in an urban campaign, the gap between what at first blush seem to be the very disparate gazes of the tourist, journalist, and, unfortunately, the sniper, becomes lessened. The connections between them will become more evident with the specific case studies of Barcelona, Beirut, Sarajevo, and Baghdad.

Civil War Barcelona

During the Spanish Civil War (1936–9), combat took the form of both battlefield engagements and inner-city fighting. Civil War Barcelona stands out as a unique example of how local social and state political factors combined to create a situation in which the stakes of the urban conflict were higher than ever before; the success of the anarchist revolution, which denoted the beginning of a new phase of the Catalan experience of modernity – one diametrically opposed to the previous organization of society and its veneration of capital, property, and social organization based on a state model – was keenly tied to the control of important urban spaces and buildings.

Thus, the hotel, which had served as an important symbol during the crucial civic period of 1888's Universal Exhibition in Barcelona and then helped to facilitate cultural exchange and social mimicry by the classes that dictated the course of Catalan liberalism and capitalism during the Roaring Twenties, became implicated in a new process of experiencing the city.[5] While the hotel's functional and symbolic value may have appeared to be set by the elites, the general transformational power of urban war on social organization within the Catalan context shows that the space in Barcelona was equally adaptable to the empowering and organizing purposes of the working classes during this revolutionary period. Again, this was possible because wartime, like sudden regime shifts of any type, affects the established social bonds that are codified in the rule of law and ritualized in space. It does so not only by interfering with the routine and continuance inherent to spatial practice, but also by destabilizing previously accrued civic meaning and placing in balance the ability to create and enforce new associations.[6] More so than overt shelling, sniping by the various militias during this period of flux was an integral part of this effect in that it suppressed activity through both its deadly presence and even the mere threat of its existence. It added obscene teeth to the more banal demarcation of space that had been done with flags, painted slogans, and makeshift barricades. Employed as a general strategy – not as a targeted assassination scheme – against civilians and combatants alike, sniping

permits the consolidation of acquired or apprehended space in a contested area where either outright victory is not yet possible or where guerrilla actions may be under way.

The Hotel Colón in Barcelona, which was taken over by the socialist PSUC (Unified Socialist Party of Catalonia) at the beginning of the Civil War, is an excellent example of what can happen to a hotel during urban war (figures 3.1, 3.2). When combat erupted and the front effectively *became* the city, the hotel's central, "close to everything" location as a traveller's space and one of global/local confluence, transformed into more than a purely socially strategic location.[7] As a tactical site in a military sense, the hotel's value lay in how it could facilitate a force's capacity for visual surveillance and consequently its ability to control the city centre, access to transportation systems, communications, and symbolic monuments and buildings. In the requisitioning of the Colón and the fighting around it one sees at once the convergence of the strategic importance of the hotel as a modified command centre and the capacity of sniping to enforce the important divvying up of space that the conflict caused. Implicated in this radical shift in usage, the potential of the tourist structure as a site of viewing cannot help but change as well, for requisitioning alters the existing civic meaning and use of space and in this case, turned vistas over the main square and side streets into sightlines – an early example of how the potential gaze of the tourist and that of the sniper could overlap.

Unlike the requisitioning that had occurred during the First World War – or even that was occurring five hundred kilometres away in Madrid – in Barcelona, the state was no longer the sole agent in adapting civilian spaces for military use. Instead, organized parties, emboldened by the weakness of the remaining central government and their own capacity to equip paramilitary groups, began to consolidate through force of arms both their political positions and the command of key spaces and thoroughfares within the city. Even though hotels are prime candidates for requisitioning and are easily converted into bases of operations for political parties and irregular militias, their inherent nature as in-between spaces does not change. The building maintains its potential to function as a hub and a conduit between local and global. What shifts is its use value as new agents bring different behaviour and practices to the space.

In his essay on the ways in which Berlin and Bucharest have dealt with their totalitarian pasts and their respective architectural legacies, Neil Leach identifies possible mechanisms for the symbolic reappropriation of built space. Central to his argument is the recognition that both context – "the 'social ground' of architecture" – and use are key determinants in the generation of meaning (Leach 83). In reference to the possible divestment of meaning in a political sense, Leach builds from Jameson's contention that architectural form is "inert,"[8] stating: "Political content is 'projected' on to form. Political content is therefore a question of allegorical content. It is dependent upon a memory of what a particular form is 'supposed' to mean, and as that memory fades, so the meaning is erased" (83). Of course, the situation in Catalonia during the Civil War is not an exact fit to that of postwar Germany or a newly democratic

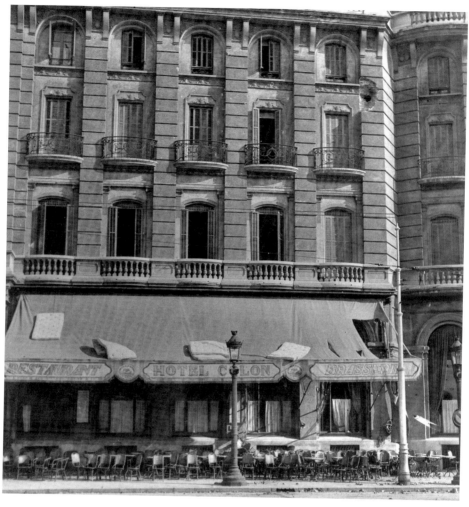

3.1 *Battle at the Hotel Colón*. Pérez de Rozas, 1936. Arxiu Fotogràfic de Barcelona

Romania, not least of all because hostilities were still ongoing and thus many actions could and should be construed as strategic within the rubric of a military or social campaign. The pace of change during wartime is different than that during the aftermath of radical alterations in social relationships. There is no time to wait for the fading of memory to take place that Jameson describes; if alteration is to occur, previously accrued civic meaning must be challenged immediately, if not forcibly erased by the new political power.

So what of the hotel's relevance as a symbol? Dominion over the symbolic and the power to dictate associations lie precisely at the heart of Leach's social grounding of

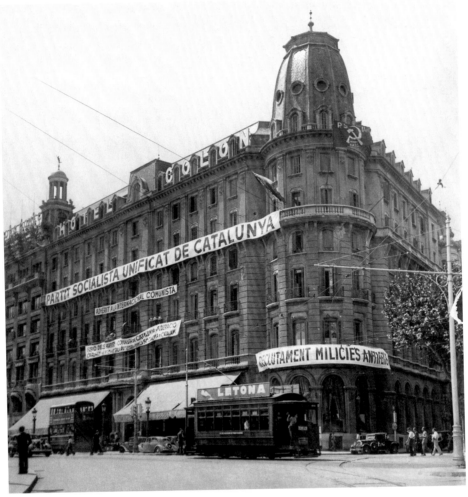

3.2 *Hotel Colón Requisitioned*. Pérez de Rozas, 1936. Arxiu Fotogràfic de Barcelona

the built environment. It is especially significant in the case of Barcelona's grandest hotels at the time of the Civil War – the Colón and Ritz – as their symbolic importance places them in the same category as more traditional monuments and overtly political buildings like palaces or parliaments. Even though the frivolities of the upper classes on display in a grand hotel may seem far removed from the blatant oppression of a dictatorship, the specific context of Catalonia is instructive once more. From the point of view of the trade unions, these classes had been engaged in an often brutal war with the Catalan elite for the better part of half a century. Thus, as an around-the-clock site of upper-class luxury, the grand hotel carries a lot of ideological baggage in that it denotes the conspicuous consumption and frivolity of those who controlled

the majority of wealth; as a space it is a monument to hegemony. Here, qualitative shifts in experience and especially in aesthetic modifications invoke the possibility of erasure as well as the receptive elements inherent to the dynamics of the generation of meaning. In the case of the Hotel Colón and the Ritz, a unique switch occurs: the dynamics of the frivolous, elite Jazz Age style that the cosmopolitan space of the hotel had helped propagate from America to Central Europe and beyond are replaced by the codes of international socialism and anarcho-syndicalism. In becoming centres for the proletarian struggle, egalitarian mores bring down the pompous theatrical scenery of the grand hotel and effectively "liberate" one of the most prized and socially restricted spaces of the plutocracy. Not only were those who had toiled behind the scenes now recognized, as is evidenced by the FOSIG's (Workers Federation of Trade Unions of the Gastronomic Industry) plan to transform the hospitality industry and "remove ostentation," the clientele, as well, were to be placed on the same equal footing (Miguelsanz i Arnalot 83). That the Colón was also a recruiting station for young revolutionaries shows how the innate theatrical nature of the hotel could not be fully suppressed. The "set" of the former capitalist dream may have changed to one displaying the socialist ideal, but the stage remains all the same.

The aesthetic transformation that accompanied the ideological one was straightforward but at the same time is suggestive in terms of the process of reappropriation at work. Located in the heart of Barcelona on the Plaça de Catalunya, the Hotel Colón was at the centre of the combat that occurred when Francoist forces initially attempted to take over the country (figure 3.1). An examination of the facades shows them to be festooned with banners and posters, visual markers and proclamations of both local and international allegiance (figure 3.2). The different messages on the Colón create an interesting palimpsest in which its name, a key to its accrued sense of place even after renovations and ownership changes, is still very much visible as a marquee trumping the improvised signs. The adornment of the facades in such a manner suggests two things: first, that, conscious or not, reinscription of this type represents an attempt to overwhelm the previously denoted social meaning of the edifice; and second, it points to the simple fact that, as a trophy in an urban and social battle, the Colón makes an ideal billboard.

As for the Barcelona Ritz, when the Spanish Civil War broke out, it was the first hotel collectivized as part of FOSIG's efforts to eliminate pretension in the hospitality industry. However, the "Ritz" name was problematic; it was too synonymous with aristocratic and capitalist ideals, and so the new proprietors promptly gave it a different moniker: the decidedly utilitarian and banal "Gastronomic Hotel #1" (figure 3.3). As with the Colón, banners were hung, but the original name, which remained loaded with its associations to privilege and wealth, remained visible, carved into the stone at the top of the building's facade and on a plate by the door. However, what pointed to the real durability of the old associations, not in stone, but in policy, was the insistence shown by both the Catalan Generalitat and, later, the displaced Madrid government

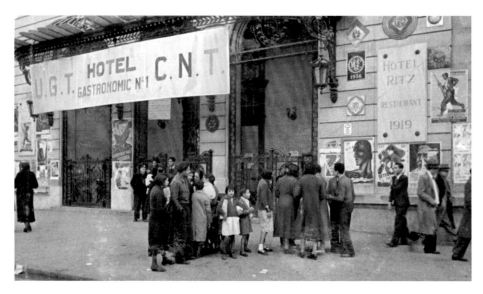

3.3 *Citizens Waiting outside the Doors of the Public Cafeteria Installed at the Ritz Hotel in Barcelona.* Anonymous, 1936. Arxiu Nacional de Catalunya

that the Ritz resume its functioning as a place of social privilege. The regional government was first to put it back into service when it wrested control of the building away from the unions in early 1937 with a seizure carried out somewhat ironically under the Collectivization Decree (Miguelsanz i Arnalot 85). Then, with the establishment of the central government in Barcelona near the end of the war, the Generalitat was evicted as state military officials and foreign diplomats moved in.

Orwell on the Fronts

It was into this atmosphere of revolution and transformed urban spaces that a young George Orwell arrived ready to combat fascism. In his subsequent book, *Homage to Catalonia* (1938), the author would relate his wartime experiences as a member of the POUM (Workers' Party of Marxist Unification) militia in both the countryside and the city. While Orwell's hybrid text does mention different hotels and the processes of requisitioning, I argue that it is especially compelling for the insights that it provides in terms of the nascent overlap of the gazes of the sniper, tourist, and media – ways of looking that later in the century would become much entwined with the wartime hotel specifically. In this way, I propose that *Homage to Catalonia* serves as a foundational document, one in which all three of these gazes are represented not only in a single text but also in the experience of one man, and that as such it merits a brief excursus.

George Orwell's vantage point changes both literally and figuratively in *Homage*. The book begins with the author firmly rooted within the military theatre perspective. This stance inflects the majority of the work and makes his later shift to a tourist position, which is patent only once the author has been discharged from active service, even more suggestive. The postponement of this non-lethal type of looking notwithstanding, the fact that Orwell not only observed Catalonia as a journalist and tourist but also was himself on both ends of a rifle's scope is what gives *Homage* such weight in terms of these three ways of seeing that would come to shape the twentieth century. Containing as it does elements of overt war reporting and testimony, such as first-hand accounts of the sniper's view, before culminating in a touristic gaze, *Homage*'s overlapping of military and civilian perspectives anticipates the sort of mixing of visual codes that theorists Jean Baudrillard and Paul Virilio would describe in their works from the 1980s and '90s.[9]

The military gaze in the book is detailed and gives an accurate representation of combat on the rural and urban fronts. Orwell's first-hand accounts are especially interesting when it comes to his time spent sniping at fascists. The Englishman's nonchalance points to more than simply the monotony and arbitrariness of war; it indicates also a desensitizing to violence more redolent of the late twentieth century than the Spanish Civil War's mythical "good fight." Consider his tone as he relates his experience as a sniper:

> In the daytime we sniped from no man's land. By crawling a hundred yards you could get to a ditch, hidden by tall grasses, which commanded a gap in the Fascist parapet. We had set up a rifle-rest in the ditch. If you waited long enough you generally saw a khaki-clad figure slip hurriedly across the gap. I had several shots. I don't know whether I hit anyone – it is most unlikely; I am a very poor shot with a rifle. But it was rather fun, the Fascists did not know where the shots were coming from, and I made sure I would get one of them sooner or later. (143)

Orwell's description of the "fun" of being the one in control of the sniper encounter ends abruptly, though, when he describes in chilling detail what it was like to be on the other end of the experience:

> However, the dog it was that died – a Fascist sniper got me instead … I was talking to the sentries preparatory to changing the guard. Suddenly, in the very middle of saying something, I felt – it is very hard to describe what I felt, though I remember it with the utmost vividness.
>
> Roughly speaking it was the sensation of being at the centre of an explosion. There seemed to be a loud bang and a blinding flash of light all round me, and I felt a tremendous shock – no pain, only a violent shock, such as you get from an electric terminal; with it a sense of utter weakness, a feeling of being stricken and shrivelled up

to nothing. The sand-bags in front of me receded into immense distance … I knew immediately that I was hit, but because of the seeming bang and flash I thought it was a rifle nearby that had gone off accidentally and shot me. All this happened in a space of time much less than a second. The next moment my knees crumpled up and I was falling, my head hitting the ground with a violent bang which, to my relief, did not hurt. I had a numb, dazed feeling, a consciousness of being very badly hurt, but no pain in the ordinary sense. (143–4)

Orwell's description of what it is like to be the victim of an unseen sniper – to be at the singular ground zero of a combat event characterized by surprise and lingering – is powerful and evocative. He suggests an analogy to being hit by a shell or a lightning bolt but there is more to it than that. As opposed to an artillery attack, in the case of sniping, the target is directly *perceived*. In that instant of falling between the crosshairs, the shooter pulls the trigger and the distance between them is bridged. Orwell's insistence on the visual effect of the bullet's impact above and beyond the initial "electric" shock further underlines the essential scopic quality of the sniping event at both ends of the deadly equation. His observation also speaks to his instinct as a journalist to describe what he observes, evident in this case in his emphasis on the intense focalization that he experiences. The phrase "The sand-bags in front of me receded into immense distance" invokes the zoom effect of the camera lens – itself an allusion to both the photojournalist and the tourist, who will become the twentieth century's viewers and travellers par excellence.

While Orwell will eventually assume the gaze of the stereotypical tourist once he is discharged from the militia,[10] his first impressions of wartime Barcelona underline both his own foreign gaze and the uniqueness of the spatial situation in the Catalan capital as regards the aforementioned requisitioning of the built environment that affected hotels like the Colón, Ritz, and countless other buildings:

What the devil was happening, who was fighting whom, and who was winning, was at first very difficult to discover. The people of Barcelona are so used to street-fighting and so familiar with the local geography that they knew by a kind of instinct which political party will hold which streets and which buildings. A foreigner is at a hopeless disadvantage. Looking out from the observatory, I could grasp that the Ramblas, which is one of the principal streets of the town, formed a dividing line. To the right of the Ramblas the working-class quarters were solidly Anarchist; to the left a confused fight was going on among the tortuous by-streets, but on that side the P.S.U.C. and the Civil Guards were more or less in control. Up at our end of the Ramblas, round the Plaza de Cataluña, the position was so complicated that it would have been quite unintelligible if every building had not flown a party flag. (126)

The still-enlisted author then returns to Barcelona after a stint at the front lines. His reading of the wartime city offers an incisive reportage of the way in which the

anarchist and socialist revolution had been exhausted, thus adding nuances to the concept of requisitioning and how space and the practices that go with it may be appropriated and altered over time. Notice especially how the "smart hotels" serve as a firm marker of class distinction and social practice:

> Getting back to Barcelona, after three and a half months at the front, reminded me of this [disjuncture of travel from Mandalay in Upper Burma to Maymyo on the Shan plateau]. There was the same abrupt and startling change of atmosphere. In the train, all the way to Barcelona, the atmosphere of the front persisted; the dirt, the noise, the discomfort, the ragged clothes the feeling of privation, comradeship, and equality ... But when the train had rolled through Sabadell and into Barcelona, we stepped into an atmosphere that was scarcely less alien and hostile to us and our kind than if this had been Paris or London.
>
> Everyone who has made two visits, at intervals of months, to Barcelona during the war has remarked upon the extraordinary changes that took place in it. And curiously enough, whether they went there first in August and again in January, or, like myself, first in December and again in April, the thing they said was always the same: that the revolutionary atmosphere had vanished. No doubt to anyone who had been there in August, when the blood was scarcely dry in the streets and militia were quartered in the smart hotels, Barcelona in December would have seemed bourgeois; to me, fresh from England, it was liker to a workers' city than anything I had conceived possible. Now the tide had rolled back. Once again it was an ordinary city, a little pinched and chipped by war, but with no outward sign of working-class predominance. The change in the aspect of the crowds was startling. The militia uniform and the blue overalls had almost disappeared; everyone seemed to be wearing the smart summer suits in which Spanish tailors specialize. (92–4)

Once Orwell has been discharged from the militia after taking that sniper's bullet to the throat, he is officially relieved of the military perspective. Now the author is finally able to see Spain as he had always thought he would – as an English tourist:

> The details of that final journey stand out in my mind with strange clarity. I was in a different mood, a more observing mood, than I had been in for months past. I had a day to put in to Barbastro, for there was only one train a day. Previously I had seen Barbastro in brief glimpses, and it had seemed to me simply a part of the war – a grey, muddy, cold place, full of roaring lorries and shabby troops. It seemed queerly different now ... I was free to go back to England; consequently I felt able, almost for the first time, to look at Spain (163–4).

The possibility of free movement activates his tourist gaze by reintroducing the element of deviance, understood here as a form of differentiation. As John Urry points out in his seminal treatise on the tourist gaze, deviance is a corollary of "departure" or

"a limited breaking with established routines and practices of everyday life ... allow-ing one's senses to engage with a set of stimuli that contrast with the everyday and the mundane" (2). Up until this point, Orwell's everyday and hence his direct experience of the foreign country in which he had thrown himself had been conditioned by the discipline and monotony of military service. Now with the possibility of departure enabled – ironically not *to* Spain but *from* it – he can indulge in descriptions that were impossible up until that moment. His gaze can linger as he observes the "pleasant tor-tuous streets, old stone bridges, wine shops with great oozy barrels as tall as a man" and the artisanal practice of making a wine skin – one of the only souvenirs that he would eventually take with him when he escapes the country. Orwell directly acknowledges his new status when he remarks, "it was queer how for nearly six months past I had had no eyes for such things ... I felt like a human being again, and also a little like a tourist. For almost the first time I felt that I was really in Spain, in a country that I had longed all my life to visit" (164). Orwell's *Homage to Catalonia* puts into stark relief the confusion of the Republican forces that were resisting Franco while vying with each other for control of the cities under threat. In its matter-of-fact, testimonial, and journalistic way, though, it also exposes the shared lingering aspect between sniping and the apprehension of the new that is inherent in the tourist gaze. This connection along with the role of the media in bringing it into relief would become increasingly evident later in the twentieth century as the hotel's gradually acquired reputation as a safe haven would be put to the test and then ultimately destroyed.

A Pattern Emerges

During the Second World War, both the Germans and the Allies requisitioned hotels across Europe for various purposes related to command and troop support. Sometimes, a hotel would even be commandeered by both sides – as was the case with the Hotel Métropole in Brussels, which the Germans took over during their occupation and the Allies subsequently controlled for a year when the war came to an end ("Hotel Metropole"). In Italy, the US Air Force seized the capital's Hassler Roma as its head-quarters while the Army made use of the Grand Hotel et de Milan as a destination for troops on leave. The Canadian Army in Antwerp had a similar idea and not only ap-propriated the Hotel Cosmopolite for their soldiers but also changed its name to the "Maple Leaf Leave Centre" in recognition of its new function ("Canadians in Belgium"). For their part, after the war, the Soviets wasted no time in requisitioning the Imperial in Vienna in order to convert it into their new high commission ("Imperial Vienna").

The Second World War also saw the hotel come into its own as a journalists' space, one where information collection and sharing could occur.[11] London's Savoy is exem-plary in this regard. One of the most important and emblematic of all the European grand hotels, during the war the Savoy found itself becoming a hub for more than

just its typical clientele, which consisted of the upper crust of British and European society. During the Blitz, fire spotters stationed themselves on its roof while different suites were given over for military purposes (Jackson 175). One room became a foreign office dedicated to helping French refugees while others transformed into a Canadian officers' club and the unofficial headquarters of the First American Eagle Squadron (181). At the same time, the Savoy's famous cocktail lounge, the American Bar, had become the place to go for both the local press and a steadily growing number of foreign correspondents who had been displaced when their own London offices were destroyed during the Blitz (188). This in turn made the Savoy and the American Bar even more important and valuable as a clearinghouse for information. The hotel was also essential for dissemination purposes given that the *New York Times*'s telephone line there continued to function even after those on Fleet Street had gone out of service (191). Whether it was in terms of the social aspect of journalism or the nitty-gritty involved in writing and forwarding a story, the Savoy was a key space during the war. That the assembled journalists even produced a one-off newspaper, *The Savoy Standard*, is further testament to the close relationship between the press and the hotel during this intense period (197). Another example of a hotel involved with the dissemination of information was the Hotel Krasnapolksy in Amsterdam, which while not requisitioned during the German occupation, apparently did serve as a source of "illegal news" during the last months of the war ("Amsterdam Grand Hotel").

As the century progressed, the relationship between the media and the hotel continued to grow, with iconic hotels emerging as "the" place for foreign correspondents during a variety of wars and urban conflicts. Time after time, the hotel's specific architectural traits and often-strategic location saw it pressed into service. And while it may have lost the edge that came with being a source of accessible communication technologies, the building's social advantages continue to hold true. For even if the advent of handheld devices has since made it possible for journalists to submit stories from virtually anywhere, connections made thanks to conversations in lobbies and hotel bars confirm their enduring importance. As Janine di Giovanni explains, hotels such as the Holiday Inn Sarajevo or Kabul Inter-Continental are the first place that people go: "it's where you find information, your fixers and interpreters" (qtd in Urquhart).

In this sense, one can say that journalists requisition hotels in a way similar to that of an army or militia, taking the space as both base and sanctuary. Media involvement of this sort cannot help but alter the dynamics of the hotel. For rather than being a space of replication or a relay for trends in hospitality or tourism, which in turn contribute to the homogenization of space, wartime hotels like those mentioned here become information hubs, active in both its retrieval and transmission. No longer a porous space of decompression, or postmodern heterotopia, the media hotel during war becomes the exact point where the local cedes instantly to the global. It is also where, with the environs as a backdrop, images of the war zone bypass any advertising apparatus – especially evident with chain hotels – and become part of the visual

reception and projection of the cities in question, in effect, a new virtual facade for a building often found at or near a conflict's ground zero. Unfortunately, this instantaneity of information transfer has led progressively to an erosion of the hotel's status as sanctuary.

The evolving connection between the hotel as a media space and a general, secular sanctuary contributed to the ways in which specific buildings became favoured sites during periods of strife. In his brief online series about wartime hotels from the late sixties and seventies, Greenaway lists three important examples: the Continental Hotel in Saigon, the Intercontinental in Dacca, and the Le Phnom in Cambodia. During the Vietnam War, the Continental fulfilled a similar function to that of the Savoy in that it was known as the place to go for information, political gossip, and spying. The hotel's terrace, which American regulars nicknamed the "Continental Shelf," was an especially hot spot for conversations and watching who was coming and going. For its part, Le Phnom served as a respite for journalists who had been exposed to the horrors of the Khymer Rouge's killing fields, while the Intercontinental, which had suffered a lobby bombing early during India's military actions against Pakistan, was converted by the Red Cross into an unofficial sanctuary or neutral zone (Greenaway).

While these brief examples testify further to the hotel's intrinsic capacity to adapt and underline how the international media responded in turn, the particular case of Beirut during Lebanon's Civil War stands out. During this conflict, which began in 1975, the strategic location of a series of hotels and the combatants' desire to control them trumped any other considerations of their space. Tourist hotels in Beirut actually served as the front lines as snipers and rocket-wielding militiamen fought among themselves before turning their sights on the civilians below. Later during the war, the "journalist hotel" itself eventually became contested ground and was destroyed from within. The role of the hotel during this conflict not only merits more detailed attention but serves as an important bridge to a discussion of how the media, sniper, and tourist gazes continued to meld and subsequently affected the hotel's acquired standing as a sanctuary space.

Beirut's "War of the Hotels"

When the Civil War in Lebanon broke out in 1975, a variety of right- and left-wing, Christian and Muslim groups battled for control of the capital, Beirut. Fierce fighting occurred in the city proper, and, as Hijazi points out, few of the city's hotels managed to escape destruction, with seaside resorts being the first to go (Hijazi). Hotel combat was centred in the Minet-el-Hosn (Port [of] the Fort) district where the St George, Phoenicia, Palm Beach, Normandie, and Holiday Inn hotels were located. Little by little, PLO forces and their Leftist allies displaced the Christian militia and occupied these strategic buildings from which sniper and artillery fire could be used to pin

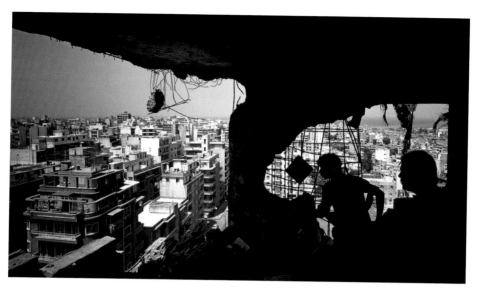

3.4 Beirut Snipers. © Raymond Depardon/Magnum Photos

down both enemy combatants and civilians alike (figure 3.4). Meanwhile, roughly a kilometre away in the Hamra shopping area, another well-known hotel, the Commodore, began to serve as the wartime headquarters for the international press – and it would continue to do so until it was destroyed in 1986 not by rocket or artillery, but from the inside by rival Muslim militiamen fighting in the lobby and rooms (Hijazi).

In Beirut, then, while smaller family-run hotels became refuges for displaced people from the south of Lebanon, the larger, ritzier examples that had once been haunts for tourists, the local elite, and journalists became the actual front line of the war during its initial phase. In this way, for the first time, the strategic qualities of hotel space were contested in a military sense in a concentrated fashion that literally pitted hotel against hotel. With their capacity to dominate the urban space around them, these tall modern buildings were prized as important command sites whose vistas could be instantly weaponized. Thus, Beirut's "War of the Hotels," which saw these buildings disputed room by room and floor by floor, would introduce a new variant of FIBUA: a vertical form that could, in victory, transform the benign way the tourist takes in his/ her environment into something obscene.

In her 2008 installation piece, *La bataille des hôtels*, Paris-based Lebanese artist and author Lamia Ziadé created a compelling mixed-media sculpture that depicts the conflict in graphic form.[12] It is at once a memory work of the contested built environment and a stylized interpretation of '70s zeitgeist. That an underlying tension between peace and violence is so strikingly captured points to Ziadé's skilful dealing with the aesthetic charge and possibilities of requisitioning itself. By employing a

pop-art sensibility to capture the specific mode of occupation in which the various militia groups took part, the artist speaks to both the excess of the historical moment and the sense of slippage and uncanniness evident when sites of tourism become battlegrounds. The overt nods to pop are part of Ziadé's overall aesthetic – a calling card of sorts – but the artist pushes beyond mere citation and develops her own visual grammar through both the textures of the materials that she employs and the creation of an ironic distance that co-opts the objectifying male gaze. Ziadé's earlier work sought to bridge the West and Middle East not only on a textual level but also on a tactile one as she requisitioned images and textiles from both sides of her – and Beirut's – experience through a materiality that made present the trappings of the Other in a striking way. While her earlier work may have been ludic and ironic and punctuated by humour, the grim subject matter of *La bataille des hôtels* creates a real tension with its style. In this piece, she deploys an assemblage aesthetic as part of a memory work that is grounded both in a historical episode and in the space of the hotel. In this way, Ziadé takes her pop aesthetic and the notion of requisitioning to a different level.[13]

Ziadé's installation captures both the intense violence of the conflict and, at the same time, the underlying quiescence and cosmopolitan potential that the modern hotel promises. While not completely to scale, relatively little geographic compression is at play, and if anything, the work captures the urban character and identity of this quarter as an area replete with hotels and anchored by the Phoenicia, the icon of Beirut's postwar success and an internationally recognized emblem for the city in its own right (Kassir 347). The piece as a whole emphasizes the visual mechanics of the hotel and the way in which the sightlines of these requisitioned and contested spaces became strategic and deadly. Their threat is represented by Ziadé's use of coloured yarn denoting rocket trajectories (figure 3.5) and the black-and-white cut-out figures that occupy the hotel.

Like macabre dolls, these photos of actual militiamen and women both pose and are posed around the maquette. Some aim their rifles, others mug for the camera that originally captured their image. Here, though, a horrible truth of this prolonged battle is made clear: the act of viewing makes one a target. Spaces that once facilitated the tourist gaze now privileged that of the sniper – with the lingering element of viewing acting as a facilitator for the overlap of gazes: tourists with their cameras, snipers with their scopes. Reinforcing this dynamic in the installation is the inclusion of the tourism posters for local hotels like the Hotel Saint Georges, the Martinez, and the Alcazar respectively (figures 3.6, 3.7). The artist alters the images of the hotels through her inclusion of the cutout figures – the majority of whom, again, are either actively engaged in combat or at the ready. In this way, Ziadé requisitions our own tourist gaze through the depiction of combat occupancy. But crucially, at the same time, she retains the unaltered text that accompanies the original image, thus creating an even more flagrant tension between the expectations of luxury in peacetime Beirut and the reality of the wartime hotel as apparent in the artist's memory work.

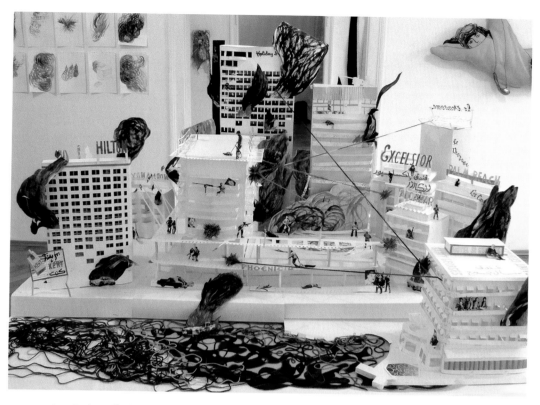

3.5 *La bataille des hôtels*. Mixed media, Lamia Ziadé. Used with permission of the artist.

The tallest structure in the installation, the Holiday Inn, looms over the other hotels and is even more striking on account of the flames and smoke that emanate from its windows on all sides. In representing its destruction, Ziadé captures the creation of the hotel as it currently exists: as an unintentional monument to/of the war, an emptied-out shell of the city's pre–Civil War potential, a gutted link in an international chain and a literal trace that refuses to be subsumed by urban development (figure 3.8). In this way, Ziade's installation activates memory by freezing, collapsing, and condensing months of fighting into one striking display.[14]

With its transformation into a space dominated by the sniper's gaze, Beirut's hotel space would become consistently implicated in atrocities against innocent civilians for the duration of the war. One of the reasons that this situation did not attract greater attention and condemnation, though, was the lack of direct and concentrated media presence in what was essentially a siege zone. Years later, however, a similar situation would occur in a different part of the world, the Balkans. This time, though, the prolonged presence of the media's gaze alongside that of the tourist-turned-sniper's would change this dynamic while reasserting the hotel's capacity to act as a sanctuary.

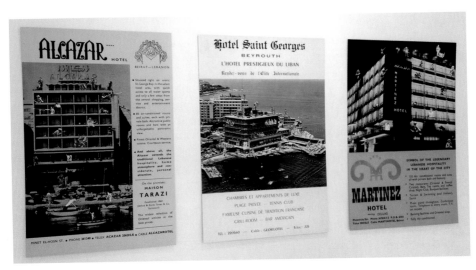

3.6 *Modified Hotel Posters*. Lamia Ziadé. Used with permission of the artist.

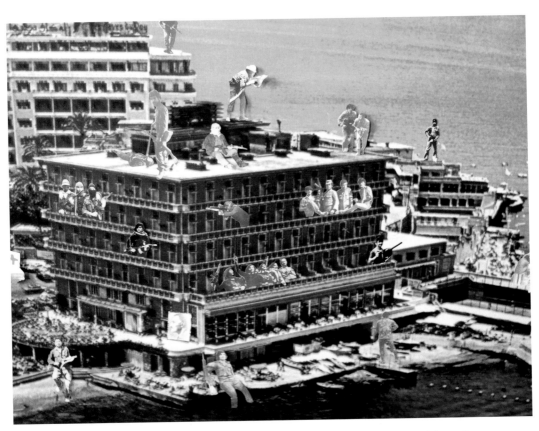

3.7 *Detail of Modified Hotel Poster*. Lamia Ziadé. Used with permission of the artist.

Again, like the bullet-ridden, burned-out Holiday Inn in Beirut, a chain hotel would become a powerful icon of how the gentility so intrinsic to modern tourism and travel can quickly and suddenly be erased.

The Siege of Sarajevo

In 1991, following Croatia's and Slovenia's declarations of independence from Yugoslavia, the mainly Muslim region of Bosnia-Herzegovina pushed for a sovereign state of its own. After fighting broke out in the first two areas between resident ethnic Serbs and the respective Croat and Slovenian majorities, it was not long before violence also erupted in Bosnia ("Bosnia and Herzegovina"). By early 1992, voters had ratified Bosnia-Herzegovina's independentist ambitions through a referendum, but Bosnian Serbs had boycotted the vote and shortly thereafter went on the offensive, attacking Muslim villages with the help of the Yugoslav army. With 60 per cent of the country under Bosnian Serb control, the capital Sarajevo was forced to endure a siege that lasted almost four years.[15] The role of Sarajevo's Holiday Inn during that time (figure 3.9) offers a prime example of how the condition of city-based combat can affect a space of mass tourism and can compel a reconsideration of the nature of the tourist gaze and how it is subsequently inflected by the transmission of urban war to the rest of the world, a process in which hotels have traditionally been very much involved.

The Sarajevo Holiday Inn, a chain tourist hotel that was constructed for the 1980 Winter Olympics played a direct role in the fighting from the very beginning of the conflict in Bosnia.[16] The "Study of the Battle and Siege of Sarajevo" written for the *Final Report of the United Nations Commission of Experts* pursuant to security council resolution 780, states that on Monday 4 April 1992, suspected Serb snipers fired on peace demonstrators in front of the parliament, wounding from thirteen to fifteen people (Spies). According to UPI and Reuters news reports, the sniping originated from the Holiday Inn, located a short distance away from the seat of government. After the initial shots were taken, a small battle ensued that lasted until Bosnian Muslim militiamen were able to take control of the building. What followed, however, was much grimmer. Even though the Bosnian Muslims were able to hold the majority of Sarajevo, the Bosnian Serbs were able to establish an effective blockade. With the consolidation of their positions in the mountains and in the neighbourhoods that they had managed to penetrate – such as Novo Sarajevo – the siege was in place. In addition to shelling, sniping became a widespread practice, with non-combatant citizens targeted alongside Bosnian militants. The attacks were especially bad on Voivode Putnika, the street that became known as the infamous "Sniper's Alley." It was along this route that the Holiday Inn was located and where scores of people were gunned down as they ventured out to fetch daily necessities regardless of the danger. During

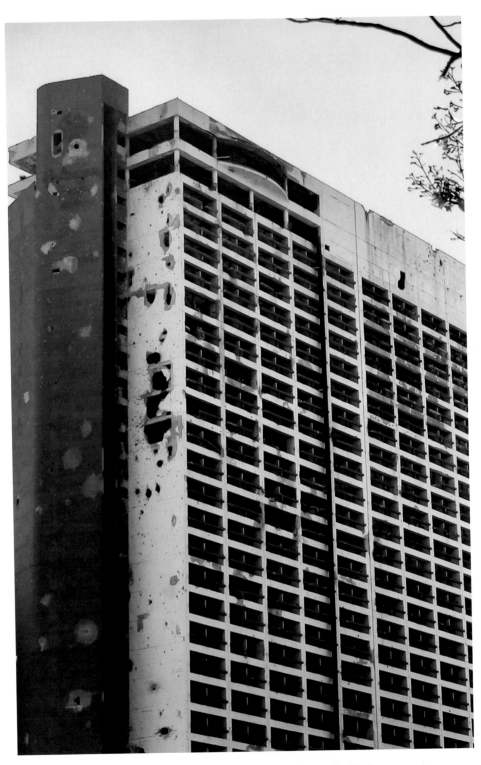

3.8　*Holiday Inn Beirut*. Photo: Jennifer Varela, 2011

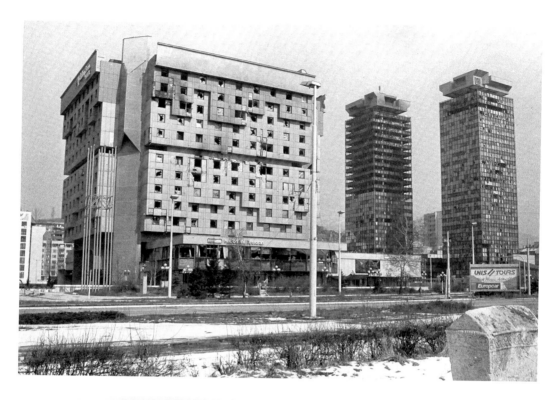

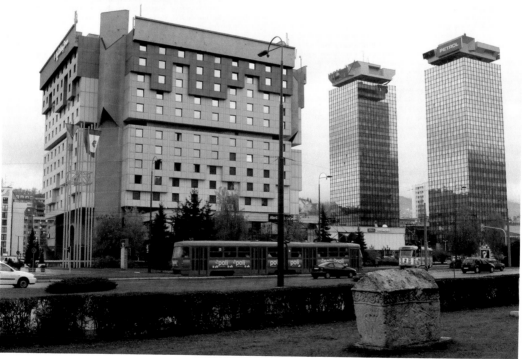

3.9 *Sarajevo's Holiday Inn during and after the Siege.* 2005 AP Photo/Hidajet Delic

the period after the initial violence, the international media took over the hotel for the duration of the siege.

Sniping came from soldiers hidden either in other buildings along the Voivode or in the mountains that completely surround the city. For the hotel's temporary residents, the act of looking, an activity intrinsic to the experience of what was once a specifically designed tourist space with enticing vistas, put one's life in peril. In this sense, the same innovations in the "visuals" of the chain hotel that Wharton describes, such as transparency and openness vis-à-vis public spaces, become dangerous liabilities under wartime conditions (188). In the Sarajevo Holiday Inn, a simple fact dominated all others: if you could see out, a sniper could see you looking out. In the uncompromising reality of the war zone, then, the chain tourist hotel became an area in which the essential lingering aspect of the tourist gaze radically mutated.

The Tourist Gaze and Sniping

As John Urry points out, the viewing of tourist sights – that is, the act of viewing by tourists – involves a different form of social patterning, one in which there is much more sensitivity to visual elements of landscape or cityscape than in day-to-day life (3). This hypersensitivity to the built environment as part of the tourist experience is induced in part by the marketing of "place" that tourist destinations develop to maximize their specificity. Guide books, postcards depicting "classic" views, and guided tours are all part of this industry; they encourage a change of one's normal pace and play off the realization that a tourist's gaze responds to a different set of criteria than that of a local resident. Freedom from the tyranny of the clock enables the tourist to prolong his or her presence. The tourist is also liberated temporarily from routine, the prime suspect in the way that a local becomes inured to an architectural milieu. As a result of this emancipatory dynamic, the tourist gaze is equally free to pause and linger, to take in and appreciate or critique, photograph, sketch, or otherwise record parts of the city that, for residents, had long ago lost their novelty.

As I alluded to above in my analysis of Orwell's foundational text *Homage to Catalonia*, the act of lingering that is inherent to the tourist experience of space and that is particularly evident in the articulation of the tourist gaze has a powerful correlate in the visual mechanics of sniping. This link between two seemingly disparate acts is especially evident in a siege situation such as that of Sarajevo. For just like the tourist's gaze, that of the "indiscriminate" sniper hinges also on lingering over an area in question.[17] The relation between the two expands when one considers that the tourist's camera and the sniper's rifle are also correlates. Just as the telephoto camera lens allows one to zoom in on a "target," so too does the sniper's scope that runs parallel to the rifle's barrel. Clearly, however, the lingering of the sniper's eye once he/she obtains a sight picture is not about capturing or enshrining the extraordinary

– prolonging the moment of lingering as a tourist's camera would – but precisely the opposite. In the Sarajevo war zone it served to disrupt the quotidian in a terrible way, controlling space and movement on the smallest possible scale: that of the individual non-combatant. The clicking of the camera shutter by a tourist seeking to immobilize a certain image is replaced by zeroing, the pulling of a trigger, and the rifle's retort. When the bullet hits its target, the results are crippling or fatal. And even when the snipers miss, their rounds still create tangible evidence on the cityscape that speak "posthumously" to sightlines and contribute to the creation of fear.[18] Viewing the scars of the sniping on their own city, residents are forced out of routine in a terrifying way. Lingering is not an option, even though, ironically, they will have become much more aware of a built environment that had perhaps become second nature to them before the chaos of urban war redefined their city and how they navigated it.

And the larger frame in which imaging links to imagining? The creation and re-creation of images for consumption is an important offshoot of the lingering aspect of the tourist gaze and serves as a foundation for the ways in which the media would become involved thanks to the hotel. Part of this core dynamic lies in the tourist gaze's potential to objectify or commodify the tourist's destination through photographs, postcards, and the like (Urry 3). Obviously, the conflict inherent to war zones disrupts tourism's utopic impulse. For not only does war ruin stereotypically scenic tourist vistas, but – playing into what French anthropologist Marc Augé describes regarding the advertising practice of presenting the viewer of an ad with the imagined image of oneself taking in the new environment – it invalidates this possibility through the catastrophic destruction of the backdrop.

As the conflict in Bosnia expanded, the world's journalists moved in, eager to cover a brutal war being fought a mere two hours' flight from Central Europe. In this regard, the Sarajevo Holiday Inn stands as an important example of a wartime hotel not only for its direct involvement in the conflict but also on account of the sheer length of the period during which it served as a media centre and a marginally safe zone. Here, then, one sees how in the space of one wartime hotel, the latent tourist gaze (inherent in the physical location of the hotel) was used by the sniper at the beginning of the war only to itself become a target during the siege and then facilitate the international media's journalistic eye. In this capacity as secular sanctuary for reporters and their local staff, the Holiday Inn enabled an act of looking that sought to record the "performance" of war for thirty-second segments that stations would broadcast thousands of kilometres away.[19] Doing so meant that any latent aesthetic association with tourism was subsumed. As Urquhart observes, the Holiday Inn "literally became part of the story thanks to its position on the front line – one side of it was completely demolished by shellfire, and the journalists lived in the other three sides. Photographers could take shots of the action from its windows" (Urquhart).[20]

Of course, the Bosnian War wiped out leisure tourism in the region – with one notable exception being that of writer Eduard Limonov, who visited Serb snipers and,

in the presence of Radovan Karadzic, even fired on the besieged city himself. In figure 3.10 both are pictured with the Holiday Inn clearly visible in the background. During the war, tourist seasons fell by the wayside as they were replaced by one long season of violence inscribed into the global imaginary until the point of saturation. A vision of a ruined Olympic and formerly multicultural city rent asunder would become the abiding image as the media gaze that emanated outwards was itself conditioned by the experience of siege and sniping. In his memoir of the period, Spanish author Juan Goytisolo captures the grotesque irony of leaving a Paris airport festooned with posters for the Hollywood film *Sniper* (figure 3.11) only to arrive in a place where celluloid make-believe was being carried out in actual fact: "the last image of Paris: the implacable visage of the elite Sniper, glorious, sublimated model, the ideal of those who shot for real in Sarajevo" (Goytisolo 11).[21]

The Holiday Inn in Sarajevo was targeted for sniping and shelling but it seems clear that had the Bosnian Serbs wanted to, they could have obliterated it. So the sanctuary effect did seem to have still held a charge there, and thus the dissemination of information continued. Of course, there are dangers inherent in the concentration of those who write the news and Urquhart addresses this in her piece. She quotes Robert Fisk of the the *Independent* who interprets the risk this way:

> The danger of being together is that reporting feeds off itself, and you get the "manufactured consent" of journalism ... if the *New York Times* has a story, the *Washington Post* must have the same story. Governments like it because they feed a story to one journalist, it will go to the rest. In this way you create a rather subservient press; journalists are more concerned about what their rival newspapers are carrying than about what's happening. (qtd in Urquhart)

Fisk's criticisms extend to depictions of journalists in hotels: "By and large the people who suffer are the civilians who cannot get visas, cannot fly home in business class, cannot afford a hotel room away from the gun battle ... there is too much concentration on journalists' hotels – we should look at the people who do not have places to stay" (qtd in Urquhart).

While the critique is certainly valid, as the *Mirror*'s Harry Arnold points out in the same article, the "security in numbers" element of sharing space in a hotel, which in many cases will have some sort of protection, is important – especially since journalists are loath to carry weapons. In the Battle of Baghdad, though, what occurred at the Hotel Palestine Baghdad puts an entirely new spin on the relationship between journalism and the space of the hotel. The deaths of three correspondents at the hands of the US military lead one to believe that it was the prime directive of the journalist – to transmit information freely – that made a target out of the ostensibly protected space of a recognized media hotel during wartime. In this sense, the hotel continued its tradition of being a part of information retrieval and dissemination. Unfortunately,

3.10 Limonov and Karadzic above Sarajevo. Video still.

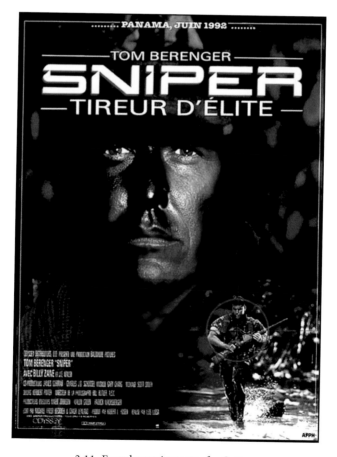

3.11 French movie poster for *Sniper*.

a decade after the Siege of Sarajevo, this relationship finally came under direct attack in the sad deaths of Taras Protsyuk and José Couso, two cameramen covering the Iraq war (figure 3.12).

The Hotel Palestine Baghdad

On 8 April 2003 at three minutes to midday, an American Abrams tank parked not far from the Hotel Palestine raised its main gun, took aim at the fifteenth floor, waited for two minutes, and then fired once (figure 3.13). The shell exploded into room 1503 where a Reuters television team was staying, killing cameraman Taras Protsyuk and injuring three of his colleagues. José Couso, a Spanish cameraman for Tele 5, who was filming from a fourteenth-storey balcony, was critically injured in the attack and later died on the operating table. This incident came on the heels of another strike, earlier in the day, on the bureau of the Arabic-language satellite news channel Al Jazeera. One correspondent was killed and a cameraman was injured in that assault, which is described in Julia Bacha and Jehane Noujaim's 2004 documentary *Control Room*.

What makes the events of 8 April even more disturbing is that, just as in the case of the 29 and 30 March assault on the Iraqi Information Ministry headquarters where foreign news media had been based, the sites were attacked in daylight and were locations known by the Pentagon to be media centres. The soldier who fired on the Palestine denies having had previous knowledge that the hotel was being used for such purposes and maintains that his division had come under fire from the area of the hotel (Goldenberg). British correspondents, though, corroborate the contention of a Spanish reporter working for Al Jazeera that there was no Iraqi resistance around the hotel when the Americans attacked (Goldenberg). According to Robert Ménard of Reporters Without Borders, footage from the French TV station France 3 as well as journalists' accounts show the neighbourhood to have been very quiet at that hour and that the US tank crew acted slowly (qtd in *Reporters Without Borders*). Ménard concludes:

> This evidence does not match the US version of an attack in self-defence and we can only conclude that the US army deliberately and without warning targeted journalists. US forces must prove that the incident was not a deliberate attack to dissuade or prevent journalists from continuing to report on what is happening in Baghdad. (qtd in *Reporters Without Borders*)

What then to make of the attack on the Hotel Palestine? While it is certainly believable that the soldiers in the tank were not aware of the particular status of the hotel that they were attacking, the fact that commanders must have known introduces a high degree of scepticism regarding the Army's contentions. Thus, what we are left

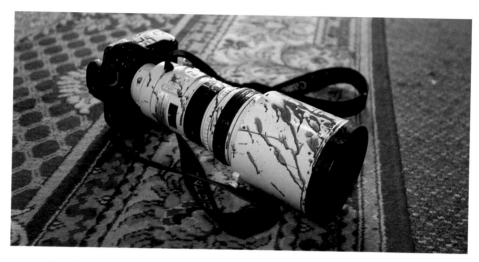

3.12 *Iraq–US War Wounded Journalist's Camera.* © Getty Images/Patrick Baz.

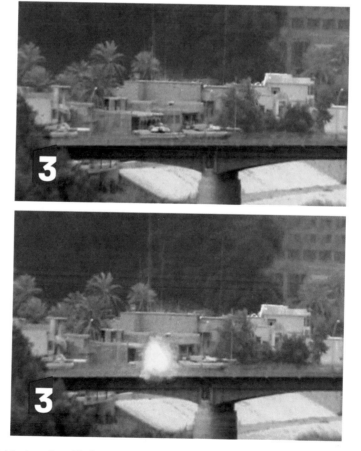

3.13 *American Tank Firing on the Hotel Palestine Baghdad*, AFP/France 3.

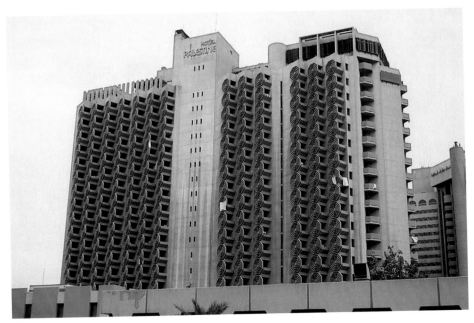

3.14 *Journalists Hang White Flags at Hotel Meridien Palestine.* © Getty Images/Ullstein Bild.

with is a direct assault on the uncontrolled transmission of information, something that the Pentagon had already gone out of its way to contain through the restrictive policy of embedding journalists within tactical units. Embeds' material could be constantly reviewed and censored if need be. Information flowing out of the war zone from the Hotel Palestine, however, could not. A plausible conclusion (and one that Reporters Without Borders strenuously defended) is that the US Forces intended to strengthen their hold on the transmission of information and images by dealing physically with their rivals. The fact that the hotel space of the Palestine represented an instantaneous, filter-less threshold between local and global meant that it became a literal target in the information war, which was, in reality, a concerted war on information. The Battle of Baghdad marks a change, then, in the spatial and political dynamics of the wartime hotel. No longer a safe haven from whence the world's reporters can dictate copy, report directly, or simply stay in relative security within the war zone, the often-mythologized war hotel of old appears to have been eliminated. The stakes in the public relations battles that go hand in hand with actual fighting in the ultramodern wars of the twenty-first century have risen so high that it seems that accidents occur with more frequency – and if they happen to leave a journalistic chill in the air, and journalists having to fly white flags, so be it (figure 3.14).

In this chapter, I have examined various examples of the wartime hotel so as to trace the way in which the condition of urban combat alters not only the use of hotel space but also its experience. As I argue above, Orwell's seminal *Homage to Catalonia*

establishes an early connection between the disparate ways of seeing that would come to dominate the twentieth and early twenty-first centuries. As a result, I have proposed that occupancy and requisitioning of the hotel are intimately connected; they are bound within a larger context that sees the touristic valence of the edifice overlap with its role in information diffusion. That the adaptability and mutability of the hotel are as much in evidence during war as during times of peace underlines the way in which it acts as a hub, a point of merging – as well as one of departure – for architecture and the social practices with which people imbue it with meaning. Each of the examples that I have examined here adds a new reading of the hotel during moments of conflict. Barcelona during the Spanish Civil War shows two important facets: first, that the state need not be the agent of requisitioning of space; and second, that reinscription of architectural and social meaning may be part and parcel of the way in which a hotel's potential as a command and control centre within an actively contested theatre is engaged. While the fact that sniping became part of the visual dynamic of the hotel in such a situation indirectly touched the concept of the tourist gaze during that period, what occurred in Lebanon's Civil War and Sarajevo during the Bosnian War makes these connections essential to understanding how the space of the hotel was actively involved in what became a very mediatized siege. The disturbing questions raised by the connections between the lingering tourist gaze, that of the sniper, and finally, the probing lens of the international media only cement the relationship between the hotel and a long tradition of information dissemination. That this well-known relationship came under direct attack in the last case I have treated here unfortunately lends credence to my broader theory of the hotel as a vital liminal zone between local and global replete with important symbolic value. It appears that the Hotel Palestine Baghdad became a target because of its journalistic function as an instantaneous gateway to the world. The fact that the US Army's excuse centres on the existence of sniper fire originating from the hotel is a sickeningly ironic reminder of the entangled associations that I have tried to tease out here between the wartime hotel, the rifle, the gaze and ultimately, the camera.

chapter four

THE DISPLACEMENT HOTEL

The ability of hotels to adapt and modify their use is a fundamental quality of the space. Throughout the course of this book we have seen multiple examples of how they have acted beyond their basic purview as retreats or lodgings for those who travel by choice. That said, changing social conditions – and especially the catastrophic situation of wartime – have led to different or alternative uses of hotels by both state and non-state actors alike. In this chapter I look more closely at the flip side of the hotel's cosmopolitan nature and consider phenomena related to the polar opposite of travel by choice: displacement. I propose that by analysing the role of hotels both in immigration detention and in their use as shelters and/or reception centres during refugee crises, we gain further insights into the nature of this flexible, ubiquitous, and unique space.

I begin the discussion by considering how hotels have been a part of state-authorized displacement. Through a reading of France's and Canada's use of them as detention centres for unauthorized travellers or those denied asylum, I demonstrate how the state can politically activate hotels' condition as a "non-place" in a way that calls into question not only the common understanding of what a travel-oriented *non-lieu* is, but also the ethical questions that surround cosmopolitan travel dynamics and processes in general. I argue that even though the homogeneity that is characteristic of the non-place hotel may seem to lump it in with other such spaces like airport terminals or chain supermarkets, the cases of detention that I cite here demonstrate that the hotel does not necessarily lose its intrinsic frontier quality as a portal. In these instances, I contend that rather than act as a point of contact, decompression, or refuge, the hotel becomes a site of exclusion, a vanishing point of the state – an example of the camp within the city walls.

In the second part of the chapter, I continue to investigate the hotel's role in displacement but from an angle that points to the reacquisition of its status as a space of sanctuary. In the wake of the Syrian refugee crisis the hotel has once more become a haven, and through consideration of its use in this way in both Germany and Canada,

two of the most amenable recipients of displaced Syrians, we see how discourses and practices of detention are being supplanted by others that revolve around inclusion and integration. The "displacement hotel" thus raises questions as to how the condition of being uprooted challenges our understanding of so-called non-places. By reading both uses and versions of this form of the hotel side by side, and by also taking into account the narratives of backlash when they emerge, we are afforded a clearer understanding of the changing nature of the space and the forms of occupancy that can be found within it.

Detention

All states exercise – or attempt to exercise – sovereignty both inside and outside their established frontiers. The practical notion of managing this sovereignty must not be underestimated; it is intrinsic to the existence of the nation-state, as Brennan observes:

> Nation-states are not only, as we customarily hear today, imagined communities: they are also, and no less fundamentally, *manageable* communities. The state as coercive negotiator presides over a community that it must, by definition, be capable of managing. What it is capable of managing becomes inexorably what must be ruled. Cultural theory has become inordinately fixated on the ideology of nationalism in recent decades … Fascinated by the narrative layerings and polysemic ambiguities of political myth and representation, cultural theory radically underestimates the practical issues of management at stake in the making of nations. Here the sober concerns of international relations are a salutary corrective. (*Cosmopolitanism* 46–7)

The specific management procedure used for regulating the movements of people in and out of a state so as to preserve sovereign control of populations is called "interdiction." While the term may refer to any authoritative prohibition, when applied to the complex issue of transnational migration or diasporas during the late twentieth and early twenty-first centuries, it is understood to be the practice by which nation-states control and manage these migrant and refugee flows. Or, to be even more precise, interdiction is the act of prohibiting, intercepting, or, in some cases, deflecting unauthorized movement. It is a multifaceted tool and umbrella concept that affords the state latitude in its dealings with individuals, both economic migrants and refugees alike. This leeway is effected even though individual states may be party to the 1951 Convention Relating to the Status of Refugees, an international agreement whose mettle is nevertheless tested by a core tenet of statehood: the right to exert sovereignty over borders and thus control entry and egress for the well-being of the state – ethical or moral responsibilities to a larger international community notwithstanding.[1]

Interdiction raises numerous legal questions regarding the treatment and processing of displaced people like refugee claimants. How and why people emigrate as well as the way in which those in transit are handled by destination countries often paint a picture of desperation and helplessness on the one hand and calculating resolve on the other. A state's determination to manage potential claimants combined with the intricacies of where actual, enforceable sovereignty begins and ends highlight the practical aspects of interdiction, which in turn lead to considerations of the built environment and the way in which some states aggressively manage both the practical boundaries of their sovereignty and how they are viewed while doing so. In his article on refugee interdiction, Attila Ataner identifies various practices related to the phenomenon and the subsequent risk that a refugee may suffer *refoulement* ("return") to the country of origin (12). Among these are more "passive"[2] pre-emptive practices such as the requirement that travellers from a refugee-producing country acquire a visa, the imposition of sanctions on carrier companies that transport illegal or irregular travellers, and the training of carrier staff in departure countries to detect those with improper documentation (12–13).[3] In addition, there are interdiction practices that are preemptive in a much more active way and, as such, test the limits of state sovereignty. These include, for instance, placing immigration officers in foreign airports for detection purposes; intercepting marine vessels in international or territorial waters; and, what seems almost paradoxical to the fortification of sovereignty, "excising" territory or space relative to a state's migration zone so as to create a situation in which national protections are lessened or eliminated for asylum seekers (13).

These varied interdiction practices illustrate the junction between policy and a surprisingly flexible, real physical space: the national environment, both natural and built. They reveal the various ways in which state authority and autonomy expand and contract and point to changes in national frontiers at both the literal and figurative levels. By employing apparatuses to extend itself extraterritorially, the state increases its influence so as to take preventive action against potential refugee claimants or migrants.[4] Conversely, the excision of territory or the creation of special zones demonstrates that the state is capable also of contracting its influence and extension. This contraction can occur within fixed and recognized national borders. Thus, in some cases, the state seemingly perforates itself, creating a "Swiss cheese" effect by selectively leaving areas of its space exposed to international jurisdiction.[5]

At first glance, a state's outright excision of its own national space, the declaration of particular parts of its sovereign territory to be ostensibly "international," or an apparent watering down of its sovereignty over satellite territories would appear to undermine the very elements of national sovereignty that immigration controls ultimately seek to fortify. In practice, though, these measures are taken more in an attempt to either create a nebulous legal zone in which the state in question can avoid the responsibilities that international conventions place upon it the moment a refugee

claimant enters national space or circumvent its own stipulated obligations concerning foreigners within its domestic purview.[6] In this legal footwork one sees Giorgio Agamben's sovereign ban in action as the state expressly delivers "something over to itself … maintaining itself in relation to something presupposed as nonrelational," with, as we shall see, the "nonrelational" aspect of the equation having its ultimate expression in the non-place (Agamben 109–10). Agamben's continuation of this point is equally pertinent to how one may theorize the excised space of the state: "What has been banned is delivered over to its own separateness and, at the same time, consigned to the mercy of the one who abandons it – at once excluded and included, removed and at the same time captured" (110). The state thus "freed" from part of itself is at liberty to exercise a more supreme form of purpose-driven, unilateral, and practical sovereignty, one in which the give and take of membership in an international community has been suspended for selfish reasons. These types of actions substantiate Étienne Balibar's contention that the "absolute" sovereignty of nation-states is thus not "universalizable," a fact that makes the idea of a "world of nations" or "united nations" contradictory (Balibar 7). Moral concerns and theoretical considerations of sovereignty aside, these evasive manoeuvres raise important questions regarding the way that states actually *manage* their own national trajectories; that is, the manner in which they develop or evolve in space and time – through both policy and practice related to citizenship and frontiers – while impeding the personal trajectories through space of "unauthorized" individuals as well as diasporic groups who would seek to enter a state's sovereign district and as a result, in the state's perception, alter its constitution. Of course, the ultimate irony could be that, as per Appadurai, nation-states may no longer even be the "guarantors" of many aspects of national life (markets, livelihoods, identities, histories, and, perhaps, fixed territoriality?) but rather, they may have simply become mere "arbiters among other arbiters" of global flows (342). Regardless of the extent to which one believes this to be true,[7] porosity remains a major source of state anxiety that continues to grow more acute as states struggle to maintain borders and, simultaneously, deal with unofficial or illegal residents who, regardless of their status, begin to take part in daily life as best they can.

The role of built spaces in the practice of immigration management is intriguing, and an examination of one such as the hotel sheds light not only on the evolution of state policy when it comes to dealing with the anxiety of migration and refugee movement, but also on the specific tactics that the changing nature of frontiers and international travel necessitate. The hotel has been used as part of the interdiction apparatus in two different ways: in the drastic practice of excising territory (France) and through the effective requisitioning of its space for detention purposes (Canada). That the typical modern tourist hotel, postwar descendant of the monumental grand style, also stands as an archetypal non-place and is intrinsically linked to travel and movement through space – national or otherwise – is central to my contention that the state's sovereign will as displayed through overt and veiled interdiction practices

activates the latent political potential of the supermodern non-place, an act that consequently necessitates the latter's re-evaluation as a space not only of interdiction but also of exclusion.[8]

There are three main forms of territorial excision involved in interdiction practices and refugee flow management. In geographical terms, they occur at varying degrees of distance from the core state territory.[9] In both France and Canada, the hotel has been employed at home. First, France excised very specific areas of Paris in order to skirt its treaty obligations regarding the treatment of unauthorized foreigners. Canada, for its part, has employed former travel hotels close to Pearson Airport in Toronto as detention centres for more than a decade.[10] That the hotels in both cases fit the basic non-place hotel mould is significant and suggests that considerations of the non-place must take into account not only the experience of travellers who journey by choice but also that of those who are displaced and subsequently become subject to the whims of another state's largesse.[11]

How have hotels come to be used in this way? A brief overview of territorial excision is helpful because while "external" exclusion zones such as the Christmas Islands and Guantanamo Bay continue to be used by Australia and the US, respectively,[12] several European states have resorted to internal exclusion in order to help manage the flow of refugees and diminish their responsibilities toward people who would come under the protection of international conventions. This has been the case in countries like Germany, Switzerland, Spain, and France, which have declared parts of their airports to be transit zones, international space in which officials "are not obliged to provide asylum seekers or foreign individuals with some or all of the protections available to those officially on state territory … in order to enable speedy removal from the country" (Kpatinde). While an accelerated program of assessment is supposedly enacted under such circumstances, detention (or retention as the French call it) is still a reality for many.[13] So, too, is the risk of removal without any due process whatsoever, exactly the scenario investigated in Switzerland in 1995 by the Geneva Coordination for the Right to Asylum. The group found that asylum seekers at Geneva's Cointrin airport had been expelled either before their cases were heard or before their legal term of detention at the airport had expired (Kpatinde).

Questions regarding spaces of transit and international travel are especially acute in regards to France because the country has declared not only sectors of its airports as excised waiting zones but also parts of harbours and certain international railway stations (Country Report France). Officials screen claimants at these ports in order to determine whether entry to the republic and hence, application for asylum, will be permitted.[14] In the meantime people are retained in these zones, waiting in limbo for the state's bureaucracy to get around to them.[15] In addition to the presence of guards, an aspect of this situation that underlines the real bureaucratic demarcation between the excised areas and the country proper is that, should an asylum seeker be allowed to "enter" France so that he/she may register at a local prefecture and attain an asylum

application form, a "safe conduct" pass – an internal passport of sorts – is issued for a period of six days (*Country Report France*). When all of these provisions and procedures are considered together, Blanchot's notion of *enfermer le dehors* through its constitution as an interiority of exception takes on a special and acute spatial resonance (qtd in Agamben 18).

More than any other, the legal case of *Amuur v. France* focused the debate regarding the space of the state, internal excision, and the legality of such a practice. On 9 March 1992, four Somali nationals who had fled the country following the fall of the Barre regime arrived in Paris on a Syrian Airlines flight from Damascus. They were refused entry to France because their passports had been falsified, and the four were subsequently detained at the Hôtel Arcade, a section of which the Ministry of the Interior had rented and converted so that it could be used as a "waiting area" for the airport (*Amuur v. France*). On 25 March the men were denied refugee status because they did not have temporary residence permits and thus did not fall under the protection of the state. Given that they were being held at the airport during the day and the hotel at night, they were unable to obtain this document. Even though they had applied for a short notice order for their release from confinement at the Hôtel Arcade on 26 March, three days later, the men were sent back to Syria. Eventually, the case came before the European Court of Human Rights, which ruled that the contention that people in international zones had not technically entered the country, and thus could not fall under Article 1 of the European Convention on Human Rights, had no merit in respect to how "jurisdiction" is defined (Mole 35). In the court's eyes, a state's responsibilities regarding expulsion under Article 3 would come into play at the moment when the state takes action (35). Importantly, the *Amuur* case hinged in large part on the applicants' argument that their detention at a hotel requisitioned by the French state – and thus appended de facto to the international zone – was unlawful. The ruling and this specific assertion regarding the hotel not only bring into question the practice of excision in general but also, at a rudimentary spatial level, highlight the problematic status of the non-place within a context that has been reconditioned in a political sense by state policy and practice and thus taken far beyond simply being a zone of transit and accommodation used overwhelmingly by travellers by choice.

In practical terms, transit zones in international airports extend from the runway to the first border control checkpoint and may contain holding areas and spaces that provide hotel-like services (Kpatinde). This observation raises the question of the mechanics of detention in the case of an internal excision of national space. International "bubbles" may be created, but multiple points of intersection in the form of infrastructure, the power networks of the state, and the complicity of foreign carriers must still penetrate and pervade the space so as to reinforce this excision. These practices in France and other countries point to the states' anxiety of securing immediate frontier zones at the same time as they highlight the conflicting legal opinions regarding the legitimacy of such measures as well as the expectation of free movement that the

increasingly market-oriented West demands. The *Amuur* case is also valuable in that it implicates the state appropriation of non-places on different levels, and clearly demonstrates the fact that the hotel – an archetypal space of the modern traveller – is particularly well-suited for integration into interdiction practices and thus apt for an examination of how, in a refining of the camp space, the latent political nature of these non-places is activated.

The Hotel as Non-Place

In addition to its remarkable flexibility, the hotel has figured intimately in the physical and metaphoric compressions of time and space that marked a spectacular growth in travel during the modernization of the West – a fact that, in modernity's wake, has led it to exemplify, along with the airport, the supermodern non-place of the cosmopolitan traveller. States and their bureaucracies have played a mediating role in the spaces that have been crucial both to the compression of space/time and to international exchange. As spaces where both travellers and goods began and ended their respective journeys as well as frontiers of the state, stations, ports, and the zones that serviced them (either legally or not) were areas where identity could be verified and access/egress controlled. From the beginning, then, the experience of compressed time and space – at least across borders – has been inflected with state power and control, and it is here that one sees both the modernist origins of the contract element that would later come to symbolize the non-place in Marc Augé's theory of the supermodern as well as the roots of its latent political capacity.

The role of the state in this management of compression – one of the markers of the modern experience – was not the only mitigating factor. It is important to recognize that these spaces were also sites where compression was relaxed. Delays notwithstanding, the physical experiences of stations and ports for the user were predominantly transitory and fleeting.[16] Through these spaces the traveller could access an increasingly rapid delivery system that would then disgorge him/her into a different space according to a regimented schedule. Now, if the compression experience was the one most immediate to long-distance movement and travel through space, how then to characterize the zone where the voyager's experience of time-space returned to a more normal pace, in relative terms? I suggest that we may also speak of a space of decompression, of a threshold space that exists in the aftermath of movement between the compression experience and the relative stasis of *being there* – no matter how much more accelerated that state of being may have become or may be in the process of becoming. Clearly, the ratified state of *being there* – of *having arrived* – experienced by one who travels by choice is precisely what is denied the migrant or refugee who experiences the aforementioned contraction of state space through territorial excision or the state's management of specific non-places, or both.

An important aspect of the spatial effect that set the pre–Second World War grand hotel apart from areas such as the railway station's concourses or platforms was that it could contribute a greater degree of delay or suspension to the potential moment of contact between the local and global. As a site of decompression, then, hotels from that period epitomized a space where not only was the compression of distance and time relaxed, but the possibility of contact between people was attenuated through one's presence in a space that had accrued identity and cachet as a destination unto itself and that at the same time was connected with its locality while serving as a bridge space to the global. In short, the traditional grand hotel existed as a "place."[17]

While the pre–Second World War grand hotel represented the first great height of hotel opulence and established many of the codes of hospitality, hygiene, and tourism related to travel by choice,[18] by no means did it remain the only model of hotel space. Just as the grand hotels served to reproduce specific codes of behaviour, service, and distinctive spatial experience, the much more homogeneous chain hotels, which took root and multiplied as long-distance travel became more affordable and easy following the war, realigned the experience of the space away from that of a destination per se and towards its status as a way point that would defy distinction or differentiation on account of its base functionality.[19] As the opposite of a "relational" space, this new type began to assume the characteristics of what we now call a non-place. This qualitative change saw the experience of decompression evolve also, as it would come to encompass the anonymous characteristic of the non-place that Augé articulates when he states that "the space of non-places creates neither singular identity nor relations; only solitude and similitude" (103).

Spatial homogeneity grew apace with the demand for cheap and safe lodgings that the subsequent boom in lower-level hotel chains addressed.[20] I would suggest that the proliferation of purely functionalist chain hotels contributed in no small way to the multiplying of Augé's supermodern non-places. In this manner, the evolution of the built space of the hotel mirrored the movement towards postmodern forms that was occurring in other disciplines.[21] Architecturally speaking – and Jameson pointed this out in his reading of Los Angeles's Bonaventure Hotel[22] – an important feature of postmodernity is that the new tensions it produces are not limited merely to the individual's experience of confusion. Rather, in addition to producing instability at the level of the subject, the tensions are codified in the built environment as well. Influential critic Vittorio Gregotti sees popularization as a corollary effect of what, for his part, he labels "hypermodern" culture and its influence on the built environment. For Gregotti, architecture no longer aims for the "constitution of critical tension, but rather a natural relationship with the tastes of the masses" (8). He further contends: "After almost two centuries of merging creativity and critical conscience as the basis of modernity, it is important to emphasize the present attempt by hypermodern culture to render architectural culture (and not only architectural culture) homogeneous with the social order" (10). The trend towards such a natural relationship founded in

the functionality of the built environment (and not organicism as the word "natural" may seem to suggest) dovetails with the "democratization" of travel and Augé's subsequent related insistence that the space of the traveller has become an archetype of his supermodern non-place.

For the Frenchman, this supermodernity exposes "individual consciousness to entirely new experiences and ordeals of solitude, directly linked with the appearance and proliferation of non-places" (Augé 93). These include "spaces formed in relation to certain ends (such as transport, transit, commerce or leisure)" and, as such, have a quantifiable aspect that shows categorically the measurements of social trajectories (94).[23] While this functional, positivistic characteristic is one facet of the non-place, another comprises the relations between the individual and these spaces, a notion that Augé sums up when he states that "as anthropological places create the organically social, so non-places create solitary contractuality," the modernist roots of which I have alluded to above (94). The merely functional, cookie-cutter style of lodging, whose social and cultural meaning has been stripped down to the essential contract of space over time, neatly epitomizes this aspect of the non-place's supermodern nature.

The democratization of travel, the increasing homogeneity of postwar spaces related to transport – especially that of the hotel – and the blurring of aesthetic and experiential lines between the resulting non-spaces (e.g., terminals merging into lounges into lobbies, etc.) reinforce Augé's notion that the act of travelling and the experience of the non-place are intimately connected.[24] At this point, the intersections between contemporary state anxiety and the phenomenon of the travel-oriented non-place become clear. Airports, stations, and hotels are all spaces occupied by those in transit. They are ports of access, staging grounds for activity by non-residents, and thus they represent areas of particular concern. That these spaces create physical clusters is also germane to the state's management of its own integrity and, as is evident in the case of countries for which internal territorial excision has become a regular practice, there is a distinct relationship between non-places and the state's determination to plot its own sovereign trajectory through spatial manipulation regardless of international conventions. This can result in the drastic action of an apparent contraction of state sovereignty on the one extreme and, on a lesser scale, the commandeering of specific spaces for precise state purposes. In the case of the hotel, what was once a space of decompression and upper-class transculturation can become, then, an airlock for the state, a non-place that has seen its latent political and authoritarian potential activated through policing and policies of containment.

In his conceptualization of the non-place, Augé keeps his reading of the experience of the spaces involved limited to what one can call "authorized" travellers. Given the themes that I have broached here, this is an important distinction. For Augé, an inherent part of the contract that an individual assumes in order to enter a non-place is that he/she must be "innocent" (102). Reading the space of the hotel through the lens of interdiction and other state practices shows the extent to which this take on

the non-place needs to be supplemented. And while the Hôtel Arcade may have been used as part of a process of spatial excision that, as demonstrated in the *Amuur* case, was ultimately an unlawful manipulation of French territory, elsewhere, the use of hotel space for interdiction and detention has been integrated into the state's prescribed parameters of frontier management. A brief description of this use in Canada is helpful in assessing how a state can inflect the non-place politically and the effect of this on the unauthorized traveller.

As a leader in the successful pre-emptive interdiction practice of controlling unauthorized immigration at its sources, it is surprising that Canada was slow off the mark in terms of the creation of purpose-built immigration detention centres. While the sinisterly named "Centre de la prévention de l'immigration" still operates in Laval, Quebec, the principal holding centre in Toronto – Canada's busiest entry point by air – was, until 2004, the Celebrity Inn. Formerly the Avion, the Celebrity was a typical airport hotel located close to Terminal 3 at Lester B. Pearson International. It was not a run-of-the-mill establishment, though: in addition to lodging "normal" travellers in one wing, it also served as a secure detention area for people who had arrived without proper identification and those immigrants who had been placed in Citizenship and Immigration Canada's "removal stream" and were awaiting deportation.[25] Pratt's description of who these people are is enlightening: "These immigration 'holding centres' are for the detention of noncriminal noncitizens, people who have come to the attention of the authorities, who have violated or are suspected of having violated Canadian immigration law, and who are judged, initially by immigration officers and subsequently by adjudicators to represent a 'flight risk' … Detention is *for* deportation" (27).

How the hotel came to be an important centre for state control practices in the Canadian system is indicative of the progression in interdiction and immigrant management processes as they pertain to spatial management as well as to policy development. Originally, the Celebrity Inn was a carrier-run operation with what had been the state airline, Air Canada, which was responsible for the costs associated with the management and upkeep of the detention areas. Faced with the increasing need to co-operate with other airlines and process their illegal arrivals, as well as with the changing nature of detention (e.g., the need to accommodate visa overstays who would be held pending hearings and appeals), the company abandoned this part of the interdiction business. Detention then became a publicly tendered three-year contract, one that, over time, came to represent very lucrative business for the successful company. Thus, a closer look at the practical aspects of the management of this space reveals a public–private arrangement that blurs even further how the state viewed the status of those held in the detention hotel. In 2004, the Celebrity Inn ceased to function as a detention centre when the no-less-ironically named "Heritage Inn" – another hotel, but one that had been specifically modified for processing in addition to detention

4.1 *Heritage Inn, Toronto*, 2017. Photo: Paul David Esposti.

– opened its doors. Canadian Border Service now administers all aspects of irregular immigration (figure 4.1).[26]

The fact that two distinct types of travellers occupied what was essentially the same space, save for the locked door leading to the detention wing, shows just how different their experiences of the same non-place could be. While the traveller in the homogeneous airport hotel may indeed relax in its "gentle form of possession to which he surrenders himself … [and] … tastes for a while – like anyone who is possessed – the passive joys of identity-loss," detainees who find themselves in the exact same space are confronted by the fact that, in their case, the emptying of individuality at the site where supermodernity meets state anxiety truly is an "ordeal of solitude" (93). In their precarious setting, between *arriving* and *arrival* or *departing* and *departure*, the sound of air traffic serves as a constant reminder that their "innocence" has not been established, and, as such, the state has not ratified their status as a refugee, migrant, or even as a traveller. The contractuality that they experience is imposed, not chosen. Movement is thus managed through a state policy that enforces the non-place solitude experience; unlike that of the authorized traveller, it is not theirs to "enjoy" at their leisure. Furthermore, what Augé sees as "taking up a position" in the experience of movement is co-opted by the state's own positioning in terms of its existing practices and future desires. The Celebrity Inn represents a key moment in the crossover between state improvisation with existing built space and the construction of purpose-built institutions. The ultimate extension of the camp cited by Agamben, which he sees as having been "securely lodged within the city's interior," is nowhere better seen than here. The transformation in the Canadian context from the requisitioned Celebrity Inn to the purposefully modified Heritage Inn detention facility can thus

be viewed as representative of the birthing process of what the Italian philosopher identifies as the new biopolitical *nomos* of the planet (176).

In his conceptualization of the non-place, Augé insists as well on the presence of a textual element, stating that "[non-places] have the peculiarity that they are defined partly by the words and texts they offer us: the instructions for use (prescriptive, prohibitive, informative)" (96). When a non-place like a terminal or hotel is commandeered by the state for interdiction or flow-management purposes, this textual component is transposed following the initial key exhortations that a traveller show valid identification and the requisite permits. Once failure at this stage has occurred, questions of textuality are displaced from the immediate environment of the non-place since messages such as boarding announcements, advertising, and customer service information no longer apply. The issue of text for the unauthorized traveller instead becomes one related to documentation: applications, appeals, and in some cases litigation. Once more, the ritual paperwork of the traveller by choice evaporates, leaving behind the red tape of detention and its consequences.

Refuge

State interdiction strategies have involved a high degree of ingenuity and exemplify the lengths to which some countries will go to skirt their international commitments. The ways the hotel has been used in the practices of interdiction and detention highlight the space's potential to be quickly employed contrary to its normal use. Nevertheless, what I call the "displacement hotel" is not limited to this type of regime, and its form of occupancy need not be exclusively one of detention. In response to the need for temporary housing for displaced people who *have* been allowed entry, hotels serve as important parts of reception and settlement efforts. As during wartime, the space's inherent flexibility and capacity to tweak the form of occupancy that it offers once more make it an ideal destination for those who require immediate shelter. This more humanitarian response to the experience of displacement has been used in both Germany and Canada, two countries that are particularly involved in resettling Syrian refugees, and the hotel has become part of that process. Here I consider specific cases of this different form of displacement hotel as well as the ways in which documentary film and radio have helped communicate the experience, thus beginning to tie the realms of imagination and built reality together.

An early iteration of the displacement hotel was the Lloyd in Amsterdam. As Ellie Sywak observes, "the Lloyd Hotel has served many purposes – from the most luxury emigrant hotel in Europe, to a prison during World War II, to artist studios in the 1990s" (Sywak). Designed in 1918 by Every Breman for the Royal Dutch Lloyd Company, the building could hold nine hundred people and accommodated emigrants before they travelled on to other ports (Sywak). With the company later

bankrupt and the hotel in the hands of the city of Amsterdam, it became a shelter for
Jews fleeing Nazi Germany. In a telling marker of just how pliable hotel space can be,
immediately upon being seized by the occupying Germans, the Lloyd was converted
from a refugee sanctuary into a prison. Its postwar life as a detention centre would
continue until 1964, when it became a specific-use facility for juvenile offenders until
eventually transforming into an artist space in the late twentieth century and finally
being restored to hotel status in the twenty-first (Sywak). The Lloyd's varied history
is symbolic of the relationship between flows and occupancy. From a way station for
those on the move to new lives, it became a practical response to the housing needs
of the displaced before seeing its use of space altered and its form of accommodation
twisted into detention.

The Lloyd's original switch from luxury hotel to shelter was in response to targeted
violence against a specific ethnic group. Some sixty years later and for a very similar
reason following the collapse of the Soviet Union, the Iveria Hotel in Tblisi underwent
a comparable transformation. When it was originally constructed in 1967, it was the
tallest building in Georgia and the most luxurious Soviet hotel, fitted with Finnish
furniture, bars, restaurants, and even a swimming pool on the roof (Meador 8). Civil
war in Georgia saw 400,000 ethnic Georgians displaced from the disputed territo-
ry of Abkhazia, a former Soviet vacation spot in the west of the country (Meador
11; Kaushik). Faced with a crisis in housing the refugees, the Georgian government
turned to hotels given the large, now-unused tourist infrastructure (Meador 16). A
thousand of them moved into the Iveria, transforming it into a de facto refugee camp
that they would occupy for ten years. Thus, what was once a luxury hotel catering to
rich foreigners and privileged party members became a vertical village for displaced
Georgians with markets on each floor and rooms and balconies modified to allow for
maximum occupancy (figure 4.2).

Journalist Paul Bradbury describes the interior from a visit he made during 2001:

> The carpets are long gone (now bare concrete), the walls boast bare plaster, the health
> centre on the ground floor I couldn't visit as the stench of urine on the marble stairs
> forced me back upstairs. There was grass growing on the sixteenth floor.
>
> On each floor there are small stalls selling vegetables, chocolate and, of course, al-
> cohol. There is no work and the government pays seven dollars a month in benefits.
> Incredibly, on the third floor, there is a fully functioning hotel with Internet and fax
> services; on the ground floor there is a casino and also a restaurant that was hosting a
> wedding party as we passed. (Bradbury 76)

In this example of luxury accommodation responding to the phenomenon of dis-
placement, we see how a former marker of pride, an architectural trophy that pro-
claimed inclusion in the international circuit of high-end travel, morphed into a
beacon communicating visually the obvious consequences of regional conflict until it

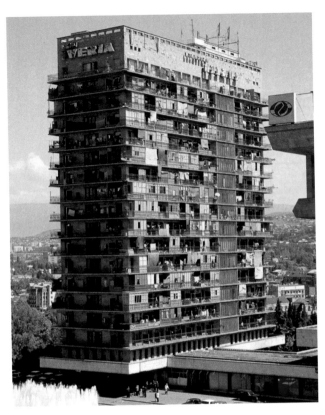

4.2 *Hotel Iveria in Tblisi, Georgia*, 2001. AP Photo/Shakh Aivazov.

was returned to its former state in 2004. According to Kaushik, following the Rose Revolution and the resignation of then-president Shevardnadze, the Georgian government decided to clear the hotel, giving $7,000 per room to the residents who subsequently moved out. Refurbished by the Radisson group, it is now the Radisson Blu Iveria and is unrecognizable from its former incarnation (figure 4.3).

One of the most moving stories of a hotel-as-refuge in the late twentieth century is that of the Hôtel des Mille Collines in Kigali, Rwanda. When tensions between Hutus and Tutsis reached a breaking point in 1994 in the wake of the assassination of the Rwandan president, the Hutu militia Interahamwe initiated the early stages of what would become known as the Rwandan genocide. In the face of growing violence and confusion regarding the West's response or, better yet, lack thereof, to the widespread killings, hotelier Paul Rusesabagina kept the Mille Collines running and sheltered over 1,200 Tutsi and Hutu refugees, including many children from a local orphanage. Rusesabagina's extraordinary bravery and nous inspired the critically acclaimed 2004 film *Hotel Rwanda*, which depicts the daily struggles that the manager – himself a Hutu married to a Tutsi – faced to keep the hotel running. What is especially

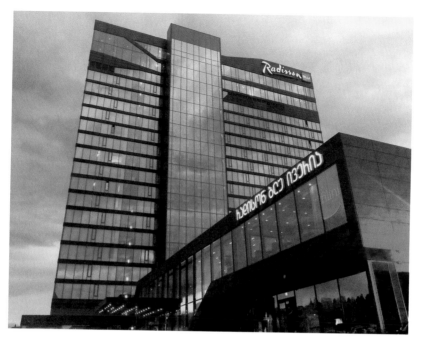

4.3 *Radisson Blu Iveria*, 2013. Photo: Beniamin Netan.

illuminating about the case of the Mille Collines is how it maintained its appearance as a four-star international hotel during the crisis. Owned at the time by the Belgian airline Sabena,[27] the hotel was both a base for foreign tourists looking to go on gorilla-spotting expeditions and a popular haunt of the Kigali elite. When the violence began, maintaining the illusion of exclusivity became essential to the security of the perimeter. The hotel's international aura and cachet could not be compromised. Any change in the perception of the hotel, especially if it were to be considered an overt refugee camp, would have seen the compound overrun much sooner than it eventually was. This tense dynamic is well presented in Terry George's film, and Paul, played by Don Cheadle, at first struggles with the palpable strain between protecting locals in danger and the Sabena dictum to "never lower the tone of the hotel." Any hesitation is brief though, and the hotel quickly becomes a sanctuary for hundreds. The film repeatedly underlines the importance of perception and shows the measures put in place to stymie militia attempts to find and identify Tutsis: bills are distributed to "guests" to maintain the illusion of normalcy while the manager has carpenters remove the room numbers from doors and instructions are given to erase the hotel registry. Ultimately, though, after many close calls and an aborted evacuation of refugees, staying at the hotel becomes untenable and it is abandoned. While the hotelier and his family were forced to leave Kigali and Rwanda, Rusesabagina's humanitarian legacy and that of the

Mille Collines live on, the hotel now famous as a site of sanctuary during one of the bleakest periods of the twentieth century.

The Syrian Refugee Crisis: Germany

Since the beginning of the Syrian Civil War in 2011, millions of residents have suffered both internal and external displacement. As of 5 January 2017, 4,860,836 people had been registered as refugees in countries outside Syria ("Syria Regional …"). Neighbouring Turkey had accepted over a million people and also served as one of the conduits for asylum seekers heading to central Europe. While other countries were closing their borders or making sure that refugees only passed through their territory,[28] Chancellor Angela Merkel positioned Germany at the forefront of European resettlement efforts and thus, in response to the greatest refugee crisis since the Second World War, Germany became the first European country to suspend the 1990 protocol that required refugees to seek asylum in their country of arrival ("Syrian Refugees"). As a result, the number of Syrian asylum seekers in Germany grew steadily with German government documents reporting that some 158,657 people had requested asylum by the end of 2015 ("Migration Reports"); later estimates would peg the total number of Syrian refugees in the country at 300,000. The high number of newcomers strained the German state's settlement system, which had been highly selective previously ("Germany: Resettlement Quotas & Actors"). An important part of the resettlement effort consisted of building accommodations and reception centres for the newly arrived Syrians. Thousands of units of modular and quick-to-build structures went up, inspiring architectural contests and serving as the focus of Germany's pavilion at the 2016 Venice Biennale, thus bringing design and aesthetics together with humanitarianism.[29] Even with such construction, though, multiple venues were needed to help meet the demand. Of the many different spaces repurposed in Germany, including military barracks and cultural centres, former town halls and office buildings, I propose that two privately run hotels stand out for symbolic reasons: the Spree Hotel in Bautzen for persisting in the face of violent protest in the region and the Café Wald, located deep in Bavaria, for being a space that having once epitomized German *Heimat* would subsequently cater exclusively to refugees' settlement needs.

The Spree Hotel is located in the hill town of Bautzen in eastern Saxony (figure 4.4). A former business hotel that struggled to survive, the Spree went through incarnations as both a leisure hotel and a home for the elderly but to no avail (Sethi). While the owner looked for a way to keep the establishment going, as Sethi observes: "In the meantime, the population of Bautzen steadily shrank, from about 47,000 residents in 1995 to about 39,500 in 2014, making it harder and harder for him to improve business. In the summer of 2013, he learnt that the local administration was struggling to house refugees and decided to help." Thus, the Spree became a home for refugees

4.4 *Gate at the Spree Hotel, Bautzen*, 2016. AP Photos/Jens Meyer.

capable of hosting 256 people with the kitchen repurposed to allow residents to cook their own meals and the bar/restaurant converted into a common area for people to gather (Sethi). Unfortunately, the Saxony region has seen violent protests against refugees, and during riots in February 2016, the Hotel Husarenhof was fire-bombed after it had been repurposed for refugee settlement but before anyone had taken up residence (figure 4.5). The *Guardian* reported at the time that a crowd of locals cheered as the Husarenhof burned (Oltermann). The Spree continues to operate and to accommodate refugees, but in light of the danger of racist attacks, owner Peter Rausch, who had previously protected the building with a razor wire fence, has also had to install special glass to guard against Molotov cocktails (Paterson; Collins). As elsewhere in Europe, the backlash against the presence of foreigners is very evident in Germany.

While the Spree was previously a non-descript business hotel and had existed in other forms before it began housing refugees, the Café Waldluft, a rustic hotel in the picturesque Bavarian town of Berchtesgaden, had long been a destination for visitors interested in hiking or taking in the local spa towns. It also served as a lunch stop for the many coaches that ply the valleys on tours of the Bavarian Alps. More recently, though, it is a town that has received its share of asylum seekers. In his insightful 2015 documentary *Café Waldluft*, director Matthias Koßmehl explores the experiences of these men along with the lives of those who receive and come into contact with them. The documentary, in which the director is never seen, begins with a quote from a sign in the town that epitomizes the place's sense of idyll: "Those who God loves, he drops into this country." Before the viewer meets the latest to have been dropped into the area, Koßmehl shoots a town parade in slow motion. Locals in traditional Bavarian

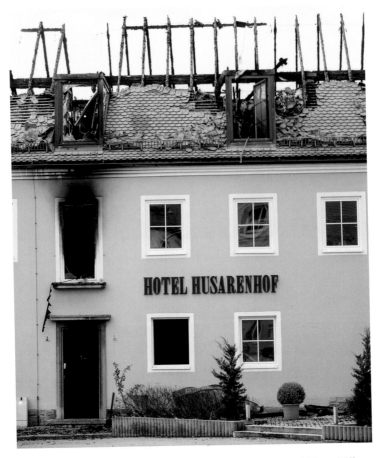

4.5 *Burnt Former Husarenhof Hotel, Bautzen,* 2016. EPA/Oliver Killig

garb march to festive music, smiling and laughing as men fire celebratory shots into the air. Everyone is white.

The film's title shot further instils a feeling of living within nature as the name of the documentary is centred between the clouds and the valley (figure 4.6). The peaceful scene is then interrupted by the arrival of a tour coach that advertises a "Bavarian Mountains and Salt Mines" tour on its side. The guide onboard provides his clients with background information that also helps the viewer, informing us that the town of Berchtesgaden has 10,000 people and dates back to 1102. Our first sight of the Café Waldluft shows its terrace enveloped in greenery while a man paces outside and speaks on his mobile phone. With cuts to a "No Occupancy" sign and a shot of a German flag being raised, a slow pan of the interior begins, revealing the owner of the hotel, Flora Kunz, from behind as she responds to phone inquiries. Koßmehl then gives the viewers our first full look of the hotel in a low-angle shot of the building in

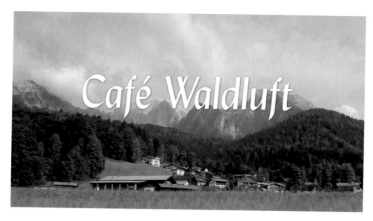

4.6 Title, *Café Waldluft*. Still © M. Kossmehl

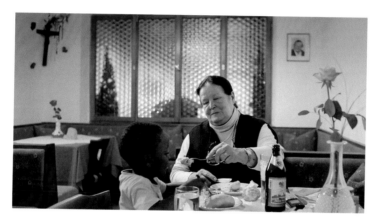

4.7 *Dinner at the Waldluft*. Still © M. Kossmehl.

bright sunlight. These carefully constructed opening scenes set the visual tone of the space and introduce motifs that will recur throughout the documentary and be revisited in different forms at the end of the picture.

With a cut to Flora eating in the dining room, we are formally introduced to her – notice, particularly, the carefully arranged mise-en-scène that further establishes the tone of the space (figure 4.7).

As is evident in the image, Koßmehl offsets previous close-ups of the crucifix in one corner and the portrait of a dead loved one with this medium shot of Flora eating veal sausage and drinking beer in the company of a small African boy. As they talk, she feeds him from her own plate, an act of generosity that is another marker of the tone of humanitarianism evident in the space of this hotel turned shelter. More details emerge as Flora speaks: the hotel holds thirty-five guests, and while at first asylum

seekers and tourists were mixed together, the Waldluft is now exclusively dedicated to refugees who are waiting for various aspects of their processing in Germany to be completed. As if reading the viewer's mind, she mentions that at first "it was a shock for the local people."

The touristic nature of the surrounding area gradually emerges as the viewer hears of the popular hiking and thermal baths nearby. In terms of the hotel itself, we learn that it was originally a "classy villa" for people to rent and then are told some important facts about its history. Notably, the former owners of the site have all had a history of being displaced themselves. First, the viewer learns that the initial titleholder had been the mayor of the town but upon finding himself on the wrong side of a political struggle, was forced to leave for the US with his family. Then, Peter Kurz, Flora's ex-father-in-law took over the hotel after having been displaced from his own land when Adolf Hitler had built a house in the same area. Finally, we learn that children from German cities that had been bombed by the Allies had been housed there during the Second World War. In this way, the current form of the hotel, while shocking for the local residents, is part of a deeper continuum. This theme is further developed later on when the hotel's cook, Ursel Kramer, who is from the former East Germany, reveals her own experience of discrimination in the wake of the fall of the Berlin Wall and the subsequent reunification of the country.

While allowing the viewer in on the worries of many asylum seekers resident at the hotel, the documentary specifically follows three different characters: Flora (the owner), Ursel, and Jamshid, an Afghan refugee who is waiting for his passport and residency permit. The asylum seekers are all in varying states of limbo, waiting for documents, or for conditions to possibly improve so that they can return home. The sense that their occupancy of the hotel space is supposedly temporary is offset by their uncertainty and further counterbalanced by the constancy of the mountains that the building faces. The peaks serve as an anchoring trope for the film and also represent a willed destination for the cook, who confesses her desire to act as a tourist in her adopted region and scale the highest one across the valley.

The viewer also meets a handful of passing tourists including a sympathetic couple from Ireland and a young woman from Australia, who explains in no uncertain terms what she thinks of her own country's interdiction practices while a couple of the men at the hotel good-naturedly flirt with her. The most interesting of the tourists, though, is long-time returning guest Maria, who appears to be none too impressed with the new occupants of the hotel. She speaks in generalizing terms when she says that the act of vacationing in Berchtesgaden has been altered by the refugees' presence. Having to see them and be aware of their struggles while sharing the same space breaks the illusion of the vacation or the "idyllic world" as she puts it. The ability to bracket out reality is a luxury that is impossible for the displaced, and Koßmehl shrewdly juxtaposes Maria's complaints with a graphic recounting of the torture that the Syrian man suffered during time spent in one of the Assad regime's jails. The tension between

different ways of seeing the town, the revisited memories of pain, and yet the constant yearning for home drive this film.

The viewer also learns that Flora is herself an outsider, even though she observes that return visits to her hometown in Austria are different; "I am a stranger there now," she declares. She is an example of someone who has put down new roots and for whom home is a movable feast. "Homeland is the place where you live," she states matter-of-factly. The concept of home and *Heimat* are central themes in *Café Waldluft* and are further explored by the recounting of the local "Ganghofer Legend," which explains how the omnipresent mountain range came to be formed. The story goes that a king who had persecuted poor people trespassing on his land was turned into stone along with his family, thus creating the seven peaks that are visible across the valley from the hotel. The recounting of the legend in a way that serves to both explicate and complement the visual motif of the mountain in the documentary further ties the need for compassion to this particular social and geological landscape and centres the hotel as a site of both reception and projection.

In a displacement hotel that acts as a sanctuary, the traditional tourist concept of escape is radically transformed. For the traveller by choice, it is often a mental respite from the burdens of one's work life. For the refugee, though, escape is more literal, a physical flight predicated on safety and risk. The Café Waldluft may have the potential to be a zone of overlap for both forms, but from the perspective of Maria one negates the possibility of the other. The director includes a telling moment when she and Flora are sitting in the dining room watching a soap opera. Maria, who is very taken by the story, observes that because she is alone in life, she needs the narrative of the soap opera; for her, its continuity is an important salve for her solitary existence. Meanwhile, Koßmehl juxtaposes this privileged perspective by showing how one Syrian asylum seeker at the hotel addresses his loneliness by composing poetry about his homeland – two different forms of storytelling used for different purposes.

The documentary ends with scenes reminiscent of how it began: the viewer is back on the coach but this time Ursel is there too; she has decided to follow through on her desire to play the tourist and scale the mountain. Even though it is a cloudy day and the view is limited, it does not seem to matter to her; she is just happy to be there. "You have to enjoy your homeland," she states. Enjoyment is plain in the final scene, too, when the camera roams the streets of Berchtesgaden following Germany's World Cup victory. The *jouissance* is total as people celebrate on foot and in cars. We see the Afghan man, Jamshid, whom we have been following throughout the film as he waves a German flag while chanting "Deutschland!" and sharing in the collective joy. This alternate parade, one clearly different from that with which the documentary began, is optimistic. Here, the inference is that sport is seemingly capable of transcending difference and team affiliation is open to anyone, regardless of the country of origin. This then is a cosmopolitan *Heimat* that the refugees who inhabit the hotel are able to access. At least for one, the hotel has acted as a portal to a new possible belonging.

The Syrian Refugee Crisis: Canada

Canada is a country composed of First Nations and immigrants and has long depended on immigration for sustained population growth. In the wake of the publishing of the Alan Kurdi photograph, Canada's response to the Syrian refugee crisis became a campaign issue during the 2015 federal election. The Liberal Party, headed by Justin Trudeau, promised to accept 25,000 refugees should it be elected. Upon assuming office in November of that year, the government set about fulfilling that promise. As of 19 December 2016, 38,713 Syrian refugees had arrived in Canada (#WelcomeRefugees).

Refugee resettlement in the Canada operates under various categories. Canada is one of only a few states that permit privately sponsored refugees; that is, newcomers are proposed by private groups such as churches or clusters of citizens, who then bear the financial and time commitments of settling those they sponsor. In the case of Syrians displaced by the civil war, publicity around their situation prompted thousands of Canadians to organize in private groups in order to be matched with Syrians on the government list. The other large category of refugee is the GAR, or government-assisted refugee, whose resettlement costs are borne by the state but whose practical needs are left to settlement agencies in the cities where they are sent. In the third category, the blended Visa Office–referred refugee, private groups handle resettlement issues with a half-payment from the government for basic needs.

Three hundred and fifty communities in Canada have organized to accept Syrian refugees; a further 20,000 people have applications that are either in process or have been finalized but have not yet travelled to Canada (#WelcomeRefugees). Needless to say, housing the newcomers, many of whom have large families, is a challenge for both settlement agencies and private committees alike. Given travel and processing delays, many of the latter found themselves paying rent on apartments for months while they waited for "their" Syrians to arrive. Meanwhile, given housing shortages and high rents in Canada's major centres, resettlement agencies were forced to improvise in terms of short-term accommodation. Once again, the hotel emerged as a crucial space.

During the height of Canada's resettlement efforts for the Greater Toronto Area, one hotel in particular became ground zero for receiving and rendering services to government-sponsored refugees: the Toronto Plaza Hotel. Like the now-closed Celebrity Inn and its replacement, the Heritage Inn, the Plaza is extremely close to Pearson International Airport, making it a convenient place for travellers in transit. Unlike the detention facilities, though, refugees who were accommodated there were free to come and go as they pleased. That said, the challenge of finding affordable housing would keep many lodged there for much longer than they had initially imagined. *Hotel Limbo*, a radio documentary produced for the Canadian Broadcasting Corporation took an in-depth look at the hotel during this intense period.

Eighteen hundred Syrian refugees came to Toronto during this initial phase of the humanitarian effort, and as one CBC producer observed, the Hotel Plaza was more than a stopgap; it "took on a life of its own." The documentary's title succinctly captures the state in which the newcomers found themselves – the Plaza was meant to be a temporary stop, but given that the rental market in Toronto was already tight, especially so for units capable of housing large families, it became a longer-term solution.

Producers visited the hotel over a period of three and a half months to speak with the government-sponsored refugees. For one of the producers, Yasmine Hassan, her first visit to the building evoked personal memories of a much different place: "The first time I walk into the hotel, I'm thrown. The crowds, the sounds all take me back to the memories I have of visiting Cairo during summer holidays. I was even a bit intimidated. The pieces of life all have to be re-established. Bit by bit. Hundreds of people with their lives on pause. All they can do is wait" (*Hotel Limbo*). Even though the hotel accommodated an average of 550 Syrian refugees between January and March of 2016, it remained open as a tourist/transit hotel. In the radio documentary, one such tourist who was surprised to find herself among the newcomers states, "I feel like an immigrant; because I'm not fitting in," but then displays a high degree of compassion: "You have to realize that these people have been through a lot and you have to take care of them now." A similar story emerges later in *Hotel Limbo* when the concierge recounts the reaction of visitors from Texas who were overwhelmed by the situation and started giving hugs to the refugees while thanking the volunteers and apologizing for their own (US) government's inaction.

The space of the hotel is suitable not only for the temporary housing of the refugees but also for providing the settlement workers from the organization COSTI Immigrant Services with an onsite space. Having their people stationed on the ground made for more efficient interactions, but even so, the organization was overwhelmed at first in part because of the difficulty in securing long-term housing. A conversation in the documentary with the COSTI representative leads to a brief history of the Plaza, which while tired and worn down now, was originally a trendy hotspot on the outskirts of Toronto. The Beverley Hills Motor Hotel, as it was known then, sported the Hook and Ladder nightclub and could boast of having hosted many big names such as Duke Ellington over its history. During the influx of refugees, conference rooms were commandeered for weekend programs such as volunteer-run English classes. The COSTI representative also explains how the Toronto school boards cooperated with the organization to take children for half-days so they could become familiarized with the education system in the country. Many of the children had missed years of school, if they had ever been at all.

As the director of COSTI muses, it is perhaps inevitable that when people are placed into a a new situation over which they have very little control, smaller things that they can comment on become large. In this case, the quality and nature of the food being prepared became a source of contention for the Syrians. Likewise, one

refugee remarks that while they are happy to be in Canada, they are not happy to be in the hotel. And as the producers observe, anxiety breeds paranoia – clearly evident in the worries of one man who feared that blood being taken from his pregnant wife was being given to the blood bank. Other residents of the hotel express concerns about future housing and explain that they were never told anything about what would happen once they arrived in Canada. "It's worse than being in Syria. I swear, it's worse than being in Syria," one proclaims.

An interview with Shahaan Malik, the front-of-house manager at the hotel, shows how the day-to-day involvement of the staff with the refugees created links that normally do not occur in a travel hotel of this type. As Malik observes, "it felt different when some of the families left – but then more busloads arrived." The dual nature of the Plaza meant that it often fell to him to explain what was going on. Whereas in the past he could explain periods of crowding at the hotel by pointing to visiting conventions, the newcomer resettlement was a novel experience.

When the producers returned nine and a half weeks after their initial visit, the hotel was very different. Many families had moved out (figure 4.8), and as one person observes, it was emotional because "they [had] settled in." The nature of what was meant to be a short occupancy had transformed and the Plaza Hotel was forced to function as more than a hotel; it had to become a residence.[30]

The Plaza was not the only hotel employed during the Canadian resettlement efforts of late 2015 and early 2016. Others included establishments such as the Studio 6 in Toronto[31] and various hotels in Hamilton, which garnered some notoriety when refugee families were temporarily relocated "to accommodate a crush of visitors to the city for a series of concerts by country music legend Garth Brooks" (Quan, "Syrian Refugees"). One of the more amusing stories of refugees being lodged temporarily in a hotel came from Vancouver. The *Huffington Post*'s headline from 10 March 2016 says it all: "Syrian Refugees Get Put Up in Same Hotel as Furries. Kids LOVE It" (Ferreras). Organizers of the event, which caters to those who like to dress up as anthropomorphic furry animals, were concerned that their gathering might be a shock to the newcomers, but given the smiles on the faces of the refugee children who rushed to meet them, they need not have worried.

Backlash

The transformation of tourist and business hotels into temporary or long-stay housing for refugees has not been without its critics, and the violence perpetrated against refugees in Bautzen stands as a dangerous high-water mark. In *Hotel Limbo* producer Craig Desson interviews two men in one of the only places where you would not find refugees in the Plaza Hotel during its stint as a sanctuary: the run-down bar located just off the lobby. There, one regular customer since the '70s bemoans the overall

4.8 *Last Syrian Family Leaving the Toronto Plaza Hotel.* Getty Images/Carlos Osorio

decline of the establishment before giving the podium to another patron, Brian, a long-term resident of the hotel who will soon be evicted to make space for more refugees. The two men criticize the lack of supervision of the children, accuse the Trudeau government of hurting at-risk Canadians in favour of foreign nationals, and also worry about possible terrorism threats due to the humanitarian effort.

While a February 2016 poll found that a slim majority of Canadians supported the government's Syrian refugee resettlement plan, concerns regarding security, cost, and the pace of the program became evident ("Canadians Divided"). In terms of the use of hotels, it is not surprising that the use of the space for both tourists/travellers and refugees disappointed some customers. As we have observed throughout this book, hotels come with their own set of expectations regarding service, how the space is organized, and the ways in which one is able to occupy that space. The fundamental illusion of a hermetically sealed room of one's own is part of the hotel's "space over time" equation, and even though we are aware that thousands of people have slept in the bed we will retire to, the way that rooms are staged allows us to imagine that it is "fresh" and new. That people may be improperly occupying hotel space can strike a nerve. This seems to be at the heart of the complaints of one TripAdvisor patron who was clearly unhappy with the presence of Syrian refugees at a Toronto hotel that had been used during the height of resettlement efforts (figures 4.8, 4.9). Others, like Jay Walker at the British Columbia Institute of Technology, respond to refugees' complaints about being stuck in hotel limbo with statements like this: "Ohh boo hoo. so your [*sic*] in a hotel room, do you have to worry about a bomb landing on your roof? Nope. They are now SAFE from war, if that's not good enough for refugees then too bad" (Loriggio and Jones). Another commenter, Chris England of Cambrian College,

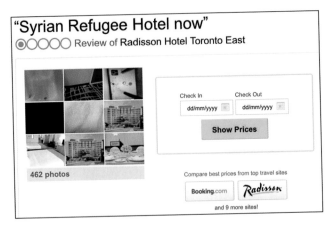

4.9 Screen capture, TripAdvisor

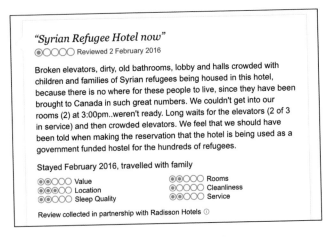

4.10 Screen capture, TripAdvisor

writes: "Unbelievable … the Canadian taxpayer is footing the bills for their travel, hotel, food, medical and dental expenses and they're whining because it's not enough, Send them back to the ME and use the money being spent to house these 'refugees' to help Canada's seniors, homeless, mentally ill and veterans" (Loriggio and Jones).

In England, the *Telegraph* reported on 18 January 2016 that an accommodation centre for failed asylum seekers cost "more than the world's most exclusive hotels" and took in only fourteen families in 2015 at a cost of more than £450,000 pounds each (Barrett). Writing in prose that compares the centre to the Royal Penthouse Suite at the President Wilson Hotel in Geneva, the author lists the amenities provided and cites an auditor's report condemning underuse of the space. Meanwhile, in Texas, federal immigration officials have supported plans to create a five-hundred-bed family

"hotel-like" detention centre for migrant women and children (Feltz). The private company bidding for the contract to repurpose an old camp for oil workers paints a rosy picture of the future detention facility: "Our facility offers a community-based alternative that will allow children to live in a home setting, attend school, and access critical legal and social services" (qtd in Feltz). Critics point out, though, that "if you are not free to leave, then it doesn't matter how nice it is. It's a prison" (Feltz). Finally, the violent events against the Spree Hotel leave no room for doubt: safe havens are never completely secure, and even if the hotel has managed to recoup part of its status as a secular sanctuary, it is still precarious and in real need of vigilance and support.

CONCLUSION:
THE HOTEL ATTRACTION

This book has examined how the realms of the imagination and the built environment have acted as frameworks to better understand the hotel's symbolic manifestations and real-world uses. From painters and photographers engaging with the space to cinema's long and rich history with it, I have paid particular attention to what the hotel has meant and could mean as part of the visual arts from a narrative and documentary perspective while my readings of both the wartime and displacement hotels have sought to offer new interpretations of this ubiquitous modern space. A singular, precise, and comprehensive notion of the hotel is notoriously hard to pin down and that is why I have interpreted it broadly through the flexible concept of "occupancy," which, like the space itself, is adaptable and in its many meanings captures well the radical possibilities of dynamic use that the hotel engenders. As we have seen, even the hotel's most essential formula – space over time – is routinely challenged and modified by the changing demands of circumstance and design.

Whether out in the world, on canvas or on celluloid, hotels are buildings, assemblages of smaller spaces and processes. As Brian Larkin reminds us, there are poetics in planning and in infrastructure.[1] I would add that given the hotel's unique characteristics as a veritable city unto itself, it is not surprising that the imagined world and the real one are constantly overlapping and that the hotel and the way of being it engenders figure prominently in this dynamic. I find Larkin's notion that infrastructures operate as systems by creating the grounds on which other objects operate (329) to be particularly interesting and see similarities between this concept and the range of ways in which hotel space has appeared and continues to manifest: sometimes it is merely part of the urban background or a vehicle for a social aesthetic; at other moments it functions as a space for travellers and for combining disparate people; or it acts as a sanctuary, a prison, or a temporary home for the displaced. The line between imagined and real, between the poetic and the concrete is mutable, and thus I would like to end *The Hotel: Occupied Space* with an especially notable example of this potential fusion: the fanciful and contested notion that the renowned Catalan architect

Antoni Gaudí once designed a massive hotel for New York City. This case, which has all the hallmarks of a historical thriller, combines a compelling core idea with an amazing discovery, an enthralling, potential modern-day use and imaginative design in the hopes of making real something that seems to have existed only in the realm of the imagination. That so many have been roused by this idea is a testament to the power of the hotel to act across domains, inspiring and captivating supporters. Before dealing directly with this elusive structure, though, it is necessary to briefly describe the context from which this idea was said to have sprung and also observe that another phantom hotel was already haunting Barcelona.

The modern Catalan experience was marked by three, if not four, competing aesthetic and political currents that jockeyed for position and, at times, overlapped and informed each other over a span of some forty years beginning at the end of the nineteenth century and stretching well into the twentieth. From the organizing principles of the *renaixença*, through *modernisme*'s elaborate literary and architectural works, up to *noucentista* classical corrections and an avant-garde that competed with anarchism for prominence, the Catalan capital, Barcelona, was the focal point, absorbing and refracting trends and styles as it grew into a metropolis. Even as a peripheral player on the national political stage, the city strove to create its own critical mass, a process made easier by the rise of a politically enabled Catalan bourgeoisie during the second half of the nineteenth century.

Understanding Barcelona's urban experience is central to my proposal that the idea of the Hotel Attraction may be read as a form of willed transatlantic *modernisme*. Cultural modernization in Catalonia entailed a growing sense of nationhood and of difference in relation to the Spanish state. One event in particular, the Universal Exposition of Barcelona in 1888, may be considered a watershed moment; it was the bourgeoisie's chance to turn towards Europe and show off artistic and economic advances. Although the event lost money and sparked both financial and political recriminations, its aftermath did not dampen enthusiasm for greater European recognition.

The Exposition left important traces in Barcelona. Along with various monuments, it transformed the northern flank of the city by recuperating an area long controlled by the military power of Madrid.[2] I propose, though, that one building destined to become a phantom should be considered the most important – a more ephemeral monument to be sure – yet one in which the objectives and circumstances of *modernisme* crystallized better than in any other. That it was a hotel is not surprising. The Hotel Internacional was designed by the renowned architect Lluís Domènech i Montaner (figure 5.1). A dedicated supporter of political and cultural Catalanism, Domènech i Montaner contributed both theoretically and practically with works such as the Palau de la Música and the Café Restaurant that came to represent the first phase of Catalan architectural *modernisme*. The Internacional was Barcelona's first world-class hotel and was commissioned to address a serious shortfall in tourist beds – beds that would be needed to host an event of the Exposition's size.[3]

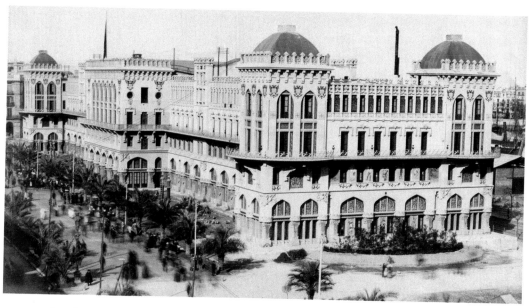

5.1 *Gran Hotel Internacional*, 1888–9. Arxiu Fotogràfic de Barcelona, Antoni Esplugas.

The importance of the Hotel Internacional to an eventual exportable version of *modernisme* fuelled by imagination and incarnated in the Hotel Attraction lies in the tension it created within its urban context. By participating in the reconfiguration of the Ciutadella's military zone, the Internacional's own particular synthesis of new technological advances in building – prefabricated modules designed to use whole bricks only – and a loyalty to the local vernacular tradition are expanded. In this way, the recuperative mode of *modernisme* is surpassed in favour of both an image that was meant to be projected and an active participation in a European aesthetic dialogue along with Morris's Arts and Crafts and the French Art Nouveau. Domènech i Montaner's observance of space and functionality had already placed him ahead of the Spanish curve. That he also considered his buildings as a whole in which all parts interrelated lends a sense of organicism that is complemented on a larger spatial scale by the fact that hotels and the global phenomenon of the world's fair were intimately connected via the activities of tourism and trade. In this way, Catalan *modernisme* as interpreted by Domènech i Montaner played to a large, international audience not only as a symbol but also as a physical experience of built space. This sense of architectural and aesthetic performance underlines the inherent theatrical aspect of the grand hotel, a baroque characteristic equally at play in its organic decoration and spaces like the lobby.

To press the point further, if the Universal Exposition site was the metaphorical foyer of a Barcelona that had been placed on display, then the actual lobby of the Hotel

Internacional may be read as an even more liminal zone. That is to say, that through the creation of a hotel on the same scale as London's Savoy or Paris's Grand and the concomitant replication of set spaces according to shared aesthetic codes, Barcelona effectively joined a transnational network that helped link it to a sense of a European centrality that it coveted and galvanized the confidence of the financiers and the architects whom they contracted. Stunningly for the populace of Barcelona, the hotel was dissembled after the Exposition was over. It was never meant to be permanent, and thus as quickly as the Catalan capital had found itself part of this international circuit, the vast physical symbol of that connection was gone. The Internacional became a ghost in the city's collective memory.

The story of the genesis of the Hotel Attraction, whose very name is suggestive for the way in which it combines both the attention and desire that Barcelona always sought, goes like this: in 1908, two unnamed American businessmen visited Gaudí in Barcelona and asked him to design a grand hotel for Manhattan. According to the tale, the architect drew up some sketches for the project but it was never realized and fell into oblivion until, in 1956, painter and sculptor Joan Matamala Flotats, who had worked in the sculpture workshop of the Sagrada Familia, revealed the existence of the Hotel Attraction project (figure 5.2). That year, Matamala published a short monograph entitled *Cuando el nuevo continente llamaba a Gaudí (1908–1911)* [When the New Continent Was Calling Gaudí], in which he included both the architect's sketches and his own elaborations on the theme and gave details on the proposed interior and special features of the hotel, such as a massive atrium with a smaller version of the Statue of Liberty. The building was to have been 360 metres tall, making it higher than the Chrysler Building and Eiffel Tower and just shy of the Empire State Building. In his work, Matamala describes how multiple dining rooms would correspond to the different continents while the outer towers would be residential with the majority of the central edifice dedicated to tourists. Matamala's "discovery" was a revelation, and the idea that Gaudí had designed a hotel for Manhattan at the beginning of the twentieth century took hold. After the destruction of the World Trade Center on 11 September 2001, a push began to resurrect "Gaudí's hotel." In 2002, an American architect named Paul Laffoley joined forces with others who wanted to enter the design in the competition for the redevelopment of the World Trade Center site (Field Levander and Pratt Gutterl 191). As Field Levander and Pratt Gutterl point out, once virtual models had been created by Marc Mascort i Boix (figure 5.3), the idea went viral, "generating international buzz and speculation about Hotel Attraction as a site of healing and hope" (191).[4] The new design is sleek and attractive and it is not hard to understand why it garnered so much attention and support. As a result of Matamala's efforts along with the actions of these contemporary enthusiasts, websites and books routinely attribute the Hotel Attraction to Gaudí. The only problem with this story is that, in all likelihood, Gaudí did *not* design the Hotel Attraction.

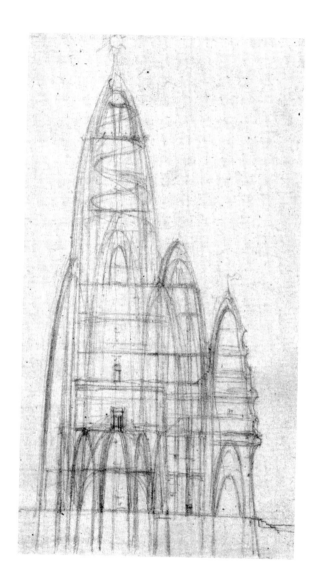
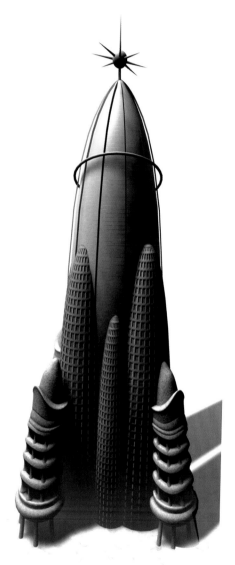

5.2 Hotel Attraction section drawing.
5.3 *Hotel Attraction and the Shadow of ...* Marc Mascort i Boix, 2002.
Based on the 3D model created by Àlex Beltran and Joan Guasch.

Architect and historian Juan José Lahuerta has convincingly argued that the most likely scenario is that Gaudí had nothing to do with the design of the hotel. In making his case, Lahuerta points out the following: first, neither Gaudí nor any of his disciples had ever mentioned the Hotel Attraction; second, none of the obituaries written when he died nor any of the studies of him mentioned it; third, the hotel does not figure in the 1927 Cercle de Sant Lluc exposition nor in the albums devoted to the Sagrada Familia; and finally, neither the critic Ràfols, who had consulted Gaudí's workshop archive while writing his first book on the architect, nor Puig Boada, who also had access to all of his drawings and documents prior to their destruction, mention it (Lahuerta 19). He further postulates that there is "too much silence" around such an attractive project that, on top of everything, would have meant that a man who never travelled would have gone to New York (19). He also casts doubt on another project supposedly meant for New York: Gaudí's "Office Building" that Ignasi Brugueras brought to light in 1952, the same date found on various drawings that Matamala did in follow-up to Gaudí's supposed design for the Hotel Attraction (20).

I agree with Lahuerta. At the same time, though, I believe that the clear and obvious power of the idea of the Hotel Attraction is still compelling and interesting. It is, I argue, a prime example of the symbolic power of the hotel and how imagining it can spill over into the real world. What is more, this phantom building speaks not only to the contemporary desire to heal a wound in New York City created by some "living-ego impulse" (Field Levander and Pratt Gutterl 191–2) but also to the transatlantic possibilities of Catalan *modernisme* and the context of Barcelona, which, as we have seen, had its own phantom hotel lurking in its recent past. This unique symbiosis of imagined and real hotel space makes the Hotel Attraction irresistible and a fitting conclusion to this study.

Now, if the built and then disassembled Hotel Internacional contributed to a *modernista* projection towards Western Europe, promoted integration, and thus marked the maturation of the Catalan modern process, the notion of the never-built Hotel Attraction sends the flow in another direction. What is more, by engaging with the nucleus of the American modern experience, New York, the dynamic of transatlantic *modernisme* meeting New World modernism becomes inflected in a different way. If Gaudí really had proposed a massive, elaborate hotel/skyscraper for Manhattan it would have been of singular importance and would not have taken decades to come to light. Not only would such a design have represented the realization of the aforementioned *modernista* expansion beyond Catalonia's borders – thus duplicating and solidifying the effect of the Hotel Internacional abroad – it would also suggest an intriguing fusion: what Laffoley has termed the "Bauharoque" or architecture of the post-, trans-, and neo-modern that would represent the last stage of modern architecture (Mascort 90). As Mascort further points out, the Bauharoque would be the union of the utopic impulse of the Bauhaus and the theatricality of the baroque (90). I propose that this may be tied further to the organicism of Catalan *modernisme*, in that

the eventual (and futuristic) advent of "smart" and "living" buildings is prefigured in a sense by the technical and aesthetic sophistication of *modernista* construction evident in Gaudí's and Domenech i Montaner's supposedly baroque excesses.

But what of the proposed urban context of the Hotel Attraction? What would it mean to construct a *modernista* building in modern New York? To consider this question is to turn again to the resonance of the *modernista* city, Barcelona, in the Hotel Attraction's capacity to bridge not only the Atlantic, but also the *modernista* and *noucentista* aesthetic modes. What I mean to say is that regardless of its stylized excess and ambitious attempt at global unification, one must consider that Catalan architectural *modernisme* was primarily expressed in the Eixample, the grid system expansion designed by Ildefons Cerdà and built in the 1860s.[5] In terms of form, the Eixample is rational ballast to the labyrinthine chaos of the old city, where the aristocrats had their power centre before they were usurped. The Hotel Attraction, an overtly *modernista* work allegedly planned for the epitome of the rational capitalist city, New York, would have echoed the physical context of Barcelona's own rational expression of urban modernity.

As a secular cathedral for the emerging reality of international travel and commerce, the Hotel Attraction would not have been a latent affirmation of Cerdà's vision, but rather the ultimate expression of a *modernisme* founded on the modern imperative of capitalism and urban development. If it had been realized, this lay counterweight to Gaudí's Catholic masterpiece, the Expiatory Temple of the Sagrada Familia – which was begun in 1882, some twenty-six years before the arrival of the supposed commission for the much larger hotel in Manhattan – would have marked an important architectural stage in the refinement process that characterized Catalan modernity and its quest to overcome a peripheral condition.

The Hotel Attraction, which has spawned maquettes and videos and even appeared in a graphic novel and featured in an "alternate reality" episode of an American television show,[6] is a wonderful example of the way in which the space of the hotel can be a focal point of imagination and reality. That the ethics behind the desire to create this building in New York City resonate with calls for compassion and true cosmopolitan understanding is laudable. One does not have to look far to see these values under threat and being mobilized; the way that hotel space has been used to detain those deemed "removable" by certain states is concerning, while stories like those of the Café Waldluft and the Toronto Plaza amply show its positive social and architectural flexibility. Painters, photographers, directors, journalists, and refugees have all understood – and continue to understand – hotel space and our occupancy of it differently. Perhaps that is the real power of the hotel: to inspire, suggest, confound, and challenge our interpretations of a space that we both imagine and experience.

NOTES

Introduction: The Overlooked Space

1 This is changing. Siegfried Kracauer's famous essay on German detective fiction, "The Hotel Lobby," and Frederic Jameson's equally famous treatment of the Los Angeles Bonaventure in *Postmodernism, or, The Cultural Logic of Late Capitalism* are the best known. More recent studies and considerations of hotels and hotel themes include: Krebs's *Hotel Stories* ...; Field Levander and Pratt Guterl's *Hotel Life: The Story of a Place Where Anything Can Happen* (not to be confused with the 1930s *Hotel Life* by Hayner); Wayne Booth's eclectic *Hotel Theory*; Joanna Walsh's personal meditation *Hotel* in Bloomsbury's "Object Lessons" series; and *New Hotels for Global Nomads* by Donald Albrecht and Elizabeth Johnson. One also finds Sandoval-Strausz's *Hotel: An American History* and Elaine Denby's seminal *Grand Hotels: Reality and Illusion*, while in 2005, the *Journal of Decorative and Propaganda Arts* published a wide-ranging special issue entitled "The American Hotel." The editor of the latter, Molly W. Berger, is also the author of the insightful *Hotel Dreams: Luxury, Technology, and Urban Ambition in America, 1829–1929*. For a rich and elucidating study of key themes in the historiography of the Western hotel, see Kevin James's *The Modern Hotel: History, Meaning and Representation*.

2 By the 1870s, extensive rail networks in England, Germany, and France saw railway hotels become very much a part of the urban landscape. In Canada, the Canadian Pacific Railway's hotel division was active across the country during the late nineteenth and early twentieth centuries. Another important stimulus for the construction of large hotels capable of handling many guests and dispensing a variety of services was the international exhibition. If railway hotels confirmed the close links between themselves and modern transportation, exhibitions, like those in London (1851) and Paris (1855), explicitly highlighted the cosmopolitan nature of the hotel space and reinforced the interdependence of both on a growing volume of industry and trade (Denby 81). A sort of exhibition in and of itself, *La Compagnie Immobilière*'s 1862 Grand Hôtel is a prime example of this effect, as it was supposedly constructed to "demonstrate to the world the achievements in science, art and industry under the Second Empire" (84). The Grand Hôtel provided a staggering array of services. Constructed in only fifteen months, it sported eight hundred rooms, Paris's first hydraulic lift, a letter box, a concierge, a telegraph desk, reception, carriage service, couriers and interpreters, a cash desk with foreign exchange, a theatre ticket desk, and a *café-divan* with billiards. It also had a full laundry, a model dairy outside of Paris, and a wine cellar holding one million bottles (84). The hotel acted as a hub for a multitude of activities, above and beyond the basic task of providing temporary shelter in exchange for money.

3 The hotel has its roots in the rudimentary accommodation accorded travellers in the ancient world. Caravanserais were integral parts of trade routes, offering shelter and protection on the road and serving as tax collection points within cities' walls (Denby 11–12). During Roman times, bare-bones *tavernae* as well as the better-considered *hospitae* provided shelter to voyagers (14).

4 See Heidegger's key precepts in *Poetry, Language, Thought*: "1. What is it to dwell? 2. How does building belong to dwelling?" (100). While providing shelter, the classic tourist hotel does not necessarily gather the "fourfold" such that a site is created that can subsequently provide for the "letting dwell" that Heidegger sees at the heart of the nature of building.

5 In their article on the geopolitics of the hotel, Fregonese and Ramadan describe the hotel's contractual nature this way: "The hotel is an infrastructure of monetised hospitality – a relationship of conditional welcoming mediated through financial exchange" (794).

6 This is not to forget about the specific, but in my mind, different, category of the "residential hotel," of which the Waldorf-Astoria was an early and luxurious example. As Dolkart observes, "transient visitors were housed in rooms on the fourth through eighteenth floors; semitransient visitors, those who stayed for about a month, had rooms on the nineteenth through twenty-seventh floors; and the towers were reserved for the apartment suites of the permanent and long-term guests. These suites were marketed to … wealthy people who wanted a full-time residence or a pied-à-terre with the comforts of a private house or apartment and the amenities of a hotel" (38–9).

7 "The Hotel Lobby" was Kracauer's first treatment of the space, and as Katz observes, "his first sustained theoretical treatise on urban mass culture." Later, lobbies will "turn up as a consistent topos in his Berlin feuilletons for the *Frankfurter Zeitung* of the 20s and early 30s" (135). Katz's suggestion in "The Hotel Kracauer" that Kracauer be regarded as a "hotel flâneur" given that he "learns to read the modern city out of the hotel's interior topography, with corridors serving as his avenues, and function rooms and front desks as his plazas and police bureaus" is highly suggestive and attractive (135). It is perhaps unfortunate that "The Hotel Lobby" became so well known and that his later writings on the subject were not as widely distributed or picked up by cultural studies scholars. Based on Katz's analysis, they offer a more nuanced understanding of the lobby and the hotel as a whole than is on offer in the German's initial treatment.

8 As Levin observes: "The phenomenology of the surface in Kracauer's writings after the mid-1920s … undertakes a serious exploration of superficies of cultural ephemera and marginal domains – hotel lobbies, dancing, arcades, bestsellers – in order, however, ultimately to transcend them" (20). Witte's description that "his observation fell upon the marginal zones of high culture and came to rest upon the media of popular culture: the cinema, streets, sport, operetta, revues, advertisements and the circus" is another concise and letter-perfect appraisal of the German's work (qtd in Frisby 110).

9 It is often overlooked that Poe's narrator in "The Man in the Crowd" is sitting in a coffee house in a hotel when his obsession begins.

1. The Pictorial Hotel

1 Variants of these two iconic spaces such as the café-concert, bar, ballet, and circus were also frequent subjects for artists such as Manet, Seurat, and the aforementioned Monet and Toulouse-Lautrec. I thank Alison Matthews David for the observation.

2 See, for example, Brazil's Ariau Amazon Towers Hotel or the Nothofagus Hotel and Spa in Chile (Baldwin).

3 Singer Sargent's *View from a Window Genoa* shows the view from his seaside hotel along with his portfolio and paints.

4 Lucian Freud is another seminal painter who has included the space of the hotel among his works. His *Hotel Bedroom* from 1954 has an ominous feel that implicates the viewer at different levels in the drama of the scene. Likewise, artist Joseph Cornell's surrealist boxes also include multiple references to hotels. Works such as "The Hotel Eden" (ca 1945); *Untitled (Grand Hotel)* (ca 1950); "Grand Hotel Semiramis" (1950); "Untitled (Hotel du Cygne)" (ca 1952–5); *Untitled (Andromeda Hotel)* (1953–); *Grand Hotel-Hotel Taglioni* (1954); and *Hotel Goldene Sonne* (1955–7) all touch on elements of the hotel experience, even though Cornell was the epitome of the "armchair voyager" who never visited Europe and stayed close to New York City (Lichtenstein).

5 Hopper bristled at being placed in any sort of movement – whether it be the Ash Can School of social realism or the more regionalist naturalism of American Scene (see Warkel 19).

6 At first glance she appears to be reading a thick book but closer inspection shows that what seems to be pages of text is really the woman's knee.

7 The same situation is evident in Hopper's 1926 painting *11 A.M.* in which a naked woman sits in a chair that inconveniently blocks a set of drawers. The nondescript room could be in either a hotel or a flat.

8 Schmied seems perplexed by the possibility that someone in the lobby might simply be "there": "Meanwhile, a young woman sits alone, reading a magazine. She seems to have plenty of time on her hands, and the purpose of her wait is even more obscure than the couple's destination" (70).

9 Two years later, Hopper would paint another woman in a red dress waiting in a hotel-like space. His *Western Motel* from 1957 depicts a woman who sits on a bed beside a window through which the viewer can see the front of a car in medium shot and rock formations in the background.

10 In 2006, *Hotel Window* sold at auction for $26,896,000. It is commonly described as expressing the loneliness and alienation of the human condition – an interpretation that I resist ("Sotheby's Sets Record").

11 That the first post–Cuban Revolution Soviet embassy was also located in the Hilton is further proof of this feedback effect. I expand on the requisitioning angle of occupancy and hotel space in chapter 3 of this book.

12 The Nacional's famous casino was closed in 1960 and the hotel fell into neglect until the revitalization of the tourist industry in the country in the 1990s.

13 The most important positions at the hotel were filled by Cuban nationals who had received training at Hilton hotels in the US (Lefever 15).

14 In addition to Havana, this was the case with Istanbul, Jerusalem, and Cairo as well (Wharton 3).

15 Subsequent projects by Serrano have expanded on this notion of "forbidden spaces" in Havana. In *Havana Mirage* he produced a series on the Capitolio and other government buildings that are off limits to Cubans. In 2011, the artist prepared an analogous project on forbidden interiors.

16 The Sol Melia Group changed the original windows and functional, open balconies to mirrored glass enclosures during a restoration in the 1990s.

17 I thank Francisco Fernández de Alba for this insight.

18 For more on the concept of after-image and the city, see Joan Ramon Resina's "The Concept of After-Image and the Scopic Apprehension of the City."

2. The Cinematic Hotel

1 This is the soundtrack of alienated work, which in chain hotels such as this may often be performed by undocumented immigrants.

2 The Hotel Scribe in Paris was built on the site where the first public projection of films by the Lumières Brothers took place (the Salon Indien of the Grand Café) on 28 December 1895.

3 Wes Anderson's *The Grand Budapest Hotel* is the latest in a long line of features that trade on this dynamic (see Field Levander and Pratt Guterl 193–5).

4 This film notably predates J. Stuart Blackton's 1907 piece, *The Haunted Hotel.*

5 See Wolfgang Schivelbusch's seminal *Disenchanted Night: The Industrialization of Light in the Nineteenth Century* for more on electrification.

6 For more on the history of hotels in America, see Field Levander and Pratt Guterl (6–12) and issue 25 of the *Journal of Decorative and Propaganda Arts*, which was dedicated to "The American Hotel."

7 That the fixed rails and trolley connect the hotel to the train station underlines the link between transport system infrastructure and early hotels.

8 In her study of Weimar urban visual culture, Janet Ward proposes that the entrance to the luxury hotel in *The Last Laugh* "is posited as a self-reflexive reference to the movie theater lobby – the equivalent luxury building for the white-collar workers watching the film" and that "the doorman, in his uniform, is empowered to stand at the point of entry to this world of fantasy" (187).

9 In a move that betrays his difference in class, Kringenlein's offer to pay for his stay in advance is met with absolute horror by the staff.

10 Among the many noir films that use the hotel as a location are: *The Maltese Falcon* (Huston, 1941), *High Sierra* (Walsh, 1941), *Fallen Angel* (Preminger, 1945), *The Killers* (Siodmack, 1946), *Raw Deal* (Mann, 1948), *The Big Heat* (Lang, 1953), *Kiss Me Deadly* (Aldrich, 1955), *The Brothers Rico* (Karlson, 1957), and *Touch of Evil* (Welles, 1958).

11 One of the best-known hotel films in the horror genre is Stanley Kubrick's *The Shining* in which the otherworldly occupant of room 237 drives the protagonist mad.

12 See Hoteldunord.org for more on the popular appeal of the film and the history of the set design.

13 For an overview of the rise of the salesman in America, see Friedman's *Birth of a Salesman.* America's most famous salesman character, Arthur Miller's Willy Loman, appeared soon after the re-release of *When Strangers Marry* with the publication of *Death of a Salesman.*

14 See his 1959 book *La prostitution, que peut-on faire?: Problèmes d'aujourd'hui et de demain.*

15 If, as per Roud, *Alphaville*'s dystopia is marked by circularity in architecture and speech (12), Lemmy Caution's constant picture taking can be read as an attempt at linearity through the archiving of specific moments and events. For more on recording and documenting in the film, see Yoshioka.

16 In 1962, Truffaut and Hitchcock recorded their famous conversations that would become the basis of Truffaut's book *Le cinéma selon Alfred Hitchcock* in 1966. Coverage of Hitchcock began in the 1950s and he was featured on the cover of the magazine's August/September 1956 issue.

17 Hitchcock has four films in the AFI "100 Years …100 Movies" list, two in the *Sight & Sound* "Top 50 Greatest Films of All Time," including the #1 position for *Vertigo.*

18 As McGilligan points out, "this shot required a special camera boom, and lens and then two days to block and shoot the elaborately rehearsed action" (196).

19 Hitchcock's inclusion of the jazz musicians in blackface cannot help but make one think of the troubled history of equality in – and accessibility to – hospitality services in the West.

One well-known response to the segregation and resistance facing racialized travellers during the twentieth century was Victor H. Green's famous *Green Book* guides, which he published between 1936 and 1964 and in which he listed locales amenable to African-American travellers (Sahagun).

20 Meanwhile, a fourth picture, the lower-budget *Psycho*, which came out the year after Hitchcock's exuberant *North by Northwest*, made infamous the motel setting – a cousin to the more established hotel.

21 See Ian Christie's list of the fifty greatest films of all time, which came out of the British Film Institute's 2012 poll with *Sight & Sound*.

22 See Nedvidek.

23 Mojica observes that following Coppola's inclusion of songs by My Bloody Valentine and The Jesus and Mary Chain, both groups re-formed to tour (Mojica).

24 For more on the famous guests and goings-on at the Chateau Marmont, see Sarlot and Basten's *Life at the Marmont: The Inside Story of Hollywood's Legendary Hotel of the Stars*.

25 The Carlyle is especially known for its café, where director Woody Allen plays a weekly jazz gig.

3. The Wartime Hotel

1 The Trianon Palace Hôtel in Versailles is one famous example of this, serving as it did as the committee headquarters for the Allied Command, a hospital, and then for the preparation of the Treaty of Versailles (Denby 282). Throughout this chapter, I point to multiple other instances as well.

2 For a historical treatment of various press hotels during wartime, see Morrison 33–46.

3 Urban combat is not a strictly twentieth-century phenomenon. During the modern age, nineteenth-century revolutionary uprisings in Paris showed how effectively parts of a city could be taken and then held by a force less organized than a regular army. In these instances, the streets themselves were used for barricades, as cobblestones became bricks for barriers – the mortar for a revolutionary fervour destined never to fully set. Both in France and Spain, bayonets and cannon round were turned on rebellious citizens at various times so as to restore order and reassert the power of the ruling elite. In even more modern terms, the Battle for Stalingrad in 1942 is often mentioned as the first major urban conflict of the twentieth century. During this exceedingly bloody battle, the Soviet Red Army successfully held off and then defeated the German Sixth Army. Hundreds of thousands of people died, and by the end of the two hundred days of fighting, the city had been reduced to rubble. While Stalingrad stands out for its ferocity, there have been many other instances of large-scale city-based conflicts over the last one hundred years. Three that immediately come to mind are: the American struggle to drive the Viet Cong out of Hue, Vietnam, during the Tet Offensive in 1968; the US Army's failed 1993 mission in Mogadishu, Somalia; and the clash during 1994 between the Russian army and Chechan fighters in Grozny, Chechnya (*Urban Warfare*).

4 See chapter 1.

5 For more details on this process, see my article, "A Periphery with a View: Hotel Space and Catalan Modernity."

6 In a Barcelona that had been carved into a myriad of enclaves, local revolutionary committees became very important arbiters of these new associations. For a study of anarchism and Barcelona, see Ealham.

7 The Colón's American Bar was the key stop for cocktail culture in the city. There, customers could count on the expertise of Barcelona's first professional barman, Irven de Monico,

a Hungarian known as "Jack" who had arrived in the city in 1915 when the first phase of the jazz age was beginning (Sagarra 264). His many clients included such luminaries as Paul Morand, Charles Lindbergh, Albert Einstein, and Winston Churchill. The Colón's basement cabaret, the Taverna Andalusa, was an equally important social space. It was less threatening than the rougher Raval-area establishments and, as a result, became the first club where women could accompany their husbands without being seen as prostitutes (Planes qtd in Permanyer 131).

8 The American government appears to have held the opposing view regarding the political nature of architecture following the Second World War. As Wharton points out, Marshall Plan funds were used to finance the construction of modern American buildings as "'architectural calling cards' of the U.S. government" (Wharton 7). What is more, Conrad Hilton, owner of one of the twentieth century's most important chains, directly linked his international hotels to the ideological program of capitalism (8).

9 See Baudrillard's *Simulations* and Virilio's *War and Cinema: The Logistics of Perception*, respectively.

10 Even then, his way of looking at the city and countryside are tempered by the fact that he must avoid detection in the wake of the outlawing of his former group, the POUM.

11 Set on the eve of the Second World War, Comfort and Greenbaum's film *Hotel Reserve* (1944) revolves around the search for an unknown spy who had taken photographs of French military bases on the protagonist's camera instead of his own. Here, the tourist practice of photography takes on a more seditious undertone, making the act one of illicit information gathering.

12 Best known for her 2011 graphic memoir *Bye Bye Babylon: Beirut 1975–1979*, Lamia Ziadé began her career designing fabric for collections by Jean-Paul Gaulthier and Issey Miyake. Her first solo show came in Paris in 1996, and since the early 2000s she has shown regularly not only in the French capital but also in Munich, Beirut, and Los Angeles. Ziadé's diverse oeuvre, which ranges from illustration through mixed-media painting/collage, to sculpture, considers themes such as female sexuality and the aesthetic potential of the banal day-to-day objects. Her work depicting naked women reclining and spreading their legs instantly calls to mind Tom Wesselmann's *Great American Nudes* from the '60s as well as his still-life collages and studies. An intrinsic element of the creation of early pop art was the bringing together of cultural ephemera, a magpie process that resulted in an aesthetic of assemblage. I would argue that at its core, pop art is a form of requisitioning.

13 I think that, in many ways, this work serves as a laboratory for what would come later in her important *Bye Bye Babylon*.

14 The artist has also commented on a strange nostalgia for the war that she has perceived – especially for the first phases of the conflict – and how, in her view, violence has its own folklore in Lebanon. As is evident in Ziadé's studies of the militiamen in *Bye Bye Babylon*, there's almost a glee in fighting, a reminder that at the beginning of the war, there was a sense that conflict was both inevitable and wanted. And while the fighting in the War of the Hotels was brutal and intense, there are also stories of combatants enjoying the luxury facilities. In *Bye Bye Babylon*, Ziadé tells her own story through a child narrator, but before she got to that point, she made *La bataille des hôtels*, which by its very nature is accessible in a different way than a graphic memoir. It exists *in* space as it tells us something *about* space. It shows how requisitioning works on different levels, creating a sense of the uncanny for those who have experienced these events and these locales. While it does employ what some might consider a too-flamboyant pop style, by including the familiar images of car bombs, the gruesome sight of a prisoner being dragged by a car until dead and reminding us of how precarious spaces can be – part of the folklore of violence – she ensures that any pop excess is tempered by Beirut's own tragic icons.

15 When the warring parties signed the Dayton Accord in 1995, Bosnia-Herzegovina was split
 into two autonomous regions: the Federation of Bosnia and the Bosnian Serb Republic (*Bosnia
 and Herzegovina*).

16 For an exhaustive history of this compelling hotel, see Morrison's *Sarajevo's Holiday Inn on
 the Frontline of Politics and War.*

17 I label the snipers in the Sarajevo siege as "indiscriminate" so as to make the distinction between
 terrorizing non-combatants and sniping as a focused military action aimed at eliminating specif-
 ic enemy officers or officials deemed to be important targets. Whereas the idea of lingering may
 be more applicable in the first case, in which a specific territory or line of sight is controlled, it is
 still relevant to a more strictly defined sniping in that patience and visual precision are crucial.

18 Compare this to a missed tourist camera shot, which may result in an undefined field, the
 imposition of a thumb into the frame, or perhaps the truncation of a building – all much more
 benign forms of the same type of fragmentation produced by a sniper's round.

19 The opening sequence of Michael Winterbottom's 1997 film *Welcome to Sarajevo* captures this
 dynamic horrifyingly well. The picture begins with a bride and her entourage getting ready
 for her wedding. As they walk down the street, a sniper's bullet strikes and kills the bride's
 mother. The scene then shifts to an adjacent row of television and print journalists who jostle
 one another to get their own shot of the dead woman. By interspersing what appears to be
 archival footage into his film, Winterbottom not only gives *Welcome to Sarajevo* an immediate
 aura of historical accuracy but also collapses the metaphoric distance between the sniper and
 the camera. The following scene in which the journalist and his cameraman edit footage while
 joking about "the whole 'news for entertainment' bollocks" adds a not-so-veiled dig at how
 the war was packaged.

20 What marks the difference between the superficial tourist gaze that may or may not be drawn
 to the vista – it may be more interested in the television, the minibar, or what have you –
 and the penetrating gaze of the media is the breaking of the window. When that metaphoric
 separator is breached, the tourist gaze can no longer be nonchalant.

21 Since 2012, tour operator Sarajevofunkytours has led visitors on a "Total Siege Tour" of the
 city's wartime landmarks. In addition to the War Tunnel Museum, bobsleigh track, and other
 sites, tourists take in Sniper's Alley, the Holiday Inn, the Markale Market massacre sites, the
 parliament building of Bosnia and Herzegovina, Ex-Marshal Tito Military Barracks, and the
 Sarajevo Children Memorial. Visitors looking for an even more intense experience can also
 spend a night at the siege-themed "War Hostel."

4. The Displacement Hotel

1 According to Attila Ataner, if security and safety are a state's main reasons for strictly control-
 ling migration, the question of sovereign power is not invoked explicitly but, rather, incidentally
 as "the legal mechanism through which migration can be regularized. For, 'regular' migration
 is, essentially, authorized migration – entry with official permission. Authorized migration,
 in turn, is safe and secure migration. The process of authorizing entry enables states to manage
 the risks involved in receiving foreign nationals" (10–11).

2 The categorization and qualifications of these practices are my own.

3 The practice of "deflecting" refugee claimants back to another transit country that has been
 deemed a "safe third country," while definitely not passive, relies on multilateral cooperation
 (Ataner 13).

4 Both the US and Canada station agents abroad for interdiction purposes. In 2003, then
 Canadian minister of immigration Denis Coderre boasted about the success of his agency's

Orwellian-named "migration integrity specialists" in deterring unauthorized travellers from arriving in Canada (qtd in Brouwer).

5 Even though the recognition of embassies and consulates as "foreign soil" within a state's own borders could be construed as another form of "perforation," it is not comparable to the creation of international migration zones in that such recognition is a product of state-to-state conventions and assumes a degree of reciprocal treatment abroad (i.e., there is no net loss of territory). For more on the inviolability of consular space, see specifically articles 29 and 31–6 of the Vienna Convention on Consular Relations and Optional Protocols.

6 This attitude is not logical since, as Mole rightly observes, anyone committing a crime in a so-called waiting area or international zone at an airport would be subject to the laws of that country (Mole 69). Regarding international obligations toward refugees, see specifically, Article 33 (1) of the Geneva Convention: "No Contracting State shall expel or return (*refouler*) a refugee in any manner whatsoever to the frontiers of territories where his life or freedom would be threatened on account of his race, religion, nationality, membership of a particular social group or political opinion" (qtd in Mole 62).

7 See Resina, "The Scale," Brennan's views on the state and the importance of management cited above, and Michael P. Smith, who, in *Transnational Urbanism*, contests David Harvey's interpretation (or lack thereof) of state agency within globalizing processes: "Despite its struggle, the state is given little or no autonomy in Harvey's discourse, often being reduced to the role of symbolic representation of state power through myth-making, the mystification of its own lack of autonomy from capital, and the aestheticization of politics" (Smith 27). For more on territoriality and locality, see Appadurai.

8 In her comprehensive study of the Canadian immigration detention apparatus, Anna Pratt draws on Foucault's concept of "prisoners of passage" and borrows from Rose when she labels detention facilities such as the Celebrity Inn as a "liminal space, a 'zone of exclusion,' the boundaries of which separate those destined for inclusion and those for whom exclusion is 'inexorable'" (Rose qtd in Pratt 25–6).

9 The other two include: (1) the operation of extraterritorial bases as a disavowal of jurisdiction and responsibility based on a feigned respect for international borders even though state control is clearly evident in the state's capacity to impede, deflect, or delay the movement of non-nationals; (2) the tactic of redefining national territories' status according to state desires regarding immigration/refugee flows.

10 One of Canada's earliest detention hotels was the Eatonville Roadhouse in southwestern Ontario, which was used to hold interned Japanese Canadians during the Second World War. See Quan, "'Last Building Standing.'"

11 For the connections between the supermodern non-place and Agamben's treatment of the camp, see below.

12 The Guantánamo Bay refugee camp built by the US in the mid-1990s as a response to increased refugee pressure from Haiti and Cuba (on land it had itself excised from the Communist state following the revolution) is an example of an extraterritorial base that has allowed the state in question wide latitude in its policies regarding asylum seekers. The camp became a repository for refugees interdicted at sea, but, as Gibney observes, the practice of turning back boats before they could reach US waters (particularly those from Haiti) and thus return asylum seekers to their country of origin without processing their claims, was upheld by the US Supreme Court in 1994 (163). As regards those refugees who did find themselves retained at the Guantánamo Bay centre, they still did not gain access to the normal constitutional protections that are due foreigners on American soil. This was because, strictly speaking, in the US's eyes, the base is not on its land. A 1999 decision by the Eleventh Circuit Court of

Appeals upheld this view when it found that, while Guantánamo Bay may be under American "jurisdiction and control," it was not US territory (Jones qtd in Gibney 163). As such, aliens held there "had no legal rights under the domestic law of the US or under international law" (Gibney 163). The international legal status of people held at Guantánamo Bay has come under even more scrutiny with the establishment of Camp X-Ray, which was designed to interrogate and hold the so-called irregular combatants captured in the US-led "war on terror." State anxiety arising from illegal immigrants arriving by sea is paramount as well in the case of Australia, where the state took interdiction and excision to a new level – both in terms of degree of response and the proximity of this reaction to the state core. In September 2001, the country "excised" parts of its own territory. Christmas Island, Ashmore Reef, and the Cocos Island were all affected as part of Australia's strategy for stemming an increasing flow of illegal immigration. This act redefined these islands' migration zone status within the state, reducing but not completely eliminating Australia's international responsibilities to asylum seekers held there even as, importantly, it denied them access to the protection of the national courts (Gibney 189). This re-evaluation of sovereign space contracted Australia's effective frontiers – not in a jurisdictional sense since the state maintained control – but rather vis-à-vis the concept of what territory would remain within the domestic realm. The excision of the migration zone created a physical buffer oriented toward the "outside" so as to preserve the privileges and extended rights of the core, where the thus protected and fully empowered citizenry resided. A UNHRC map of the Australia Excision Zone as of November 2003 shows the extent of the area, as well as a red "security belt" running the length of the country's north shore, from Exmouth in Western Australia to Mackay in Queensland (Geographic Information and Mapping Unit). With the excision zone and buffer established, Australia then actively sought to push the processing of refugees even farther back by enlisting Papua New Guinea and Nauru as screening sites for refugees headed towards Australia in an arrangement they called the "Pacific Solution" (*Country Report Australia*). In the case of Australia, then, one sees the interdiction practice of outward-oriented excision at perhaps its most drastic. The state preferred to de-domesticate territory rather than extend national privileges or rights to foreigners who made their way into that space. This unilateral, contractive approach was, nevertheless, mitigated by a multilateral expansion "after the fact" that saw Australia try to extend the reach of its immigration officers to centres abroad and thus consolidate the buffer between domestic territory and a foreign space in which there would be no guarantees of successful admission to the intended country.

13 According to the US Committee for Refugees and Immigrants, oral hearings for asylum seekers in Germany should occur within forty-eight hours of arrival, and while no one ought to be held for more than nineteen days at the airport, there have been reports of detentions lasting months (*Country Report Germany*). Wilkinson notes that Germany does not consider holding people in international zones "detention" because they are always free to leave – but only back from whence they came (Wilkinson). This is not a view shared by Achiron and Jastram, who observe that "detention does not just involve jails. Detention is confinement within a narrowly bounded or restricted location, which includes prisons, closed camps, public or privately operated detention facilities, hotel rooms, or airport transit zones, where freedom of movement is substantially curtailed and where the only opportunity to leave this limited area is to leave the territory of the asylum country" (Jastram and Achiron).

14 Amnesty International reports that, as of May 1995, there were 78 transit zones in France (Kpatinde). According to Kpatinde, there are three groups of aliens who may be detained in these zones: "Those who lack visas, guarantees of return and/or sufficient resources; those who, according to the French Air and Border Police, represent a threat to national security,

including people who have been previously banned from French soil or who have been issued an expulsion order; and people listed in the European Union's computerized databank as a threat to the national security and international relations of a country that has signed the Schengen accords."

15 In perhaps the most widely publicized case of someone being caught between states, Merhan Karimi Nasseri, an Iranian-born refugee without papers, spent various years living in Terminal One at Charles de Gaulle Airport in Paris.

16 For the turn of the twentieth-century tourist (or "non-exilic elite," to use Brennan's term [*At Home* 37]), the experience of compression was closely linked to the aesthetics of the artistic and technological avant-gardes. It was the cinematic experience of the railcar, where the window-framed landscape became a film at speed; or the view from the ship's deck, where an unchanging horizon was offset by the wake, indicative of progress; or that from an airplane, the ultimate site of topographical apprehension. The physical and psychic materializations of compression spaces contribute to what Stephen Kern identifies as the "transformation of the dimensions of life and thought" that occurred as a result of the rapid technological and cultural innovations at the turn of the twentieth century (1–2).

17 According to Augé, places can be considered as being "relational, historical and concerned with identity" (77–8). Grand hotels such as the Paris Ritz and the London Savoy may have been beacons for international activity and, in the case of the Ritz empire, parts of high-class chains, but nevertheless they maintained a local connection that saw them acquire monumental status and even function metonymically in many cases for their respective cities as well as for the upper class in general.

18 See the analysis of *Grand Hotel* in chapter 2.

19 This is not to say that standardization was not a part of the architectural traits of the pre-war hotel. See Pfueller Davidson for the early twentieth-century origins of postwar standardization.

20 This dynamic would become a norm that would not be challenged by a return to local specificity on a large scale until the late 1990s with the advent and expansion of the "boutique hotel" phenomenon.

21 The "simulacra" hotels of Las Vegas that reproduce famous monuments and parts of world cities represent the postmodern hotel taken to the furthest degree.

22 See Jameson 38–45.

23 By activating non-places politically, the state will assimilate them into its own "trajectory."

24 The Vancouver Airport is at the vanguard of the evolution of the non-place. Not only does the Fairmont Vancouver Airport hotel's lobby extend directly into the US departures area, the hotel mirrors the literal and figurative sterilized nature of the airport non-place in that it is one of the few hotels to offer hypoallergenic rooms. Additionally, the airport has become the first to install individual sleeping pods, known as "Metronaps," which travellers can rent for short periods in the international departure area – thus merging the hotel room and the terminal (Engle K11).

25 See Pratt 28–30 for a detailed description of the layout of the Celebrity Inn.

26 I thank Doug Kellam for providing me with information regarding the history of the Celebrity Inn.

27 Sabena reopened the hotel following the conflict and it was subsequently sold to MIKCOR Hotel Holding in 2005.

28 As Baker points out in an article from November 2016, approximately 60,000 Middle Eastern and African refugees are currently stuck in Greece. Having made it out of Turkey, they were stalled en route to destination countries in Europe when Macedonia closed its border with Greece. Greek leftists and anarchists subsequently commandeered the abandoned City Plaza

hotel, reconnected the electricity and water, and converted it into a co-op for four hundred refugees (Baker).

29 See the "Making Heimat" project, http://www.makingheimat.de/en.

30 For more on the Plaza Hotel and a photo essay on the last family of Syrian newcomers to leave for new housing, see Keung.

31 See Amad.

Conclusion: The Hotel Attraction

1 In "The Politics and Poetics of Infrastructure," Larkin examines anthropological literature that theorizes infrastructure in terms of the biopolitical and technopolitical. Additionally, he considers the ways in which infrastructure can create meaning and "structure politics in various ways: through the aesthetic and the sensorial, desire and promise" (327).

2 For a close reading of one particularly compelling building that was constructed around the time of the fair, see my piece, "Barcelona's Permeable Monument."

3 Domènech i Montaner did not have very much leeway with which to work. He was on a strict budget and an even stricter timeline. Nevertheless, guests were checking in a mere three months after construction began on the mammoth five-storey, 1,600-room, iron-framed hotel, (Hughes 367–8). Bohigas provides an even more astonishing figure for the actual construction period: sixty-three days; he mentions how telegrams of congratulations on the hotel's completion were sent to Domènech from as far afield as the United States (50). Conversely, the Café-Restaurant was still under construction when the fair opened on 20 May (Casanova 132).

4 In 2002, as part of the Year of Gaudí, the Escola Tècnica Superior d'Arquitectura de Barcelona presented an exhibition on the Hotel Attraction. A year later, Josep M. Montaner and Pedro Azara collected together the materials for their book *Hotel Attraction: una catedral laica / El rascacielos de Gaudí en New York*.

5 Originally planned by the urbanist as a way of ruralizing the city through hybrid garden blocks, the vision failed miserably as bourgeois business interests overwhelmed the utopian impulse. Rather than leave the blocks open for parkland, they were entirely cut off and in many places filled in. The Eixample grid is peppered with *modernista* architecture thanks to the patronage of the new industrial rich and is thus symbolically linked to the economic power of those who were also intent on wresting more local control for Catalonia.

6 See *El enigma Gaudí* by Sire and episode 21 of the second season of the TV series *Fringe*, respectively.

WORKS CITED

Agamben, Giorgio. *Homo Sacer: Sovereign Power and Bare Life.* Trans. Daniel Heller-Roazen. Stanford: Stanford UP, 1998.

Albrecht, Donald, and Elizabeth Johnson. *New Hotels for Global Nomads.* London: Merrell Publishers, in association with Cooper-Hewitt National Design Museum, New York, 2002.

Alphaville. Dir. Jean-Luc Godard, 1965.

Amad, Ali. "What It's Like for the Syrian Refugees Living in Toronto's Hotels." https://torontolife.com/city/life/syrian-refugees-living-in-toronto-hotels-q-and-a/.

"The American Hotel." Ed. Molly W. Berger. *Journal of Decorative and Propaganda Arts* 25 (2005).

"Amsterdam Grand Hotel." http://www.historichotelsthenandnow.com/grandkrasnapolskyamsterdam.html.

Amuur v. France. European Court of Human Rights, 1996.

Appadurai, Arjun. "Sovereignty without Territoriality: Notes for a Postnational Geography." *Anthropology of Space and Place: Locating Culture.* Ed. Setha M. Low and Denise Lawrence-Zúñiga. London: Blackwell, 2003. 337–50.

Ataner, Attila. "Refugee Interdiction and the Outer Limits of Sovereignty." *Journal of Law and Equity* 3.1 (2004): 7–29.

Augé, Marc. "About Non-Places." *Architectural Design* 66.11–12 (1995): 82–3.

– *Non-Places: Introduction to an Anthropology of Supermodernity.* Trans. John Howe. London: Verso, 1995.

Bacha, Julia, and Jehane Noujaim. *Control Room.* Magnolia Pictures, 2004.

Baker, Aryn. "Greek Anarchists Are Finding Space for Refugees in Abandoned Hotels." 2016. http://time.com/4501017/greek-anarchists-are-finding-space-for-refugees-in-abandoned-hotels/.

Baldwin, Dave. "The World's 10 Coolest Treehouse Hotels." Thrillist.com.

Balibar, Étienne. "Europe, an 'Unimagined' Frontier of Democracy." *Diacritics* 33.3–4 (2003): 36–44.

– *We, the People of Europe? Reflections on Transnational Citizenship.* Trans. James Swenson. Princeton: Princeton UP, 2004.

Barrett, David. "Asylum Centre Costs More Than World's Most Exclusive Hotels." http://www.telegraph.co.uk/news/uknews/immigration/12106353/Asylum-centre-costs-more-than-worlds-most-exclusive-hotels.html.

Baudrillard, Jean. *Simulations.* New York: Semiotext(e), 1983.

Bellboy, The. Dir. Fatty Arbuckle, 1918.

Bentley, Bernard P.E. *A Companion to Spanish Cinema.* Woodbridge, Suffolk, UK: Tamesis, 2008.

Berens, Carol. *Hotel Bars and Lobbies.* New York: McGraw-Hill, 1997.

Berger, Molly W. *Hotel Dreams: Luxury, Technology, and Urban Ambition in America, 1829–1929.* Baltimore: Johns Hopkins University Press, 2011.

Big Heat, The. Dir. Fritz Lang, 1953.

Big Sleep, The. Dir. Howard Hawks. Warner Bros., 1946.

Bohigas, Oriol. "The Life and Works of a Modernista Architect." Trans. Joaquina Ballarín. Domènech i Montaner Año/Year 2000. Ed. Lluís Domènech i Girbau. Barcelona: Col·legi d'Arquitectes de Catalunya, 2000. 24–53.

"Bosnia and Herzegovina." 1998. http://www.washingtonpost.com/wp-srv/inatl/longterm/balkans/overview/bosnia.htm.

Bradbury, Paul. *Lebanese Nuns Don't Ski.* CreateSpace Independent Publishing Platform, 2013.

Braque, Georges. *Terrace of Hotel Mistral.* 1907. 81.3 cm × 61.3 cm. Metropolitan Museum, New York.

– *The Viaduct at L'Estaque.* 1908. Oil on canvas. 73 cm × 60 cm. Private collection.

Brennan, Timothy. *At Home in the World: Cosmopolitanism Now.* Cambridge, MA: Harvard UP, 1997.

– "Cosmopolitanism and Internationalism." *Debating Cosmopolitics.* Ed. Daniele Archibugi. London: Verso, 2003. 40–50.

Brothers Rico, The. Dir. Phil Karlson, 1957.

Brouwer, Andrew. *"Attack of the Migration Integrity Specialists!* Interdiction and the Threat to Asylum." CCRweb.ca.

Café Waldluft. Dir. Matthias Koßmehl, 2015.

"Canadians Divided on Legacy of Syrian Refugee Resettlement Plan." http://angusreid.org/canada-refugee-resettlement-plan/.

"Canadians in Belgium." http://www.veterans.gc.ca/eng/remembrance/history/second-world-war/canada-belgium.

Cannon, Steve. "'Not a Mere Question of Form': The Hybrid Realism of Godard's *Vivre Sa Vie.*" *French Cultural Studies* 7.21 (1996): 283–94.

Casanova, Rossend. "Café-Restaurant." Trans. Joaquina Ballarín. Domènech i Montaner Año/Year 2000. Ed. Lluís Domènech i Girbau. Barcelona: Col·legi d'Arquitectes de Catalunya, 2000. 130–47.

Christie, Ian. "The 50 Greatest Films of All Time." http://www.bfi.org.uk/news/50-greatest-films-all-time.

Collins, Katie. "Inside Germany's Repurposed Buildings That House Refugees." https://www.cnet.com/pictures/europe-refugee-crisis-germany-takes-over-buildings/8/.

Country Report Australia. US Committee for Refugees and Immigrants, 2002.

Country Report France. US Committee for Refugees and Immigrants, 1998.

Country Report Germany. US Committee for Refugees and Immigrants, 2002.

Dault, Gary Michael. "The Hotel That 'Will Not Go Away.'" *Globe and Mail* 29 January 2005.

Davidson, Robert. "Barcelona's Permeable Monument: Fontserè's Umbracle and the Parc de la Ciutadella." *Journal of Romance Studies* 14.3 (2014): 86–99.

Denby, Elaine. *Grand Hotel: Reality and Illusion.* London: Reaktion, 1998.

Dolkart, Andrew S. "Millionaires' Elysiums: The Luxury Apartment Hotels of Schultze and Weaver." *Journal of Decorative and Propaganda Arts* 25 (2005): 10–45.

Donzel, Catherine, and Marc Walter. "Jazz at the Savoy Hotel." *Grand Hotel: The Golden Age of Palace Hotels.* Ed. Marc Walter. New York: Vendome Press, 1984. 226.

Ealham, Chris. *Anarchism and the City: Revolution and Counter-Revolution in Barcelona, 1898–1937*. Edinburgh: AK Press, 2010.

Éluard, Paul, Mary A. Caws, Patricia Terry, and Nancy Kline. *Capital of Pain*. Boston, MA: Black Widow Press, 2006.

Engle, Jane. "Vancouver Airport on Snooze Control." *Toronto Star* 12 March 2005, K11.

Fallen Angel. Dir. Otto Preminger, 1945.

Feltz, Renée. "Immigration Officials Consider Bid for New 'Hotel-Like' Detention Center." https://www.theguardian.com/us-news/2016/jun/25/immigration-detention-center-texas-stratton-oilfield-systems.

Ferreras, Jesse. "Syrian Refugees Get Put Up in Same Hotel as Furries. Kids LOVE It." http://www.huffingtonpost.ca/2016/03/10/furries-convention-syrian-refugee-kids-vancouver_n_9432534.html.

Field Levander, Caroline, and Matthew Pratt Guterl. *Hotel Life: The Story of a Place Where Anything Can Happen*. Chapel Hill: U of NC Press, 2015.

Fregonese, Sara, and Adam Ramadan. "Hotel Geopolitics: A Research Agenda." *Geopolitics* 20 (4): 793–813.

Freud, Lucian. *Hotel Bedroom*. 1954. Oil on canvas. 91.1 cm × 61 cm. Beaverbrook Art Gallery, Fredericton.

Friedman, Walter A. *Birth of a Salesman: The Transformation of Selling in America*. Cambridge, MA: Harvard UP, 2004.

Frisby, David. *Fragments of Modernity: Theories of Modernity in the Work of Simmel, Kracauer, and Benjamin*. Cambridge, MA: MIT Press, 1988.

Geographic Information and Mapping Unit, Population and Geographic Data Section. "Australia Excision Zone." UNHRC, 2003.

"Germany: Resettlement Quotas and Actors." http://www.resettlement.eu/country/germany.

Gibney, Matthew J. *The Ethics and Politics of Asylum*. Cambridge, UK: Cambridge UP, 2004.

Godard, Jean-Luc. *Alphaville: Screenplay*. London: Lorrimer Films, 1966.

Goldenberg, Suzanne. "Fury at US as Attacks Kill Three Journalists." 2003. https://www.theguardian.com/media/2003/apr/09/pressandpublishing.Iraqandthemedia.

Goldwater, Robert. "The Fauves, the Brücke, the Blaue Reiter." *Major European Art Movements 1900–1945*. Ed. Patricia E. Kaplan and Susan Manso. New York: E.P. Dutton, 1977. 42–90.

Goytisolo, Juan. *Cuaderno de Sarajevo*. Madrid: El País/Aguilar, 1993.

Grand Budapest Hotel, The. Dir. Wes Anderson. Fox Searchlight Pictures, 2014.

Grand Hotel. Dir. Edmund Goulding, MGM. 1932.

Greenaway, H.D.S. "The War Hotels." https://www.pri.org/stories/2009-02-27/war-hotels-introduction.

Gregotti, Vittorio. *Inside Architecture*. Trans. Peter Wong and Francesca Zaccheo. Cambridge, MA: MIT Press, 1996.

Grosz, George. *The City*. 1916–17. Oil on canvas. 100 cm × 102 cm. Thyssen-Bornemisza Collection, Madrid.

Harvey, David. *The Condition of Postmodernity*. Oxford: Blackwell, 1989.

Hayner, Norman S. *Hotel Life*. Chapel Hill: University of North Carolina Press, 1936.

Hayward, Susan. *Cinema Studies: The Key Concepts*. London: Routledge, 2000.

Heidegger, Martin. "Building, Dwelling, Thinking." *Rethinking Architecture: A Reader in Cultural Theory*. Ed. Neil Leach. London and New York: Routledge, 1997. 100–9.

High Sierra. Dir. Raoul Walsh, 1941.

Hijazi, Ihsan A. "Beirut: A War's Aftermath." http://www.nytimes.com/1991/01/27/magazine/beirut-a-war-s-aftermath.html?pagewanted=2&src=pm.

Hopper, Edward. *11 A.M.* 1926. Oil on canvas. 71.37 cm × 91.69 cm. Hirshhorn Museum, Washington, DC.

– *Hotel Lobby.* 1943. Oil on canvas. 81.9 cm × 103.5 cm. Indianapolis Museum of Art, Indianapolis.

– *Hotel by the Railroad.* 1952. Oil on canvas. 78.7 cm × 101.6 cm. Smithsonian, DC.

– *Hotel Room.* 1931. Oil on canvas. 152.4 cm × 165.7 cm. Museo Thyssen-Bornemisza, Madrid.

– *Hotel Window.* 1955. Oil on canvas. 101.6 cm × 139.7 cm. Forbes Magazine Collection, New York.

– *Western Motel.* 1957. Oil on canvas. 77.8 cm × 128.3 cm. Yale University Art Gallery, New Haven.

Hopper, Edward, and Heinz Liesbrock. *Edward Hopper: The Masterpieces.* New York: Schirmer, 2000.

Hôtel du nord. Dir. Marcel Carné, 1938.

El hotel eléctrico. Dir. Segundo de Chomón, 1905.

Hotel Limbo. Radio documentary. Producers: Craig Desson, Yasmine Hassan, Julia Pagel. 2016.

"Hotel Metropole." http://www.historichotelsthenandnow.com.

Hughes, Robert. *Barcelona.* New York: Vintage, 1992.

Hunt, Nigel Alexander. "Hotel Habana Libre." http://www.hotelhabanalibre.com/en/history.html.

Hutchinson, Pamela, and Tony Paley. "The Genius of Alfred Hitchcock at the BFI: 10 of His Lesser-Known Gems." *Guardian Online.* https://www.theguardian.com/film/filmblog/2012/jul/04/alfred-hitchcock-genius-bfi-retrospective.

"Imperial Vienna." http://www.imperialvienna.com/en/tour_hotel.

Ingram, Paul L. *The Rise of Hotel Chains in the United States 1896–1980.* New York and London: Garland, 1996.

Iversen, Margaret. "In the Blind Field: Hopper and the Uncanny." *Art History* 21.3 (1998): 409–29.

Jackson, Stanley. *The Savoy: The Romance of a Great Hotel.* London: Frederick Muller, 1964.

James, Kevin. *The Modern Hotel: History, Meaning and Representation.* Channel View Publications, 2018.

Jameson, Frederic. *Postmodernism, or, The Cultural Logic of Late Capitalism.* Durham, NC: Duke UP, 1991.

Jastram, Kate, and Marilyn Achiron. *Refugee Protection: A Guide to International Refugee Law.* UNHCR, Inter-Parliamentary Union, 2001.

Jordan, Barry, and Mark Allinson. *Spanish Cinema: A Student's Guide.* London: Hodder Arnold, 2005.

Kassir, Samir. *Beirut.* Berkeley: University of California Press, 2010.

Katz, Marc. "The Hotel Kracauer." *differences: A Journal of Feminist Cultural Studies* 11.2 (1999): 134–52.

Kaushik. "Radisson Blu Iveria: A Luxury Hotel That Became a Refugee Camp." http://www.amusingplanet.com/2014/07/radisson-blu-iveria-luxury-hotel-that.html.

Kern, Stephen. *The Culture of Time and Space, 1880–1918.* Cambridge, MA: Harvard UP, 1983.

Keung, Nicholas. "Last Syrian Newcomers Leave Toronto's Hotel for Refugees." https://www.thestar.com/news/immigration/2016/05/20/last-syrian-newcomers-leave-torontos-hotel-for-refugees.html.

Key Largo. Dir. John Huston, 1948.

Killers, The. Dir. Robert Siodmak, 1946.

King, Geoff. *Lost in Translation.* Edinburgh: Edinburgh UP, 2010.

Kiss Me Deadly. Dir. Robert Aldrich, 1955.

Koestenbaum, Wayne. *Hotel Theory: 8 Dossiers; Hotel Women: 18 Chapters.* Brooklyn: Soft Skull Press, 2007.

Koolhaas, Rem. *Delirious New York: A Retroactive Manifesto for Manhattan*. New York: Monacelli Press, 1994.

Kpatinde, Francis. "Welcome to Limbo." *Refugees Magazine* 101 (1995). http://www.unhcr.org/publications/refugeemag/3b54400b4/refugees-magazine-issue-101-asylum-europe-welcome-limbo.html

Kracauer, Siegfried. "The Hotel Lobby." Trans. Thomas Y. Levin. *The Mass Ornament*. Ed. Thomas Y. Levin. Cambridge, MA: Harvard UP, 1995. 173–85.

Krebs, Martina. *Hotel Stories: Representations of Escapes and Encounters in Fiction and Film*. Trier: Wissenschaftlicher Verlag Trier, 2009.

Lady Vanishes, The. Dir. Alfred Hitchcock, 1939.

Lahuerta, Juan José. "Nueva York." *Hotel Attraction: Una catedral laica. El rascacielos de Gaudí en New York*. Josep M. Montaner y Pedro Azara (ed), Edicions UPC – Escola Tècnica Superior d'Arquitectura de Barcelona, Barcelona, 2002. 18–20.

Larkin, Brian. "The Politics and Poetics of Infrastructure." *Annual Review of Anthropology* 42 (2013): 327–43.

Leach, Neil. "Erasing the Traces: Berlin and Bucharest." *The Hieroglyphics of Space: Reading and Experiencing the Modern Metropolis*. Ed. Neil Leach. London: Routledge, 2002. 80–91.

Lefever, Michael M., and Cathleen D. Huck. "The Expropriation of the Habana Hilton: A Timely Reminder." *International Journal of Hospitality Management* 9.1 (1990): 14–20.

Lichtenstein, Therese. "Andromeda Hotel: The Art of Joseph Cornell." http://www.tfaoi.com/aa/6aa/6aa332.htm.

"Life without Zoe" Dir. Francis Ford Coppola in *New York Stories*, 1989.

Lim, Dennis. "It's What She Knows: The Luxe Life." *New York Times* 10 December 2010.

Loriggio, Paola, and Allison Jones. "Toronto Hotel Becomes Temporary Housing for Syrian Refugees Who Dream of Their Own Homes." http://nationalpost.com/news/canada/toronto-hotel-becomes-temporary-housing-for-syrian-refugees-who-dream-of-their-own-homes.

Lost in Translation. Dir. Sofia Coppola, 2004.

Mackenzie, Compton. *The Savoy of London*. London and Toronto: George G. Harrap, 1953.

Made in USA. Dir. Jean-Luc Godard, 1966.

Maltese Falcon, The. Dir. John Huston, 1941.

Man Who Knew Too Much, The. Dir. Alfred Hitchcock, 1956.

Marie Antoinette. Dir. Sofia Coppola, 2006.

Mark. "*When Strangers Marry* (1944) (aka *Betrayed*)." http://wheredangerlives.blogspot.ca/2010/05/when-strangers-marry-1944.html.

Matamala i Flotats, Joan. *Cuando el nuevo continente llamaba a Gaudí (1908–1911)*. 1956.

Meador, Clifton. *Tourist/Refugee*. Supplement in *Art Journal* (Summer 2005).

Ménilmontant. Dir. Dimitri Kirsanoff, 1924.

Merriman, Peter. "Driving Places: Marc Augé, Non-Places, and the Geographies of England's M1 Motorway." *Theory, Culture & Society* 21.4/5 (2004): 145–67.

"Migration Reports." http://www.bamf.de/EN/DasBAMF/Forschung/Ergebnisse/Migrationsberichte/migrationsberichte-node.html.

Miguelsanz i Arnalot, Àngel. *The Ritz: Barcelona*. Barcelona: Lunwerg, 1994.

Miller, Arthur. *Death of a Salesman: Certain Private Conversations in Two Acts and a Requiem*. Penguin: New York, 1976.

Mojica, Frank. "Cinema Sounds: Lost in Translation." 2010. http://consequenceofsound.net/2010/05/cinema-sounds-lost-in-translation.

Mole, Nuala. *Asylum and the European Convention on Human Rights*. Council of Europe, 2000. http://www.echr.coe.int/LibraryDocs/DG2/HRFILES/DG2-EN-HRFILES-09(2000).pdf.

Monet, Claude. *Hotel des roches noires, Trouville.* 1870. Oil on canvas. 81 cm × 58.5 cm. Musée d'Orsay, Paris.

Montaner, Josep M., and Pedro Azara, ed. *Hotel Attraction: una catedral laica, el gratacel de Gaudí a New York.* Barcelona: Edicions UPC, 2003.

Morrison, Kenneth. *Sarajevo's Holiday Inn on the Frontline of Politics and War.* London: Palgrave Macmillan, 2016.

Nedvidek, Emily. "Color Symbolism in *Vertigo.*" WFU Mediaphiles. https://wfumediaphiles. wordpress.com/2014/12/08/color-symbolism-in-vertigo-emily-nedvidek-hitchcock-essay-2/.

"Night in Hotel Limbo, A." https://www.youtube.com/watch?v=WDeRBLZU3CM.

North By Northwest. Dir. Alfred Hitchcock. MGM, 1959.

Oltermann, Philip. "Crowd Cheer Fire at Hotel Being Converted into Refugee Shelter in Saxony." https://www.theguardian.com/world/2016/feb/21/crowd-cheers-fire-hotel-refugee -shelter-saxony-germany.

Orwell, George. *Homage to Catalonia.* Harmondsworth: Penguin, 1975.

Paterson, Tony. "German Refugees Hide behind Razor Wire to Escape Angry Backlash in Bautzen." http://www.independent.co.uk/news/world/europe/refugees-hide-behind-razor-wire-to-escape-angry-german-backlash-in-bautzen-9775836.html.

Permanyer, Lluís. *Biografía de la Plaça de Catalunya.* Barcelona: Edicions La Campana, 1995.

Pfueller Davidson, Lisa. "Early Twentieth-Century Hotel Architects and the Origins of Standardization." *Journal of Decorative and Propaganda Arts* 25 (2005): 72–103.

Poe, Edgar Allan, "The Man of the Crowd." Penguin Classics. Cambridge, 2011. ProQuest Information and Learning.

Pratt, Anna. *Securing Borders: Detention and Deportation in Canada.* Vancouver: UBC Press, 2005.

Quan, Douglas. "Last Building Standing." http://news.nationalpost.com/news/canada/ last-building-standing-ontarios-last-reminder-of-japanese-internment-now-faces-demolition.

– "Syrian Refugees Uprooted from Hotels to Make Room for Garth Brooks Fans: 'It's Really a Non-Issue.'" http://news.nationalpost.com/news/canada/its-really-a-non-issue-syrian-refugees-uprooted-from-hotels-to-make-room-for-garth-brooks-fans.

Raw Deal. Dir. Anthony Mann, 1948.

"Reporters Without Borders Accuses US Military of Deliberately Firing at Journalists." 2003. https://rsf.org/en/news/reporters-without-borders-accuses-us-military-deliberately-firing-journalists .

Resina, Joan Ramon. "From Rose of Fire to City of Ivory." *After-Images of the City.* Ed. Joan Ramon Resina and Dieter Ingenschay. Ithaca, NY: Cornell UP, 2003. 75–122.

– "The Concept of After-Image and the Scopic Apprehension of the City." Ed. Joan Ramon Resina and Dieter Ingenschay. Ithaca, NY: Cornell UP, 2003. 1–22.

– "The Scale of the Nation in a Shrinking World." *Diacritics* 33.3–4 (2003): 46–74.

Roud, Richard. "Introduction: Anguish Alphaville." *Alphaville: Screenplay.* London: Lorrimer Films, 1966. 9–14.

Rutes, Walter, A., Richard H. Penner, and Lawrence Adams. *Hotel Design: Planning and Environment.* New York and London: W.W. Norton, 2001.

Sagarra, Josep Maria de. *Memòries.* Vol. 2. Barcelona: Edicions 62, 2000.

Sahagun, Louis. "This Guidebook Helped African Americans Find a Hotel along Segregation-Era Route 66." http://www.latimes.com/local/lanow/la-me-route-66-20160516-snap-story.html.

Sandoval-Strausz, A.K. *Hotel: An American History.* New Haven, CT: Yale University Press, 2007.

Sarcotte, Marcel. *La Prostitution, que peut-on faire?: Problèmes d'aujourd'hui et de demain.* Paris: Buchet-Chastel, 1971.

Sarlot, Raymond and Fred E. Basten. *Life at the Marmont: The Inside Story of Hollywood's Legendary Hotel of the Stars*. New York: Penguin, 2013.

Schivelbusch, Wolfgang. *Disenchanted Night: The Industrialization of Light in the Nineteenth Century*. Trans. Angela Davis. Berkeley: U of California P, 1988.

Schmied, Wieland, and Edward Hopper. *Edward Hopper: Portraits of America*. Munich: Prestel, 1995.

Serrano, Ramón. "*Lo que se ve es lo que se ve / What You See Is What You See*." http://www .corkingallery.com/artists/contemporary/ramn-serrano/artworks.

Sethi, Aman. "Rising Right Targets Refugees in Germany." http://www.thehindu.com/todays-paper/tp-international/Rising-Right-targets-refugees-in-Germany/article14394895.ece.

Singer Sargent, John. *A Hotel Room*. 1907. Oil on canvas. 61 cm × 44.5 cm. Private collection.

– *View from a Window Genoa*. 1911. Watercolour with pencil and oil. 40.3 cm × 53 cm. British Museum, London.

Sire. *El enigma Gaudí*. Ediciones Taga, 1984.

Sloterdijk, Peter. *Critique of Cynical Reason*. Minneapolis: University of Minnesota Press, 1987.

Smith, Michael P. *Transnational Urbanism: Locating Globalization*. Malden: Blackwell, 2001.

Somewhere. Dir. Sofia Coppola, 2007.

"Sotheby's Sets Record for Edward Hopper at $26.9 M." http://artdaily.com/news/18390/Sotheby-s-Sets-Record-For-Edward-Hopper-at--26-9-M#.WW5JmdPytm8.

Spies, Ralph Peter, Daniel J. Bronson et al. *Study of the Battle and Siege of Sarajevo*: United Nations, 27 May 1994. https://www.phdn.org/archives/www.ess.uwe.ac.uk/comexpert/ANX/VI-01.htm.

Stark, Richard, and John Banville. *The Jugger*. Chicago: U of Chicago P, 2009.

"Syrian Refugees – A Snapshot of the Crisis in the Middle East and Europe." http://syrianrefugees .eu/timeline/.

"Syria Regional Refugee Response." http://data.unhcr.org/syrianrefugees/regional.php.

Sywak, Ellie. "The Lloyd Hotel: Prison, Sanctuary, Embassy." http://www.aspiremetro.com/blogs/the-lloyd-hotel-prison-sanctuary-embassy-lux-hotel/. (Link no longer available.)

39 Steps, The. Dir. Alfred Hitchcock, 1935.

Touch of Evil. Dir. Orson Welles, 1958.

Travers, James. "*Hôtel du Nord*: Synopsis and Film Review." 2011. Filmsdefrance.com.

Truffaut, François, and Alfred Hitchcock. *Le cinéma selon Hitchcock*. Paris: R. Laffont, 1966.

Urban Warfare. BBC, 2005. http://news.bbc.co.uk/1/shared/spl/hi/middle_east/03/urban_warfare/ html/default.stm.

Urquhart, Cath. "Don't Expect Room Service." 23 November 2001. http://global.factiva.com.

A Very Murray Christmas. Dir. Sofia Coppola. Netflix, 2015.

Watkin, David. "The Grand Hotel Style." *Grand Hotel: The Golden Age of Palace Hotels*. Ed. Marc Walter. New York: Vendome, 1984. 13–25.

"#WelcomeRefugees." http://www.cic.gc.ca/english/refugees/welcome/milestones.asp.

Wharton, Annabel Jane. *Building the Cold War: Hilton International Hotels and Modern Architecture*. Chicago and London: U of Chicago P, 2001.

Vertigo. Dir. Alfred Hitchcock. Alfred J. Hitchcock Productions, 1958.

Vidler, Anthony. *Warped Space: Art, Architecture, and Anxiety in Modern Culture*. Cambridge, MA: MIT Press, 2000.

Vienna Convention on Consular Relations and Optional Protocols. Vienna: United Nations, 1963. http://legal.un.org/ilc/texts/instruments/english/conventions/9_2_1963.pdf.

Vila-San-Juan, José Luis. *La vida cotidiana durante la dictadura de Primo de Rivera*. Barcelona: Argos Vegara, 1984.

Virgin Suicides, The. Dir. Sofia Coppola, 2000.

Virilio, Paul. *War and Cinema: The Logistics of Perception*. Trans. Patrick Camiller. London: Verso, 1999.

Vivre sa vie. Dir. Jean-Luc Godard, 1962.

Walsh, Joanna. *Hotel*. London: Bloomsbury, 2015.

Ward, Janet. *Weimar Surfaces: Urban Visual Culture in 1920s Germany*. Berkeley: U of California P, 2001.

Warkel, Harriet G. *Paper to Paint: Edward Hopper's Hotel Lobby*. Indianapolis, IN: Indianapolis Museum of Art, 2008.

Weapon of Choice. Dir. Spike Jonze. 2000.

Wharton, Annabel Jane. *Building the Cold War: Hilton International Hotels and Modern Architecture*. Chicago: U of Chicago P, 2001.

When Strangers Marry. Dir. William Castle, 1944.

Wilkinson, Ray. "The Debate over Detention." *Refugees Magazine* 113 (1999). http://www.unhcr.org/publications/refugeemag/3b8112d44/refugees-magazine-issue-113-europe-debate-asylum-debate-detention.html.

Yoshioka, Maximilian. "Technocratic Totalitarianism: One-Dimensional Thought in Jean-Luc Godard's *Alphaville*." *Bright Lights Film Journal*, 2012. http://brightlightsfilm.com/technocratic-totalitarianism-one-dimensional-thought-in-jean-luc-godards-alphaville/#.WpxeRpPwZKM

Young and Innocent. Dir. Alfred Hitchcock. 1937.

Ziadé, Lamia. *Bye Bye Babylon: Beirut 1975–1979*. Trans. Olivia Snaije. Interlink Graphic, 2011.

– *La guerre des hotels*. Installation, 2008.

Index

Adorno, Teodor, 5
advertising, 104, 110, 111
Agamben, Giorgio, 122, 129
Air Canada, 128
airport, 124, 127, 164n24
Al Jazeera, 114
Albrecht, Donald, 155n1
Alcazar Hotel (Beirut), 104
Allen, Woody, 79, 159n25
Alphaville (film), 60, 68–9, 81, 158n15
Ambassador East (Chicago), 75
American Bar (Colón, Barcelona), 159n7
American Bar (Savoy, London), 101
Amuur v. France, 124–5, 128
anarchist revolution, 91, 99
Anderson, Wes, 158n3
anonymity, 7, 25, 47, 59, 64
Apollinaire, Guillaume, 14
Arbuckle, "Fatty," *The Bellboy* (film), 8, 52–4
architecture, "inert," 92
Arnold, Harry, 112
assemblage, 104
Ataner, Attila, 121, 161n1
Atlantic City, 70
Atlantic Hotel (Berlin), 16, 55
Augé, Marc, 111, 125–7, 129, 164n17
Avion (Toronto), 128

Bacha, Julia, 114
back of house, 49, 54, 86
Baghdad, 90, 112, 116
Balibar, Étienne, 122

Barcelona, 50, 95, 117, 148–2; anarchist revolution in, 91, 159n6; *Eixample*, 165n5; Orwell's wartime impressions of, 98–9; Universal Exhibition of 1888, 91
Barrymore, Lionel, 62
bataille des hôtels, La (installation piece), 103–6; 105, 106, 160n14
Baudrillard, Jean, 97, 160n9
Baum, Vicki, 56
Beirut, 102-07
Bellboy, The, 8, 52–4, 59
bellhop, 50
Bemelmans Bar (Carlyle Hotel, New York City), 86
Benjamin, Walter, 5, 20
Benjamin Franklin Hotel (Philadelphia), 75
Berger, Molly, W., 155n1
Berlin, 92
Betrayed (film). See *When Strangers Marry*
Beverley Hills Motor Hotel (Toronto), 141. *See also* Plaza Hotel (Toronto)
Big Sleep, The (film), 70
Big Sleep, The (novel), 69
Bogart, Humphrey, 62
Bonaventure Hotel (Los Angeles), 126
Booth, Wayne, 155n1
Bosnia-Herzegovina, 107, 117, 161n15
bourgeois interior, 20
boutique hotels, 164n20
Bradbury, Paul, 131
Braque, Georges: *The Terrace at the Hôtel Mistral*, 14, 16, 17; *The Viaduct at L'Estaque* 14, 19, 44

Breman, Every, 130
Brennan, Timothy, 120, 162n7, 164n16
Brugueras, Ignasi, 152
Bucharest, 92
business travel, 47

café, 3, 13
Café Waldluft (Berchtesgaden), 135–9, 153
Café Waldluft (film), 135–9
Cahiers du cinema, 71
camp, 119, 129
Camp X-Ray, 163n12
Canada: and Syrian refugee crisis, 8–9, 119,
 130, 140–5; use of hotels in interdiction
 practices, 122–3, 128–30
Canadian Border Service, 129
Canadian Pacific Railway, 155n2
Cannon, Steve, 66
caravanserais, 156n3
Carlyle Hotel (New York City), 80, 159n25
Castro, Fidel, 27, 33, 44
Catalonia, 91
Celebrity Inn (Toronto), 128–9, 140, 164n25,
 164n26
chain hotels, 101, 126
Chateau Marmont (Los Angeles), 84–6,
 159n24
Chomón, Segundo de: *El hotel eléctrico* (film),
 8, 50–2, 53,
Christie, Ian, 159n21
Clooney, George, 86
Commodore Hotel (Beirut), 103
communication technology: hotel as site of,
 90; role in loss of secular sanctuary status,
 102
compression of time and space, 5, 125, 126
Continental Hotel (Saigon), 102; "Continental
 Shelf" terrace bar, 102
Control Room (documentary), 114
Convention Relating to the Status of Refugees,
 120
Coppola, Francis Ford, 79
Coppola, Sofia, 8, 49. See also *Lost in Transla-
tion*; *Somewhere*; *A Very Murray Christma*
Cornell, Joseph, 157n4
cosmopolitan space, 95
Cosmopolite (Antwerp), 100
COSTI, 141

Couso, José, 114
Cuban Revolution, 27, 29, 33, 46
Cyrus, Miley, 86

Dault, Gary Michael, 37
Day, Doris, 72-73
decompression, 4, 5, 101, 119, 125, 126
Denby, Elaine, 155n1
Desson, Craig, 142
detainees, 89
detention centres, 8, 120–5, 127–30, 140, 145
displaced travellers, 89, 119–45; backlash
 against, 120, 142–5
displacement hotel, 119–45
Domènech i Montaner, Lluís, 148–9, 153,
 165n3
doorman, 54–5
dwelling, 4, 20, 21, 156n4

Ealham, Chris, 159n6
Eatonville Roadhouse, 162n10
electrification, 50
Éluard, Paul: *The Capital of Pain*, 68
Empire Hotel (San Francisco), 76
ennui, 80, 83, 85

factory, 3
Fatboy Slim
FIBUA (Fighting in Built Up Areas), 90, 102;
 vertical form in Beirut, 103
Field Levander, Caroline, 150, 152, 155n1,
 158n3, 158n6
film noir, 64
First World War, 52
Fisk, Robert, 112
France: transit zones in, 163n14; use of hotel in
 interdiction practices, 122–5
Franco, Francisco, 95
Frankfurter Zeitung, 156n7
Fregonese, Sara, 156n5
French New Wave, 64
Freud, Lucien, 157n4

gangsters, 62, 63
Gaudí, Antoni. *See* Hotel Attraction
Geneva Coordination for the Right to Asylum,
 123
genre pictures, 59–64

George, Terry, 133. See also *Welcome to Sarajevo*

Germany: accommodation of asylum seekers in, 8, 119, 130, 134–9, 163n13

Giovanni, Janine di, 101

Glinn, Burt, 7, 26, 29–35, 37, 46, 90

Godard, Jean-Luc, 8, 60, 64–70. See also *Alphaville*; *Made in USA*; *Vivre sa vie*

Golding, Edmund, *Grand Hotel*, 8, 25, 49

Goytisolo, Juan, 112

Grand Budapest Hotel, The, 158n3

Grand Hotel (film), 8, 25, 49, 55–9, 59, 81; "Grand Hotel: people come, people go" quote, 57

Grand Hotel (novel), 56

Grand Hôtel (Paris), 150, 155n2,

Grand Hotel et de Milan, 100

Green, Victor H., 159n19

Greenaway, H.D.S., 102

Gregotti, Vittorio, 126

Grosz, George: *Metropolis*, 16, 19, 44

Guantánamo Bay, 162n12

Harvey, David, 162n7

Hassler Roma Hotel (Rome), 100

Havana Hilton/Habana Libre, 7, 26, 28, 37, 37f, 38–46, 62; remodelling of, 27; requisitioning of, 29; renaming of, 33, 35; as trophy, 28

Hayner, Norman S., 155n1

Hayward, Susan, 55, 59

Heidegger, Martin, 156n4

Heimat, 134, 139, 165n29

Heritage Inn (Toronto), 128–9, 129f, 140

heterotopia, 49, 56, 101

Hilton, Conrad, 160n8

Hitchcock, Alfred, 8, 49, 71–8, 158n16, 158n17, 158n19, 159n20. See also *The Man Who Knew Too Much*; *North by Northwest*; *Vertigo*; *Young and Innocent*

Holiday Inn (Beirut), 102, 105, 107, 108

Holiday Inn (Sarajevo), 101, 109f, 111, 161n16, 161n21; constructed for Winter Olympics, 107; sniping from, 107

Homage to Catalonia (memoir), 96–100, 110. *See also* Orwell, George

Hopper, Edward, 13, 19; alienation and, 20, 26; *Hotel by a Railroad*, 21–2, 23; *Hotel Room*,

21, 22, 25, 47; and occupancy, 20, 26, 37; and urbanity, 20

hospitae, 156n3

hospitality, 54, 126; "monetised," 156n5

Hôtel Arcade (Paris), 124, 128

Hotel Attraction, 7, 9, 147–8, 150–3, 165n4

Hotel Colón (Barcelona), 92, 93f, 94f, 95, 159–60n7

hotel eléctrico, El (short film), 8, 50-52, 51f, 53f, 59

Hotel Husarenhof (Bautzen), 135, 136f

Hotel Internacional (Barcelona), 148–50, 149, 152, 165n3

Hotel Krasnapolksy (Amsterdam), 101

Hotel Limbo (radio documentary), 140–2

Hotel Lobby, 23, 24, 25, 33; *Hotel Window*, 26, 27

Hôtel des Mille Collines (Kigali), 132–4

Hotel Nacional (Havana), 157n12

Hôtel du nord (film), 60–2

Hotel Palestine Baghdad, 112, 114–17, 115f, 116

Hotel Reserve (film), 160n11

hotel room: futuristic 52; "Mr Kaplan's" in *North by Northwest*, 75; "resetting" of, 20; temporary nature of, 16

Hotel Rwanda (film), 132–3

Hotel Scribe (Paris), 158n2

Hotel Vertigo (San Francisco, formerly Empire Hotel), 76

hub, hotel as, 155n2

Huck, Cathleen D., 28

Huston, John, 62

hybrid space, hotel as, 62

Imperial Hotel (Vienna), 100

information dissemination, hotel's role in, 112, 116

Intercontinental (Dacca), 102

interdiction, 120–5, 127

international exhibitions, 155n2

interurban space, 3, 90

Iveria Hotel (Tblisi), 131–2, 132

James, Kevin, 155n1

Jameson, Frederic, 155n1, 92, 93, 126, 164n22

jazz band, 72

Jesus and Mary Chain, The, 159n23

Johansson, Scarlet, 80, 83
Johnson, Elizabeth, 155n1
journalism: and hotels during Second World
 War, 100–1; photojournalism, 98; relation-
 ship between hotel and, 89–90, 101; and
 Sarajevo Holiday Inn, 110; under attack at
 Hotel Palestine Baghdad, 116; war report-
 ers, 91, 101

Kabul Inter-Continental, 101
Karina, Anna, 64, 69
Katz, Marc, 6, 156n7
Kaushik, 132
Keaton, Buster, 52–4
Kern, Stephen, 164n16
Key Largo (film), 60, 62
King, Geoff, 79, 102
Kirsanoff, Dimitri: *Ménilmontant* (film), 60–1
Koolhaas, Rem, 49, 56
Koßmehl, Matthias, 135–8
Kpatinde, Francis, 123
Kracauer, Sigfried: as hotel flâneur, 156n7;
 The Hotel Lobby, 5–7; 25, 26, 155n1,
 156n7; phenomenology of the surface in,
 156n8
Krebs, Mariana, 155n1

Laffoley, Paul, 152
Lahuerta, Joan José, 152
Larkin, Brian, 147, 165n1
Las Vegas, 3, 164n21
Last Laugh, The (film), 54–5, 56, 59, 158n8
Leach, Neil, 92, 93
Lebanese Civil War, 102–7, 117
Lebanon, 90
Lefever, Michael M., 28
Le Phnom Penh, 102
Levin, Gail, 20
Liesbrock, Heinz, 20
Life without Zoe (short film), 79
Limonov, Eduard, 111–2, 113
Lloyd Hotel (Amsterdam), 130–1
lobby, 5, 53, 65, 75; as transitional space, 24.
 See also Kracauer, Sigfried
long-term stay. *See* residential hotel
Lost in Translation (film), 79–84
loyalty programs, 5
luggage, 50

Made in USA (film), 60, 69–70, 71
Magnum Photos, 29
male gaze, 104
Malik, Shahaan, 142
Manet, Édouard, 14
Man Who Knew Too Much, The (film, 1956
 version), 72–4, 74f
Marie Antoinette (film), 79
Marriott Hotel Los Angeles, 47
Martinez Hotel (Beirut), 104
Mascort i Boix, Marc, 152
Matamala Flotats, Joan, 150, 152
media gaze, 8, 91, 96, 105, 111, 117
Méliès, Georges, 50
Ménard, Robert, 114
Ménilmontant (film), 60–1
Metronaps, 164n24
Métropole (Brussels), 100
modernisme, 148–53
Mojica, Frank, 159n23
Mole, Nuala, 162n6
Monet, Claude: *Hôtel des roches noires,
 Trouville*, 14, 15f, 19, 25, 44
Morrison, Kenneth, 159n2, 161n16
motel, 159n20
Murnau, F.W. See *The Last Laugh*
Murray, Bill, 80, 83, 86
My Bloody Valentine, 159n23

Nasseri, Merhan Karimi, 164n15
New York Bar (Park Hyatt, Tokyo), 81, 83
New York City, 9, 148, 153
non-place, 119, 122–3, 125–7, 130, 164n23
Normandie Hotel (Beirut), 102
North by Northwest (film), 71, 72, 74–5, 75f,
 159n20
noucentisme, 148
Noujaim, Jehane, 114

Oak Bar (Plaza Hotel, NYC), 74
occupancy: definition of, 4; displacement
 and, 130; fantasy of, 56; military, 35; requi-
 sitioning and, 117;
Orwell, George, 90, 96–100, 110, 116–17;
 experience of being shot, 97

palimpsest, hotel facade as, 95
Palm Beach Hotel (Beirut), 102

Paris, 69, 159n3
Park Hyatt (Tokyo), 80–4
Peláez, Amelia, 33
Pfueller Davidson, Lisa, 164n19
Phoenicia Hotel (Beirut), 102, 104
Picasso, Pablo, 14
place, grand hotel as a, 126, 164n17
Plaza Hotel (New York), 74, 75
Plaza Hotel (Toronto), 140–3, 143f, 153, 165n30
Poe, Edgar Allen: "The Man in the Crowd," 156n9
porous space, hotel as, 85
postcards, 3, 110
Pratt, Anna, 128, 162n8, 164n25
Pratt Guterl, Matthew, 150, 152, 155n1, 158n3, 158n6
President Wilson Hotel (Geneva), 144
prostitution, 60, 64–8
Protsyuk, Taras, 114
Psycho (film), 159n20

"quickie marriages," 64

Radisson Blu Iveria (Tblisi), 132. *See also* Iveria Hotel
railway hotels, 155n2
railway station, 3, 125, 126, 127
Ramadan, Adam, 156n5
reception desk, 23
refuge, hotel as, 60, 100, 119, 130–4
refugees, 125, 162n12, 164n28. *See also* displaced travellers
renaixença, 148
Reporters Without Borders, 114, 116
requisitioning, 63, 89; Havana Libre/Hilton, 90; information gathering/dissemination and, 90; non-state agents and, 92, 119; political recruiting and, 95; related to pop art, 104; Sarajevo Holiday Inn journalists and, 110; state and, 124; war reporters and, 101
residential hotel, 156n6
Resina, Joan Ramon, 157n18, 162n7
Reuters, 114
revolving door, 58, 68; symbolism of, 55, 57–8;
Ritz Hotel (Barcelona), 94, 95, 96; collectivization and name change of, 95
Roaring Twenties, 55, 91
Rose, Nikolas, 162n8

run of house, 25
Rusesabagina, Paul, 132–3
Rwandan genocide, 132–4

Saint George Hotel (Beirut), 102, 104
sanctuary, 119, 139
Sandoval-Strausz, A.K., 155n1
Sarajevo, 90; Siege of, 107, 111, 114, 117; "Sniper's Alley," 107, 161n21; "Total Siege Tour," 161n21
Sarcotte, Marcel, 64
Sargent, John Singer: *A Hotel Room*, 14, 16, 18f, 19, 44, 157n3
Savoy (London), 100; during Blitz, 101, 150
Savoy Standard (one-off newspaper), 101
Schivelbusch, Wolfgang, 158n5
Schmied, Wieland, 24
Scorcese, Martin, 79
Second World War, 100
secular sanctuary, 90, 101, 111, 112; role of communication technology in loss of, 102. *See also* refuge.
Serrano, Ramón, 7, 26, 29, *What You See Is What You See (Lo que se ve es lo que se ve)* series, 35, 37–46, 90, 157n15
Sethi, Aman, 134
Sheraton Johnson (Rapid City), 75
Sherwyn Hotel (Pittsburgh), 75
shopping arcade, 3
Silberman, Marc, 55
Simmel, Georg, 20
site of fantasy, hotel as, 47
Sloterdijk, Peter, 13
Smith, Michael P., 162n7
Sniper (film), 112, 113
sniper's gaze, 8, 90, 91, 92, 96–8, 111, 117, 161n17; overlapping with tourist gaze, 104, 110
Sofitel Paris Le Scribe, 68–9
Somewhere (film), 80, 84–5,
sovereignty, 120–5, 127
Spanish Civil War, 90, 91, 96–9, 117
spatial détente, 20, 21
Spike Jonze, 47–8
Spree Hotel (Bautzen), 134–5, 145
Stalingrad, 159n3
Stark, Richard: *The Jugger* (novel), 70
Statler Hotel (Boston), 75
Stella, Frank, 37

stop motion, 50
strategic value, 91–2, 101, 104
Stryker, Deena, 7, 29, 35–6, 46, 90
surveillance, 63, 69
switchboard, 57, 58
symbolic value, 93; Catalonia and, 91; grand
 hotel and, 94; performative nature of hotel
 and, 95
Syrian refugee crisis, 119, 130, 134–5, 140–5
Sywak, Ellie, 130

tavernae,156n3
threshold space, hotel as, 60
time: commodification of, 61; relationship of
 hotel with space and, 90, 147
Toulouse-Lautrec, Henri de, 14
tourism, 126; democratization of, 127; eman-
 cipatory nature of, 110; utopic impulse of,
 111
tourist gaze, 8, 90, 91, 92, 96–100, 107, 117,
 161n20; lingering quality of, 100, 110;
 overlapping with sniper's gaze, 104
trace, 20, 75
transculturation, 3
transitory space, hotel as, 64, 119
travel by choice, 89, 119
travelling salesmen, 63
Trianon Palace Hôtel (Versailles), 159n1
Truffaut, François, 71

Universal Exposition of 1888 (Barcelona),
 148–50. See also Hotel Internacional
 (Barcelona)

urban warfare, 159n3; alteration of daily life
 and, 90–1
Urquhart, Cath, 111
Urry, John, 99–100, 110,

Vertigo (film), 71, 72, 75–8, 158n17
Very Murray Christmas, A (film), 80, 86
Vidler, Anthony, 6
Virgin Suicides, The (film), 79
Virilio, Paul, 97, 160n9
Vivre sa vie (film), 60, 64–8; movie poster, 65

Waldorf-Astoria (New York City), 156n6
Walken, Christopher, 47, 48
Walsh, Joanna, 155n1
Ward, Janet, 158n8
"War of the Hotels" (Beirut), 102–7
war reporters. See journalism
wartime hotel, 8, 89–117
Weapon of Choice (music video), 47, 48
Welcome to Sarajevo (film), 161n19
Wharton, Annabel Jane, 28, 110, 160n8
When Strangers Marry (film), 60, 63
Whittier Hotel (Detroit)
Winterbottom, Michael, 161n19
Witte, Karsten, 156n8
world's fairs, 155n2

Young and Innocent (film), 71–2, 73

Ziadé, Lamia, 103–6, 160n12, 160n14; Bye Bye
 Babylon, 160nn12–14